Unmasking the Forger

By the same author

File on the Shroud
The Image on the Shroud
The Gospel of Barnabas
Relics and Shrines

Unmasking the Forger

The Dossena Deception

DAVID SOX

UNWIN HYMAN
London Sydney

First published in Great Britain by Unwin Hyman,
an imprint of Unwin Hyman Limited, 1987.

UNWIN HYMAN LIMITED
Denmark House, 37–39 Queen Elizabeth Street,
London SE1 2QB
and
40 Museum Street, London WC1A 1LU

Allen & Unwin Australia Pty Ltd
8 Napier Street, North Sydney, NSW 2060, Australia

Allen & Unwin New Zealand Limited with the Port Nicholson Press
60 Cambridge Terrace, Wellington, New Zealand

British Library Cataloguing in Publication Data

Sox, H. David
 Unmasking the forger: the Dossena deception.
1. Art – Forgeries
I. Title
069.5′4 N8790

ISBN 0–04–440026–8

Set in 11 on 13 point Century Schoolbook by
Nene Phototypesetters Ltd, Northampton
and printed in Great Britain by
Biddles Ltd, Guildford and King's Lynn

For two long-time friends named Bill – Chase and Wright who both know a great deal about art – and probably not a little about fakes

Contents

Illustrations

Preface

Joseph Duveen, the best known art dealer of all time, was once reported to have said, 'If I had the Sistine Chapel, I could sell it tomorrow half a dozen times over.'[1] From the recent revelations concerning Duveen's methods of dealing it could be added, and he probably would.

Art has become a bigger business than even Duveen could have envisioned. Christie's recently ran an advertisement in the newspapers declaring: 'The world's most valuable pictures – sold at Christie's.' Pictured were two examples to illustrate the claim: Edouard Manet's *La Rue Mosnier aux Paveurs* – 'Sold at Christie's for £7,700,000 – Highest auction price for an Impressionist Picture' and Andrea Mantegna's *The Adoration of the Magi* – 'Sold at Christie's for £8,100,000 – Highest auction price for an Old Master Picture'. However, early in 1987 these prices were surpassed by the sale there of Van Gogh's *Sunflowers* for a staggering £22,500,000.

Of course, the advertisement gives no hint of an interesting fact concerning the Mantegna. Several British experts were not sorry to see it leave Britain for the Getty Museum in California since they doubted its authenticity. This is not to imply that Christie's also sells highly valuable works of art of dubious origin, but as the reader will soon read, art forgery also continues to be big business.

What follows is not an attempt at biography or exposé. It is probably far too late for anyone to write a biography as the records of Alceo Dossena are scanty, and those who know the fuller story have either gone to their Maker – or are just about to. Considering that the full sting of the Dossena affair occurred decades back, if some in the art establishment think this be sensationalism it is undoubtedly latter day. The emphasis is on investigation, and I had no idea in the beginning where it would take me.

What has been most intriguing about my experience with the Dossena case was the reaction of some of the museums involved. With the notable exception of the Saint Louis Museum, David

Wilkins at the Frick Fine Arts Collection in Pittsburgh, and an
initial help from the Fogg in Harvard, I basically faced a blank
wall. I have had the considerable advantage of the BBC taking an
interest in my investigation and on 4 December 1986 half an hour
of the 'Timewatch' series was devoted to my work on Dossena, in
which I was the presenter. At the time of the film, I had not
tracked down Dossena's son, Walter Lusetti, or talked to the last
claimant to the unmasking of the forger, Pico Cellini.

I learned much from the television experience, however, and
thank both the producer, Neil Cameron, and series editor, Roy
Davies, for their patience with a novice to the mysteries of
television. Television – for better or worse – certainly places
factors into basic perspective. Neil worked hard to penetrate the
impregnable American museum walls of silence regarding in-
volvements with Dossena's clever works. I well remember our last
evening in Cambridge, Massachusetts, when he tried in vain to
gain entrance into the Boston Museum of Fine Arts to discuss the
Dossena creation, a tomb in the style of Mino da Fiesole. The
response of the museum director was: 'Just who is this Reverend
Sox?' The implication was that I had not the proper credentials to
be discussing one of their acquisitions. But, as the reader will soon
see, it would have made no difference to the director if I had been
a curator from the British Museum or a hairdresser, since his
museum decided long ago that no one would ever penetrate their
walls to find out any more about that tomb.

It was this arrogance in the art establishment which most
depressed me – and stiffened my resolve to continue. After
receiving basic responses to my queries from the American
museums – largely material I would discover in the libraries
anyway – even answers to fundamental questions ceased in time.
I can almost visualise a memo going out (probably from Boston) to
all possibly concerned to remain mute. My favourite reply in the
latter days came from Patrick de Winter, curator of Early
Western Art at the Cleveland Museum: 'the director of the
museum, Evan Turner, currently abroad, has instructed [me] not
to make further statements regarding the two Dossena forgeries,
perhaps contemplating writing to you himself'. I especially like
the 'contemplating' touch. Of course, I never heard from Mr
Turner or anyone else as time went on.

What the American museums appear not to recognise is:
(1) British museums and libraries are not as paranoid as their

American counterparts; and (2) there are persons in Europe who know a great deal and would like to set the record straight. As an American who has lived in England for fifteen years I am increasingly vexed by attitudes I have had to face in research using American sources. I have met this previously with my work on the Turin Shroud and the Gospel of Barnabas. I would like Americans to know how much easier it is to do research in England than in my native land, and I doubt seriously if this investigation would have got very far if I had stayed solely in the States. For me it is a sad commentary on a nation that glories so much in freedom and access.

There is no doubt that for a long time there has been an attempt to keep controls on the Edward Warren/John Marshall/Harold Parsons stories, and I only hope some bright young sleuth will one day look even further into that fascinating connection. For the record I would now like to say that – considering the dynamite I have read and heard – I have been very kind to all concerned and can only imagine what might happen in the future.

There are a number of people to thank for their great assistance. At the top of the list is Russell Lynes, formerly at *Harper's* magazine, who got so near the full story of Dossena many years ago. He is in the best American tradition of intelligent sleuthing. I am equally indebted to Albert Franz Cochrane who did a superb job of detecting, also for *Harper's*, several years before Lynes. Bernard Ashmole kindly answered many questions, and supplied useful information. He is one of the last links to Marshall and the Dossena affair.

Charles Rose in Lewes was a great find, and I appreciate his time in showing me Lewes House, and supplying me with some interesting insights. Anthony Radcliffe of the Victoria and Albert Museum and Brian Cook at the British Museum could not have been more helpful – and both speak well of the best breed of museum curators. I am also indebted to long-time acquaintance, John Beckwith, who helped me with some early contacts. I found Sir John Pope-Hennessy to have written the most useful of all material available on the forging of Italian Renaissance art. I also thank his former museum, the V & A, for great assistance. The National Art Library at that museum is the best in the world for courtesy and material. Thomas Hoving and Geraldine Norman have also been extremely helpful and both are formidable sleuths in their own right.

Thanks are also due to the Cremonese newspaper, *La Provincia*, and Elia Santoro who got together those who had responded in Dossena's hometown, Cremona, to my plea for facts concerning the forger's early years. I am especially grateful to Ercole Priori, Emilio Dossena and Luisella Baruffini.

Eleonora Botti has patiently and kindly translated many Italian materials for me, and this was extremely helpful. I also thank Brian McGregor, librarian of the Ashmolean Museum, Oxford, for access to the Warren–Marshall papers, and the Archives of American Art for permission to quote from the papers of William Milliken. The reader will recognise a debt to that extraordinary biography of Edward Perry Warren by Osbert Burdett and E. H. Goddard, but unfortunately no one from that production survives to whom I can extend my gratitude.

Usually writers never want to admit that other books gave them any substantial direction as to style, but I should say that Seymour Reit's delightful *The Day They Stole the Mona Lisa* (London: Robert Hale, 1981) was useful as a format for sub-dividing parts into smaller reading sections, which I think the reader will find helpful as he faces such a bulk of factual material. I have generally avoided titles such as Professor, Lord and Doctor throughout the book, not for egalitarian reasons but because they become tiresome after a while. Also when particular references are not cited it is because the source for that information expressed a preference for anonymity.

Colin Simpson's *Artful Partners: Bernard Berenson and Joseph Duveen* (New York: Macmillan, 1987) was published after I had completed the bulk of my research. Simpson mentions a number of matters related to Dossena and the dealers who handled his creations, but as I find no other corroboration for some of his suggestions of 'a cabal of Italian dealers' in relationship with Dossena, I largely refer to Simpson in the Chapter Notes and References to Parts Two and Four.

Lastly and most appropriately, thanks go to Walter Lusetti and Pico Cellini because their insights broadened my view of the Dossena affair considerably, and to Merlin Unwin for making the book a possibility in the first place.

PART ONE

The Backdrop

1

By December 1916 the Great War was two years' old. In November, President Woodrow Wilson had won a second term under the slogan, 'He kept us out of war', but neutrality became increasingly difficult with the acceleration of German U-boats sinking American merchant ships.

Italy was aligned with the Triple Entente hoping to acquire Italian-speaking areas from Austria, but many Italians wondered if it was worth the heavy toll of the battlefield. An odd sidelight to the war was a flooding of the international art market with many Italian treasures, the origin of some creating speculation in Paris and London. Some pieces were of major importance, and rumours had it that the Vatican had been forced to prune its vast collections. The truth was that a number of noble Italian families were using family treasures to pay their bills, and other works had been pilfered from unguarded country estates and neglected churches.

On Christmas Eve 1916, a tall and slightly stoop-shouldered soldier on leave from the Poggio Mirteto garrison made his way down Via Mario de Fiori, a Roman street known for its pedlars and prostitutes. He was 38 years old and carried a marble sculpture of the Madonna in bas-relief. It was wrapped in newspaper, and Alceo Dossena who was short of funds for Christmas gifts for his family hoped to sell the piece.

Dossena showed the piece to Felicetto, the owner of a small cafe. Felicetto was used to soldiers selling a variety of items for drinks or girls, but he was not interested in what he suspected was a stolen Madonna – certainly not at Christmas. But he sent someone to fetch a friend whom he told Dossena was 'very important in the art world'. This was Alfredo Fasoli, the owner of a jewellery shop in the nearby Piazza di Spagna.

Fasoli knew enough about art to recognise that the soldier's relief was not an ordinary piece. The patina was extraordinary and it looked convincingly like a Renaissance masterpiece. He also suspected it had been stolen but offered 100 lire for it (about £8). Back in his shop, Fasoli examined the marble more carefully and began to suspect it was a modern work.

A few days later, Fasoli ran into Dossena and invited him for

a drink in a cafe frequented by art dealers. He asked the soldier if he had any other pieces like the Madonna, and after a few drinks, Dossena told Fasoli he had created the relief and artificially aged it in the base of a military urinal. Fasoli's mind buzzed with excitement but he kept his ideas to himself for the moment. Meanwhile, he assured Dossena he could find a market for similarly executed works. Thus began an arrangement which would eventually cost museums around the world a sum estimated in the 1930s at between $1 to 33 million.

The foregoing is the oft-repeated story of Alceo Dossena's beginning as the most versatile forger of all time – his creations would range in style from archaic Greek and Etruscan to Italian Renaissance; in material from terracotta to marble, wood and bronze. With little variation over the past fifty years, several books on art forgery have presented a remarkably similar account of his career,[1] starting with the Christmas Eve tale. I retold it on BBC television in December 1986, and would have continued to accept it and the basic outline of Dossena's life previously recorded if I had not come across several individuals in Rome and Cremona in January 1987. Two men I interviewed were especially important – Dossena's illegitimate son, Walter Lusetti, and the surviving claimant in what Russell Lynes aptly termed 'the discovery sweepstakes', the art restorer, Giuseppe 'Pico' Cellini.

In our preparatory research for the 'Timewatch' programme, the BBC team was given the clear impression that Lusetti was 'probably long-time dead', and Cellini was 'so untrustworthy' as not to be worth our going to Italy to interview him. I now know why this view is fostered by individuals in the art establishment, and have had Lusetti's and Cellini's sides of the story confirmed by two other Romans who prefer to remain anonymous.

Uncovering the full (or perhaps more accurately, the fuller) story has not been easy. There are no biographies of Dossena, and both a romantic version of the affair and a covering-up of certain links have been nurtured. However, in January 1987 many pieces of the puzzle fell into place for me, and a more accurate version of the Dossena story is now possible.

Writing in 1968, the well-known American art critic and former *Harper's* magazine editor, Russell Lynes, attempted to

unravel the Dossena affair, and explained the difficulties he
had had. A friend, Francis Henry Taylor, former director of the
Metropolitan Museum, told Lynes: 'I'll tell you anything you
want to know, but I warn you, you won't get anywhere.'[2]
Another contact 'a dealer and the head of a distinguished
gallery' said to Lynes: 'You don't want to write about Dossena'.[3]
The more Lynes looked around New York the more he was
convinced: 'There was scarcely anyone in the art world here
who was not taken in by Dossena at one time or another.'[4]

Unmasking the forger becomes as much an exercise in
unmasking others: dealers, museum curators, buyers, and
purchasing agents. To give a capacious accounting necessarily
involves several individuals who either claimed to have un-
masked Dossena, or for whom others have made the claim. At
times, their stories are more intriguing than that of the forger
himself.

The basic outline of Dossena's life which has been used by art
historians and writers on art forgery is based largely on an
account given by the Roman antiquarian, Augusto Jandolo, in
his 1938 memoirs. More interesting than the figures and events
he presents are the ones he omits. Sepp Schüller refers to
Jandolo as 'the friend and biographer of Dossena'.[5] His 'biogra-
phy' is a 33-page chapter in *Le Memorie di un Antiquario*
largely written in fanciful narrative form. Subsequent authors
took Jandolo as 'gospel truth' and rightly so in most instances.
Jandolo mentions Marshall and the dealers Fasoli, Durlacher,
and Jacob Hirsch. He also presents two figures of whom few
writers on Dossena took much note; his assistants, Gildo
Pedrazzoni and Patrizio Incarnati. We look in vain for Dosse-
na's legitimate son, Alcide, or Walter Lusetti, as well as the
dealers, Palesi, Balboni and Morandotti. Also absent is any
reference to Dossena's last studio at Via Margutta, and for good
reason. It was next door to the Jandolo family's art dealing
headquarters. The family has been in the business in Rome for
decades. Augusto's shadowy brother, Ugo, was involved in
selling some of Dossena's works. Jandolo's 1916 Christmas Eve
scenario, albeit charming, streamlines Dossena's beginnings as
an art forger.

Obviously, Jandolo purposely excluded certain Roman deal-
ers, whose reputations he did not want to damage, from
acquiring Dossena's forgeries. The irony is that elsewhere in his

memoirs, Jandolo has forceful attacks on spurious art, and was
responsible for unmasking a number of bogus works.[6] Anatole
France once said that 'the trade of an art dealer is incompatible
with honesty', and he was astonished when he met Jandolo 'to
find . . . a dealer who told the truth. The fact seemed so
extraordinary that I had to pass it on when I returned to Paris.
But I was sure before I started that no one would believe me.'[7]
That is milder than Picasso's 'People who make a trade of art
are usually swindlers',[8] but getting near the truth of the
Dossena affair necessitates a sifting through half-truths and no
mean amount of subterfuge projected by dealers and their
associates over many years.

2

Alceo Dossena was born in Cremona on 8 October 1878 though
many writers give it as 9 October. His home town is in the
southern part of Lombardy about 80 kilometres from Milan.
Cremona is an ancient town having been colonised by the
Romans in the third century BC. The Roman remains –
columns, tombs, impressive mosaics – kept in the municipal
museum – indicate its ancient significance. Twice Cremona was
destroyed before being rebuilt in 1334 under the domination of
Milan. It prides itself as a 'città della arte' but is keenly aware
that as regards the tourist trade its artistic significance is
largely ignored today.

The visitor who does go to Cremona is quickly aware of its
most famous son – Antonio Stradivari – known outside Italy by
the Latinisation of his surname – Stradivarius. Miniature
'Stradivariuses' are for sale all over Cremona, and some real
violins as well. The richly decorated Palazzo Raimondi contains
a violin-making school.

In his chapter on Dossena, Schüller could not resist the
embellishment: 'Alceo showed at a very early age that he was to
learn any handicraft . . . He made violins which are said to have
been as good as the highly prized old instruments.'[9] There is
much of this in the chapters on Dossena in books on art forgery.
We have the Dossena family, 'artisans of diverse talents', busily
repairing ancient monuments with son Alceo learning tricks of
the trade at their heels. Others insist he was apprenticed as a

cartoonist to a local silk weaver. Even the biography, *Alceo Dossena, Scultore* by Walter Lusetti, published in 1955, presents questionable material.

But the 'biography' is only three pages in a collection of fifty-one photographs of Dossena's works, and even that was not written by Walter Lusetti. As will become significant, the 1955 presentation was composed by Pico Cellini and Harold Parsons for reasons quite removed from giving the life-story of the forger.

If I had not initiated a search for biographical data in Cremona in January 1987, I would have been left with the skeleton facts given in the various volumes on art forgery – and the fancy of various writers. The 1955 book says that Dossena was 'of a poor family and passed a boyhood of constant toil. In art he was self taught and by his own efforts became a painter and an accomplished draughtsman as well as a sculptor.'[10] Well – that is not quite the way it was.

Alceo's parents were Regina Melgari and Giovanni Dossena who was a porter at the local railway station. Giovanni is described as a strong, robust man but there is no indication that either parent was especially artistic. Alceo is remembered as an intelligent, impulsive and unruly child – according to one school report he had 'all the characteristics of an *enfant terrible*'. He hated school and had to repeat several classes before finishing his elementary education. In desperation the Dossenas decided to send him to the local trade school – 'Ala Ponzone Cimino' – where they hoped his natural inclinations towards art could find some useful outlets.

By all accounts the school was well suited to Alceo's needs. Teachers were well known for discovering practical applications for various talents. To this day Cremona is known for such institutions. Alceo excelled in creating in every medium presented in the workshops, but was bored with classroom instruction. He completed the first year's course in decorative arts and was into his second year in sculpture which he greatly loved when he was expelled. The school records do not give the reason, but one of his nephews claims to know the story.

Apparently 12-year-old Alceo and his sculpture teacher did not get along and the boy felt his teacher was not recognising his budding talent. Alceo made a statue of Venus at home and brought it to school for what sounds like 'show and tell time'.

The teacher appeared unmoved by the creation, and Alceo took it home again. On his way, he met some school mates who made fun of his Venus while they were playing in a hole near a playground. When they left, Alceo broke off Venus's arms and placed the statue into the side of the hole. Several days later, the 'discovery' was brought to school by excited children who insisted they had found an artefact.

Another teacher at the school was astounded by the discovery and put it on display. When Alceo became aware of this, he entered the teacher's classroom and shouted: 'You asses! I'm the one who made the statue.' He reached in his pocket and pulled out the broken arms. The outburst sent Alceo to the principal's office, and as this was but one of many examples of unruly behaviour, Alceo was expelled. His parents made several efforts to have their son readmitted to school, but he was only allowed to attend certain day courses, and by his last year was enrolled in a night class in sculpture. During the day Alceo worked as an errand boy for various workshops in Cremona, and at some stage he was briefly apprenticed to the well-known stone mason and sculptor, Alessandro Monti in Milan. From various accounts it appears Alceo Dossena's craftsmanship earned him odd jobs repairing balustrades, columns and statues in nearby churches and palaces. One thing is certain, the Dossena family was very poor and lived for a time in a dilapidated house under a bridge. If young Alceo were to succeed at anything it would be totally up to him.

Dossena married Emilia Maria Ruffini on 22 May 1900, but little is known about her except that she had 'a sweet disposition'. A year later, Alcide was born and the family moved to Parma. The Dossenas had a number of different residences apparently because the neighbours complained of Alceo's habit of working late at nights on various sculptures. In 1914, Dossena was drafted into the army and was first stationed at the Poggio Mirteto garrison in Perugia. By 1915 he was at the aeronautical depot in Rome, and a picture of him with his friends shows him proudly seated next to a Madonna and Child he had just created.[11]

One writer has suggested that from his many experiences in repair work, Dossena 'was constantly called upon to match, first the forms and techniques of some long-dead sculptor, then the specific kinds of marble which he had to treat so that its

patina would be identical with that of the original'.[12] This is jumping a few steps ahead of the known facts but there are a number of suggestions that Dossena's restorations as a youth were so convincing that it was difficult to distinguish them from the original works. There is no doubt also that somehow Dossena excelled early on in giving his works an incredible look of age. Few forgers have ever matched his ability in achieving such a fine patina.

The 1955 book says that as a boy Dossena had an admiration for 'the works of the Lombard sculptors and the patina which their marbles had acquired through age'.[13] There is much to admire in Cremona. Its imposing cathedral has the tallest campanile in Italy and its façade, faced with marble, is a lesson in art history – Gothic porch, medieval frieze, thirteenth-century rose window surmounted by a pediment designed 300 years later, and a number of Renaissance embellishments. John Pope-Hennessy suggests that Dossena was inspired by the fine pulpit reliefs of the Pavian sculptor, Amadeo, from whom 'he gained a taste for angular drapery and broken planes which he indulged even when later he copied Florentine Renaissance sculptures'.[14]

A finer creation by Amadeo, an exquisite high relief depicting St Imeroi giving alms, which is on the face of a pillar of the triumphal arch of the chancel, looks like an even more direct influence on some of Dossena's creations. Another is Cremona's best loved Madonna, high on the upper loggia of the cathedral façade, which has been attributed to Gano da Siena.

A visit to the twenty-four rooms of the municipal museum reveals enough ancient statues, rich terracotta reliefs and Renaissance works to inspire any potential artist. Cremona has always been noted for its fine terracottas, and friezes in terracotta are a standard decoration on many churches and palaces. Another early influence on Dossena often noted is that of the family of sculptors, the Pisani.

Nicola Pisano (active *c.* 1258–78) is regarded as the founder of modern sculpture and, with his son Giovanni, revived the realism and dignity of Roman carving. This is much in evidence in the extraordinary pulpits in Siena, Pisa and Pistoia. According to Otto Kurz, Dossena was most convincing in imitating Pisano: 'Dossena's performance as Giovanni Pisano is remarkable. It is one of the rare cases in which a forger actually

succeeded in catching the fundamental facts of an artist's personal style, together with an almost correct expression. If Dossena had limited his activities to this sculptor he would probably never have been found out.'[15]

Pope-Hennessy maintains that Dossena remained a true son of Lombardy and 'the Renaissance style for which he felt the most natural sympathy was that of Lombardy'.[16] His techniques were much bolder and less disciplined than any of the forgers in Florence, and this partly led to his exposure. On the other hand, it could be maintained that Dossena's choices for inspiration were very clever – they were not the artists on whom other Italian forgers had centred their attentions.

3

After the armistice of November 1918, Dossena returned to Rome and set up a studio in an abandoned warehouse in the Trionfale quarter. According to Cellini, he first made small terracotta pieces. Cellini's older brother, Lorenzo, who also had served in the Italian army, worked nearby. He created *maiolica* pieces in what was called the *Valle de Inferno* (Valley of Hell), and hell it was with all the ceramic furnaces blazing forth. The area lies just behind the Vatican.

Lorenzo regularly changed the name of his establishment – from 'They Shine because of the Fire' to 'Salamanders'. Walter Lusetti confirmed his father knew Lorenzo, but did not indicate they were as close as Cellini suggested. Though maintaining a legal residence in Cremona, it appears Dossena never returned there – and with good reason. He had a mistress in Rome, and she was Walter Lusetti's mother. Writers on Dossena have confused Teresa Lusetti with Signora Dossena who remained in Parma for a while. She later moved to Genoa and Livorno where it is assumed she died. Lusetti was hesitant to speak of her, but said Alcide joined his father in Rome for a time. He married Santini Vitucci a few months before Dossena's death in 1937, and Alcide died in Cremona on 17 August 1946.

Both boys helped their father in his studios, and the 1955 book has Walter Lusetti dedicating the work 'to the memory of my father to whom I was ever close, and with whom I worked from the earliest days of my youth'.[17] The photographs Lusetti

showed me in Rome confirmed the close relationship. One in particular I recall – Alceo in uniform with his young son propped up on his shoulder beaming down at his father. He produced no pictures of Alcide or his mother who from all counts never stepped foot in Rome. I found Walter Lusetti charming, and had been led to believe that he was 'illiterate and backward'. Indeed no one among my early contacts thought he was still alive, but I found his name in the telephone book and almost dropped the phone when he responded 'si' to the question: 'Are you the son of Alceo Dossena?'

Finding Lusetti's flat in the Magliana area was not easy and necessitated equally long underground and taxi trips. He lives alone in a fairly comfortable – but far from luxurious – flat in a modern complex on the way to the airport, in what used to be farming country. Lusetti was pleased with the attention, and showed me his scrapbooks and mementoes of his father. He has kept a careful record of the many newspaper articles on Dossena and a file on what has happened to his many creations. That last project has become increasingly difficult.

Under Italian law, Lusetti is not allowed to use his father's surname, and is thus forever stigmatised with illegitimacy. I noted, though, that he has added 'Dossena' after his name on the letter-box. Lusetti is tall and slim and has remarkably clear blue eyes which are reminiscent of photographs of his father. In the late 1940s, he went to Argentina where he worked for five years and clearly had some success there as a sculptor in marble. I was shown a number of clippings on exhibitions of the work of 'Walter Dossena, son of the famous Italian artist'. One piece was particularly impressive – a large modern-style David, and there was also a photograph of a Lusetti Madonna and Child being presented to a very young-looking Eva Peron. He appeared quite pleased that I recognised her. None of Lusetti's works was evocative of old masters, and his style was pretty much a continuation of what his father created after his exposure.

Lusetti insists that he and Alcide only assisted their father in the studio as did Gildo Pedrazzoni and Patrizio Incarnati. Jandolo presents the other two as helping 'il maestro' with the acid baths which aged Dossena's marbles. In 1947, Harold Parsons noted that Pedrazzoni had gone on to make several 'Greek' reliefs and statues which fooled most of the Italian

archaeologists when they were exhibited at a Palazzo Venezia exhibition of privately owned art objects.[18] The four assistants basically parted company after the death of the master in 1937, but as I later learned Alcide Dossena and Incarnati were later involved in an attempt to keep the studio going in Rome, and later in Cremona. Lusetti says he knows nothing of the subsequent careers of Pedrazzoni or Incarnati.

Walter Lusetti was quick to remind me that he was only 12 when his father was producing his greatest forgeries, but he also likes to give the impression that he was the heir to his father's talents. Alcide was 'never terribly good on his own'. I was shown no photographs of Alcide's work – or any of that of the other assistants. One relative in Cremona says Alcide was quite good at marble sculpture and like his father proudly placed 'AD' on them. The relative also hints that Alcide was actively involved with several of his father's works, but after a while I felt I was in the middle of family squabbles between the Rome and the Cremona connections.

Towards the end of my visit with Lusetti, I gingerly inquired about his feelings now concerning the 'scandoli' in the newspaper clippings before us. Lusetti hesitated, and then showed me one of the last photographs taken of his father. Dossena was in his studio covered with marble dust. He looked haggard. At his side was a Madonna which later went to a church in Yugoslavia, and in the foreground a large bottle of wine. Lusetti looked up. 'My father was a complicated man in some respects. He was a good father – and a good man. I do not think he ever realised the full extent of how his works were sold and passed around. He was . . .' Lusetti struggled for the right word. 'Ingenuo' he said. That adjective means 'ingenuous or naive'. He then winked and added: 'You might say my father led two lives.' Lusetti did not want to elaborate, but from what I have learned about Dossena I think I know what he was implying.

4

Alceo Dossena's introduction to forgery was not heralded by his simple arrival in Rome, on Christmas Eve 1916, with a marble Madonna. Over several years after his military duty he appeared regularly in bars and cafes frequented by art dealers

from the Via Margutta and the Ripetta. He brought small terracotta pieces – usually Madonnas or saints – and they earned him a small income. According to the 1955 book, he was 'in straitened financial circumstances at the time' which must be an understatement considering there was the mistress, Alcide, Walter and Signora Dossena back in Parma to be cared for.

In the beginning, Dossena could not afford to work in marble, but he did receive a small commission to make a bust of Don Guanelia for the church of San Giuseppe. Marble was to become his favourite medium. He was also given a small credit from an innkeeper by ceding him a statuette of the Virgin. The innkeeper sold it to Fasoli, and this was the start, as the 1955 book puts it, of the exploitation of Dossena.[19]

No one comes off worse in the re-examination of the Dossena affair than Alfredo Fasoli. I can find no defence for him, and by all accounts he was an unscrupulous 'user' to the end. It also appears that Fasoli presented a scenario to Dossena that many works were needed for an American church being constructed in the Renaissance manner. He had a large order for statues with the patina and character of age. The story hooked Dossena, and as the 1955 book has it:

> Dossena set to work with enthusiasm. Fasoli, cold and calculating, had already laid his plans. Out of five works ordered, at least three were constantly rejected and the sculptor was compelled to destroy them. In this way the sculptor was never fully remunerated for his work and was held in a state of moral servitude; but the interests of Fasoli were undamaged, for with the sale of a single statue he realized many millions of lire at a time.[20]

But the full story is broader than this Pinocchio–Stromboli dramatisation. As Dossena continued to bring his wares to the cafes, more important dealers took note of their potential worth. According to Russell Lynes' friend, Mario Prodan, who once wrote for *Harper's*, Romano Palesi was the real genius in the whole affair.[21] Palesi was known as the 'wormwood king' to other dealers because of his profitable business in fake antique furniture in Rome. Palesi launched Dossena into the international art market and induced scholars to produce falsified documents authenticating the varied creations. Palesi had a

valuable contact in Carlo Balboni of Venice who was well established in dealing with rich American museums. Palesi was careful, however, not to bypass Fasoli's interests and relied heavily on the latter's reputed ability 'to speak equally to ladies and washerwomen, to dukes and to recruits',[22] an ability notably absent in Palesi and Balboni.

It was Palesi who created many of the ingenious tales of provenance for potential buyers. Often used was that 'somewhere' in the dense forests of Mount Amiata (south-east of Siena) was 'an abbey which had been partially buried in an earthquake in the seventeenth century'. Palesi claimed 'a certain priest named Don Mario' had discovered the abbey and had given him its floor plan indicating where a large number of important sculptures had been removed. Not wanting to raise the suspicions of the Italian authorities, the location was kept secret and Palesi agreed to sell the pieces abroad in the utmost secrecy.[23]

The involvement of other Roman dealers with Dossena will perhaps remain forever undisclosed, but Cellini mentioned two names who have been confirmed by other sources: Ugo Jandolo and Morandotti. The latter remains a shadowy figure who apparently operated out of the Palazzo Massimo off the Viale XXI Aprile. Jandolo, of course, is well known, and was so successful in the trade that he lived in grand style in a former papal palace in the Via Flaminia. Later when business was not so good, he had to sell the palace and move to a flat at Via Margutta, 51.

As the dealers took charge, Dossena moved mistress and boys from one studio to the next. As Cellini aptly puts it, 'larger studios were needed for larger statues'. After Trionfale, the first was an establishment at the corner of the Via Fiume and the Passeggiata Ripetta. This was followed by the one which appears in photographs after Dossena's exposure – a large building on the Via del Vantaggio and the Passeggiata which still houses both a restorer's studio and an art gallery. Cellini remembers how heavy the curtains became as time went by and how there was a secret chamber in which no one was ever allowed. Cellini, however, did not mention two studios which Lusetti recalled – one on the Via Maria Adelaide and the last, on the prestigious Via Margutta – number 54, next door to the Jandolos.

Schüller presents Dossena in the early period of his creating as

> happy ... with much work to be done ... he found continual
> stimulation in the streets and squares, palaces, churches and
> museums. He was well treated by his 'bosses'. Sometimes they stood
> him special meals and champagne. But they did not always pay him
> punctually and often complained that 'business was bad'. Dossena
> was simple enough to wonder whether they 'could meet their
> expenses even with my help'. He was given orders to execute
> certain carvings in the manner of this or that master. As a
> craftsman he saw nothing out of the way in such instructions. He
> searched museums and books for examples of the works of the
> artists in question. Then he would produce a new work in the style,
> spirit and technique of the master concerned.[24]

These are largely the reflections of Augusto Jandolo, and I
asked Cellini and Lusetti how independently they thought
Dossena worked. Both agree it is now probably impossible to
answer that question. Most likely many of his ideas came as
Schüller suggests – from his musings of the great masters'
works. Dossena never directly copied any particular work – he
always created 'in the manner of'. And contrary to what some
observers have stated, this was not in the manner of any
particular artist but, as Anthony Radcliffe of the Victoria and
Albert Museum suggested to me, 'a combination of various
artists for a single work'. We see a variety of inspirations from
Giovanni Pisano, Simone Martini, Vecchietta, Donatello, Mino
da Fiesole, but it would be the dealers and the experts who later
indicated that particular 'Dossenas' were *a* Simone Martini or a
Donatello.

Doubtless the dealers guided Dossena as well. After all, their
major concern was what would be most convincing for a
particular sale. Schüller states that in the beginning Dossena's
monthly income averaged about £80. 'It can only be regarded as
pocket-money when one realises that a fraudulent sale of some
of Dossena's "old masterpieces" could run into millions for his
exploiters. For example, he would be paid 200 lire for a figure
the subsequent sale of which brought in 3000 lire.'[25] Lusetti's
testimony bears this out as well, and he says that even in the
'heyday' of Dossena's creativity the family had little money to

spend. The major reason Lusetti went to Argentina was to make some money for works which never sold well in Italy.

5

Sixty years ago, the most celebrated art dealer of all time, Joseph Duveen, noted that 'Europe had plenty of art and America had plenty of money'. His astonishing career was the result of that simple observation.[26] The newly rich had a passion to obliterate their meagre origins on farms or behind the counters of country stores. They sought to fill their grand new houses with aristocratic European art – 'to veneer their *arrisme* with the traditional'.[27] Pittsburgh steel master, Henry Clay Frick purchased half a block of Fifth Avenue at 70th Street to create a new world palace containing old world art. His biographer, Ann Burr, says he would sit in his gallery on Saturday afternoons 'on a Renaissance throne under a baldachino, holding in his little hand a copy of the *Saturday Evening Post* while an organist played his favourite tunes, "Silver Threads among the Gold", and "The Rosary".'[28]

Probably the first reference to a work by Dossena in an art journal was in February 1924 in an article by the director of the Detroit Institute of Arts, Walter Valentiner. He was unaware that 'two marble reliefs of the Annunciation' which he described as 'especially important, noble and . . . filled with the tender lyric atmosphere of Sienese art' were by Dossena. Valentiner attributed them to Lorenzo Vecchietta (1412–80), 'one of the few Renaissance artists, who have left evidence of their versatility in proven works'. Ironically, Valentiner noted that the luxurious robes of Mary and Gabriel reminded him of Greek reliefs of the fifth century BC.[29] After imitating Vecchietta, Dossena went on to create in the manner of archaic Greek sculpture. There are no records of what happened to the Vecchietta pieces, and Alan Phipps Darr, curator of European Sculpture at Detroit wrote: 'unfortunately our museum does not possess either of the reliefs . . . nor do I know of their whereabouts'.[30] An account in *The Illustrated London News* (5 January 1929) pictures the pieces and says they were bought in Paris in 1921, and sold to an American collector.[31] *The New York Sun* (20 February 1924) says they were purchased by a

famous American publisher[32] but that was several years before they were known to have been created by Dossena.

Many of Dossena's most convincing works disappeared in like manner. Some undoubtedly were returned to the dealers who had originally sold them, but others were destroyed and some reappeared for sale in different art markets.

Few things are more enjoyable to art experts and museum curators than unmasking a forger. There are a number who claim that distinction with Dossena: from Henry Clay Frick's daughter, Helen, to the purchasing agents John Marshall and Harold Woodbury Parsons. Captain Piero Tozzi, a painter and dealer and former member of the Italian Legation in Washington, was credited by *Art News* (1 December 1928) as being 'the first man to find Dossena and connect him with the series of forgeries which came on the market a few years ago'.[33] And Cellini has always maintained he knew about Dossena long before anyone else.[34]

One reason why Russell Lynes did not write his story on Dossena for *Harper's*, 'in the early 1950s when I had done my legwork', was that he 'could see no way to resolve the conflicting opinions and claims about who had first discovered and revealed the forgeries. Most of the dealers, critics, scholars, agents, and curators who had been involved innocently or otherwise were still competing for first place in the discovery sweepstakes, though the race was long over.'[35] Lynes goes on to say, 'Now it doesn't make much difference whose claims were the real ones; the story seems to me no less entertaining or revealing for that.'[36]

Twenty years on, Lynes' words are still true, and as we will see the person most responsible for unmasking Alceo Dossena was the forger himself. By 1926, it was rumoured in inner circles of the art world that a master Roman forger had not only created some Renaissance pieces which had made their way into American museums, but was also responsible for some very convincing Greek and Etruscan works. It would not be until November 1928 that the full story became public knowledge, but an early linking of Dossena to forgery occurred in 1926 with a wooden sculpture for sale in Bologna. An inscription added by a dealer was the tell-tale clue. It was copied word for word from a known fake in the Museo Civico Archeologico in Bologna.

Few in the art world heard about the Bologna incident, and by 1927 the link to Dossena's studio in Rome was still very vague, but at least one man was hot on the forger's trail – John Marshall. But none of the sleuthing was as significant for Dossena's exposure as the fact that in early 1927 Teresa was near death. According to one account, Dossena 'had frittered away all his money . . . Bills for doctors and medicines accumulated.'[37] Teresa died in May, and according to Lusetti this hit his father badly. He wanted to give her the type of funeral he thought she deserved. Teresa had been through the most difficult as well as the seemingly promising periods of his life – and he could not even give her his surname or legitimise her son.

Dossena went to Fasoli claiming he was owed $7,500 for a piece that had been sold to a London dealer for $150,000. Mario Prodan rightly says Fasoli made the fatal error of brushing him off. Dossena might have been naive, but was no fool. In Prodan's words, 'his fine Mediterranean temperament breaking forth, he spills the beans. He takes all the photographs of his fakes to a magistrate, and accuses his hard-hearted colleague of having left him out in the cold. The news explodes like a bomb. Rome is stunned.'[38]

Lusetti adds another dimension to the break. Marshall's sleuthing had become known to Palesi and Fasoli, and they 'decided to rid themselves of Dossena as a man who might become dangerous to them'. At the time Dossena went to Fasoli for money owed he was working on a bust of Mussolini. Fasoli maintained that as Dossena carved *il Duce*'s features he had verbally vilified the head of state.[39]

Dossena sued Fasoli for 1,250,000 lire for back payments due him. Fasoli counteracted with an anti-fascist charge against Dossena. Dossena's next move was brilliant – he persuaded the 'number 2 Fascist', party secretary Farinacci, to defend him. Simply by accepting the case, Farinacci destroyed Fasoli's charges. 'Insult to the Regime' was set aside for insufficiency of proof, but the same judgement was also given to Dossena's case against Fasoli. There was no way the Italian courts were going to try to unravel the fakes' dispute which was just hitting the press. Dossena paid Farinacci with two small statues he had made before the trial. An odd footnote to the trial occurred on 28 April 1945 when Dossena's lawyer was strung up by his heels in

a Milan petrol station, along with Mussolini and his mistress.

6

The year 1870 was a landmark for American museums of art. Two great institutions were incorporated – the Metropolitan Museum of Art in New York and the Boston Museum of Fine Arts. They were the first of the 'encyclopaedic' galleries in the United States, and began to fill their halls with all the Old Masters, Greek statues, Chinese vases and Egyptian mummies they could lay their hands on.

Removal from the restrictions of state control, as in Europe, meant that the American museums could develop with free-wheeling enterprise, and those with far-sighted directors certainly did. Very soon they became obsessed with attendance – the real indicator of success for an American museum. Special exhibitions and spectacular acquisitions were the chief means of bringing in the crowds.

The American museums were greatly handicapped by the distance from the active centres of the art market, and these difficulties were overcome by having purchasing agents resident in Europe. Two of the most successful were the friends, John Marshall and Edward Warren, who became associated with the two great comprehensive collections of the Boston and Metropolitan Museums.

John Marshall acted as a purchasing agent for the Met for twenty years, and was beginning to draw the lines of some extraordinary forgery to the door of Alceo Dossena's studio when he suddenly died on 15 February 1928. Marshall's work became extremely taxing, and according to one Metropolitan Museum official he had 'complete authority to initiate and to conclude purchases for the museum out of his annual appropriation'.[40] That appropriation varied considerably as the years wore on, but with its intention to be 'the greatest treasure house in the Western Hemisphere', Marshall yielded a considerable influence over the direction of its future Greek and Roman collections.

Before his death, Marshall was becoming suspicious of a number of ancient Greek sculptures. Like a number of other foreign art agents in Italy, he had heard rumours that a master forger of Renaissance art had turned his talents to creating in

the Greek and Etruscan manner. A friend of Marshall, Bernard Ashmole, one time Lincoln Professor of Classical Archaeology at Oxford, delivered the first J. L. Myres Memorial Lecture in New College, Oxford on 9 May 1961 on 'Forgeries of Ancient Sculpture: Creation and Detection'. The lecture was later published and contains important insights into both Marshall and Dossena. Ashmole asserts: 'That [Dossena] was exposed so quickly is due to the fine judgement, integrity, and perseverance of one man, an Englishman, and a New College man, John Marshall.'[41] Ashmole prefaced this remark by saying: 'Nowadays the name of Alceo Dossena is well enough known and not a little whitewash has been used on it.'[42]

Among his many papers at the Ashmolean library in Oxford there is no mention of Dossena by name, and Marshall never got to his studio in Rome. There is one note of Fasoli's address in a diary but no indication of linking the dealer with the forger.

There is no doubt, however, that Marshall was putting many pieces of the puzzle correctly in place, and had he not died early in 1928 he would have deserved the credit Ashmole and others now give him for 'exposing Dossena so quickly'. It is a pity Marshall was never able to write his side of the story, either concerning Dossena or other aspects of his extraordinary career. Marshall's observations kept at the Ashmolean and elsewhere are brilliant, but in such disorganised fashion as to remain unnoticed.

By chance, I came across a reference stating that the papers of John Marshall and Edward Warren were kept at the Ashmolean library in Oxford. They had been willed to the library by Warren who died after his friend. According to the Ashmolean librarian, Brian McGregor, they had been in the office of the Lincoln Professor for a considerable time before being transferred to the library in 1978. When I first encountered them, I had anticipated leafing through orderly notebooks all carefully arranged and catalogued. I was shown two shelves of files in a bookcase in the librarian's office which had rested there seemingly untouched from 1978.

McGregor kindly invited me to make whatever I could of the materials, and said the only other person who had expressed an interest in them was a student from Princeton University who had studied at Oxford several years ago. Going through the papers was like leafing through grandmother's trunk in the

attic. Interspersed with purchasing orders from various museums were menus of memorable Roman meals and receipts from grand hotels all over Europe. There seemed to be no logical place to begin, so I dug right in to see what might be useful.

Marshall was meticulous in describing a variety of pieces he had discovered and there were any number of drawings of busts and statues and ornamentation. It was certain both he and Warren had enjoyed their work. The enthusiasm of a day's find was usually followed by an incomparable meal in a good restaurant.

I returned to the Ashmolean twice and later, with the discovery of a little known biography of Edward Warren, pieced together a facet of the forger's story which has never been fully presented. The Warren–Marshall relationship had an extraordinary impact on the future collections of several museums, and is the reason why aspects of the Dossena affair have remained confusing and indeterminative. Osbert Burdett and E. H. Goddard's *Edward Perry Warren: The Biography of a Connoisseur* was published in 1941, and remains extremely difficult to obtain.[43] According to Goddard's preface, the 'memoir' was 'finished in difficult circumstances'. Burdett had intended to complete the work within ten years of Warren's death, but he died in 1936. As Goddard admits the result is plagued by 'lack of cohesion . . . different styles and approaches . . . and repetitions'. Warren had also insisted that 'any Memoir should so far as possible be limited to statements of fact and that gossip and expressions of authors' opinions should be excluded'.[44] Given these limitations the book is far from being an easy read, but contains a wealth of information which has been largely overlooked.

So influential did Warren and Marshall become in the heyday of their collecting that Alexander Murray of the British Museum asserted: 'There is nothing to be got nowadays, since Warren and Marshall are always on the spot first.'[45] Edward Perry Warren was born in Waltham, Massachusetts in 1860, and was the third son of Samuel Dennis Warren, a very wealthy paper manufacturer who founded the Cumberland Paper Mills in Maine. As a brochure at the turn of this century put it: 'Warren papers are used in school books, trade books, magazines and catalogues that picture and describe the products offered by American industries.'

As a boy, Warren took an early interest in classical art and used to go 'anticking' – as his family called it – about the countryside in a Roman toga of his own making. Burdett and Goddard say he was 'born in the nineteenth century with a pre-Christian soul'.[46] Warren entered Harvard College in 1879, and during his senior year met Bernard Berenson, the son of a Lithuanian Jew who had emigrated to America. When Warren met him he was a freshman at Boston University. They shared common interests in classical languages and art, and Warren sponsored Berenson's admission to Harvard. For the next ten years, Berenson was to rely on Warren for annual payments to continue his budding connoisseurship in Europe. Warren could afford to be generous. When his father died in 1886, he was left with an income of £10,000 a year. By 1899, Berenson's famous career was launched sufficiently to make him free from Warren's bounty, but he never forgot the initial help and dedicated his essay on Lorenzo Lotto to his friend.

Young Warren had no interest in the family business and, despite his father's initial objections, entered New College, Oxford in 1883. He did extremely well until 1888 when his eyesight bothered him. This was a problem he would have throughout his life. Warren was happy to leave any ties with the family fortune in the hands of a trust, and blindly signed a document which gave to trustees, of whom his brother Samuel was one, a free reign in managing the Cumberland Mills. Later he would regret the decision, and because of financial worry was driven to bring a tragic lawsuit against Sam in 1909. Sam Warren died during the trial and the family plus many in Boston never forgave him for what had occurred.

Following Oxford, Ned Warren was in need of a spacious and secluded residence where he could satisfy his several tastes: art, Arabian horses, Saint Bernards, and young men. In line with Warren's desire that 'gossip . . . should be excluded' from their biography, Burdett and Goddard never say that Ned Warren was a homosexual, but one would have to be incredibly naive to overlook this aspect. In the biography there is the germ of an autobiography Warren once tried to complete, containing lengthy discussions about the idea of Greek love as featured in Plato's *Symposium*. Ned says that at Oxford: 'I was on the look-out for affections between my own sex, real affections'. He

was pleased he 'did find more of the appreciation of the beauty and charm of youth at Oxford than at Harvard'.[47]

At the end of the autobiographical fragment, Burdett– Goddard dryly remark: 'Clearly a man with such ideas and with such a soul would be a misfit in every way imaginable in New England society.'[48] Warren speaks of 'the value of the masculine ideal' and realised that the monastic seclusion of Oxford, as it existed, was a possible atmosphere for the encouragement of 'the Hellenic ideal of personal sympathy and love between younger and older men' – and if that were truly to succeed 'women should be kept out'.[49]

In 1899, Warren found the house which satisfied his needs. He wrote to John Marshall from the White Hart Hotel in Lewes: 'The house that may do is huge, old, and not cheap . . . It is in the centre of Lewes and yet has a quiet garden, a big kitchen garden, a paddock, greenhouse, and stables ad lib . . . I am much inclined to it.'[50] I was taken around the property on 27 January 1987 by the Assistant District Secretary of the Lewes District Council, Charles Rose. There is still a trace of its former glory despite the extensive remodelling which converted Lewes House into administrative offices in the 1970s. The gardens are extensive, and two pieces of the great collections of art gathered during Warren's era remain there – a sad headless goddess and a pedestal of some sort. 'Thebes', the guest cottage containing Warren's private office is less changed.

A good description of what Lewes House life was like under Warren is given in William Rothenstein's *Men and Memories* as quoted by Burdett–Goddard:

a monkish establishment, where women were not welcomed. But Warren, who believed that scholars should live nobly, kept an ample table and well-stocked wine-cellar; in the stables were mettlesome horses, and he rode daily with his friends, for the body must needs be as well exercised as the mind. Meals were served at a great oaken table, dark and polished, on which stood splendid old silver. The rooms were full of handsome antique furniture, and of the Greek bronzes and marbles in place of the usual ornaments. In the garden was the famous Ludovisi throne – fellow of that whereon Venus is seen to rise from the sea – which by hook or by crook, rather, I think, by crook . . . had been smuggled out of Italy. There was much mystery about the provenance of the treasures at Lewes

House. This secrecy seemed to permeate the rooms and corridors, to exhaust the air of the house. The social relations, too, were often strained.[51]

We will hear about the 'Ludovisi throne' again, and Rothenstein has applied its name to another 'throne' which was in the garden and now in the Boston Museum. Charles Rose confirms that the air of mystery still remains – particularly on the top floor where Warren had his many storage rooms for treasures. One caretaker's dog regularly refused to enter one of them, and Lewes District Council personnel insist a ghost haunts the floor.

Installed in the great house Warren next looked for a companion 'with whom to share his fortune, his project and his heart', and had a number of young men from his college days in mind. Arthur West, who had travelled through Italy and Sicily with Berenson was the first of a long line of companions who also acted as private secretary. In 1889, Warren persuaded West to join him, but the relationship was short-lived. West went on to become a curate in Wales, and when Berenson visited him in 1893, he was amazed that the curate was expected to care for 7,000 on a salary of £20 a quarter.[52]

Another companion was John Fothergill, who was described as 'an eccentric but an acute critic'; he wrote an excellent article on 'Drawing' in the eleventh edition of the *Encyclopaedia Britannica*. Fothergill went on to become the host of the 'Spread Eagle' inn at Thame, and his *Confessions of an Innkeeper* was a great success in 1931.

Matthew Stewart Prichard, 'exceedingly handsome' according to one account and for Burdett–Goddard, probably the keenest and most capable of assistants – a view not shared by others.[53] Frank Gearing, who was Warren's secretary from 1902 until Warren's death, remembered Prichard as

over six feet tall, with spare athletic body, a rather cadaverous face, with long, thin nervous hands . . . He was thorough in all he undertook, and very precise in details . . . [he] studied chemistry in order to make experiments in cleaning the deposits from antique marbles . . . In the streets of Lewes he wore a Turkish fez, walked in the middle of the road with an abstract air, impervious to the jibes and jeers of the locals, salaamed on entering a room, used Turkish or Arabic phrases on greeting and departure.[54]

Gearing's widow still lives in Lewes, but refuses to say anything about Edward Warren except that 'he was a nice gent'. Prichard later became secretary to the director of the Boston Museum of Fine Arts which caused tension between the two old friends, and he also befriended the fabled Isabella Stewart Gardner ('Mrs Jack') of Boston. She was struck by his middle name and asked if he also were a royal Stuart. 'Yes, I am,' he told her, and probably he had better reason to believe it than she.[55] Bernard Ashmole recalls that Prichard was drowned in the river at Lewes but I was unable to confirm this.[56]

Charles Rose's booklet on Lewes House comments that 'the constant stream of visitors, whose lifestyles were quite alien to the average Lewesian, the Arab horses, and the six St Bernard dogs gave the house a reputation for eccentricity and few local people, except for his household staff, ever saw it from the inside.'[57] Outside, residents experienced the Lewes House occupants on horseback or in canoes or naked at the local swimming baths which was their substitute for the Greek gymnasium. There Prichard taught many of the Lewes lads to swim. For those invited to the house there was good food and exquisite wines, but candles provided the only lights and quills were the only pens allowed.[58]

Two more of Warren's companions had connections with Boston. Burdett–Goddard say of the first, Richard Fisher, that he was the most shadowy,[59] and earlier he had been a friend of Marshall. The second becomes extremely important in the Dossena affair – Harold Woodbury Parsons. In Burdett–Goddard he is only given a surname, so when I first encountered 'Parsons' in the Warren biography I thought it too coincidental to be true.

The first mentioning of Parsons is that he was a young American who wanted to 'escape' to Europe. Later it is said he was one of Warren's new friends whom Marshall appeared to like. But that was it.[60]

Perhaps the most memorable visitor to Lewes House was the French sculptor, Auguste Rodin. William Rothenstein had met Warren through John Fothergill, and interested Warren in Rodin's work and financial difficulties. After a visit to Paris, Warren commissioned a perfect replica of Rodin's celebrated group, *La Foi* (The Troth), which was completed to his very particular specifications.

The result – *Le Baiser* (The Kiss) – was finished in 1906 and brought to Lewes House, but because of its size and weight, was kept in the coach-house. According to Charles Rose:

> In 1914 Warren offered it to the town for display and for just over two years it occupied pride of place in the Town Hall. It seems incredible today that in the year of Rodin's death (1917) the Borough Council, fearing that the subject of the statue might have an undesirable effect upon the local inhabitants, asked Warren to take it back. It was returned to its home in the coach-house where it remained until Warren died and any hope of this beautiful work of art remaining in local hands was lost. Eventually it was purchased by the Tate Gallery for the token sum of £7,500.[61]

7

None of Edward Warren's many companions was as important as John Marshall. Indeed in our day we would think of the two as lovers. 'There are not many men like Johnny; there are not many friendships like ours,' Warren once wrote.[62] The two used the nickname 'Puppy' for each other, and as Burdett–Goddard say, 'they were, or became almost replicas of each other . . .'[63] At a distance there was even a physical likeness.

Ludwig Curtius described Warren as 'this well-groomed young man of medium build and athletic appearance, who had a keen look in his dark brown eyes.'[64] Marshall was 'less sturdy in build, more nervous and lively in movement . . . When his nerves were out of order he could show caprice and impatience, but never beyond the rescue of a witticism, for he dreaded boredom, and insisted, like a child, on being kept amused all day and every day.'[65] Ashmole notes he was the 'more human' of the two, and Curtius observed 'Marshall was the impetuous, impulsive and more volatile partner of an incomparable friendship. Marshall's influence made Warren half English, and Warren's made Marshall half American.'[66]

John Marshall was the fourth child of John and Priscilla Marshall of Liverpool. His father was a wine merchant and of conservative thinking and deep religious attachment. The Marshalls hoped Johnny would become a clergyman, and early on at Oxford he appeared likely to enter Holy Orders. He first went to Liverpool College, but won a Classical Scholarship to

New College in 1881. It was not until his third year at Oxford that he met Warren, and it seems their friendship developed slowly.

After several unsuccessful attempts to find the right companion, Warren made a number of overtures to Marshall. These date from 1887 to 1889. In June 1889, Warren wrote, 'Why is it so hard to stir you?' By September, Marshall had laid down exacting conditions for sharing his life with Ned. To one Warren responded, 'As for your plan of dining with the servants, I shall be most charmed, of course, to let you do so if I may be of the party, but I had hoped that usually you would consent to dine alone with me.'[67] Then finally everything was settled – from when and where holidays would be spent to the brands of whisky to be stocked. Marshall would be as compulsive with details in his communications with Warren as later he was in dealing with museum purchases. Five and six drafts for a particular letter survive in the Ashmolean collection. By November 1889, all was settled, and as Burdett–Goddard put it, 'the man of his choice was almost at his side'.[68]

By the next year, their extraordinary careers of collecting started in a rather low-key manner. Despite the earlier reticence, Marshall appeared genuinely thrilled with his new existence. By taking him on, Warren assumed a responsibility which earlier he could never have envisioned. Marshall was more of a scholar than Warren and needed some sort of academic fulfilment. He was fascinated by the history of Greek art, but life at Lewes House was less disciplined than he had hoped, and he complained of the Saint Bernards who had the run of the house, fouling the stairs and raiding the hen-roosts; and even more irritating was the constant stream of guests.

Marshall was also uncertain just what his duties as secretary were supposed to entail. But Ned was by instinct a collector and Marshall's similar budding inclinations fused with his friend's, and thus started a decade of travel and contacts with agents in the art trade plus the necessity of setting up a flat in Rome. The earliest purchases were expensive, and Warren's arrangement with the Boston Museum was extremely vague in the beginning. His brother, Sam, with whom he had continual difficulties concerning personal finances, was later to become president of the Board of Trustees but neither his family nor the museum ever seemed to take Ned's position as purchasing agent very seriously.

Blithely the two engaged upon their new venture, and the
first important purchases were made in 1892 at Adolph van
Branteghem's sale in Paris, where they purchased a kylix
signed by Euphronios together with other vases. Before War-
ren's time, the Boston Museum's classical collection contained
'two big Etruscan sarcophagi, and a roomful of small objects,
among them . . . fifteen good or fairly good pieces'. Warren was
to build it into a first-rate assemblage. By 1894, he had given
some of his possessions to Boston, placed others on loan, but the
mass of objects remained at Lewes House. In the same year,
Warren was $77,000 overdrawn and used $40,000 of his capital
on his purchases. In another year alone he would spend $20,000
of his personal fortune to acquire only three statues, and
though later he could declare that each one was worth more
than he had paid for the three together, it was difficult to
persuade his family he was not wasting his wealth.

When on one occasion Ned justified his extravagance by
writing to Sam that he did not wish to die wealthy, Sam replied,
'I should not count on too premature a decease, and then you
will not be troubled.'[69] The Warrens felt that Ned's collecting
was little more than an extension of his boyhood 'anticking',
and the antique trade was nothing more than 'huckstering'.
The pressure to return to Boston and enter some sort of
respectable business remained. Ned and Johnny's enthusiasm
for finding treasures had no limits and during the most
productive periods they came across some important pieces: the
fourth-century BC Chios head, important heads of Homer and
Aphrodite, and impressive collections of cameos and coins. In
his catalogue of the Boston Museum's sculpture collection,
published in 1925, Lacey D. Caskey remarked that only
twenty-six out of 134 pieces did not reach the museum through
Warren.

Some of Warren's finds languished in dark storage for half a
century – bronzes and vase fragments containing decidedly
erotic subjects. For a long while a grave stele of a young athlete
was also viewed as unsuitable by local puritans. There were
other disappointments as well. As discussed in Part Two, the
most notable was not being able to acquire items in the great
Ludovisi collection in Rome. Another was a statue of Athena, a
Roman copy of Myron's famous bronze which stood grouped
with Marsyas on the Acropolis at Athens. The statue had been

unearthed when the Russian collector, Count Grigori Stroganoff, was making the foundations for his house in the Via Sistina, in 1884. Warren had the offer of it in the autumn of 1908 but could not raise the money, and so it went to the new museum in Frankfurt.

Marshall and Warren built up a widespread collecting organisation much like that of Bernard Berenson. BB was quite impressed with the agreement they finally reached with Boston by which Warren would receive 30 per cent above the original cost. Warren said it 'neither covered ordinary expenses nor gave any reward for skilful buying', but as Ernest Samuels remarks: 'Berenson must have felt the irony of his own impulsive arrangement with Mrs Gardner to charge her only a 5% commission, an arrangement he had finally been tempted sometimes to circumvent.'[70]

Collecting in Italy became difficult with the domineering policies of a new director of Fine Arts and Antiquities, and some of Marshall and Warren's letters suggest they feared the antiquity trade would be stopped altogether. Warren came up with an ingenious plan to circumvent potential problems. Writing to Marshall from Lewes on 16 February 1893, he said:

> An idea occurred to me in bed, very safe but requiring much care. You have [the object] delivered at a dissecting-room . . . There it is packed in a coffin and locked. It is exported as a corpse to England; then taken to a dissecting place, there boxed again by Althaus, so that it shall not arrive here in a coffin. You would have to have a certificate that it died by no contagious disease, and you or Matt [Prichard] would go by the same train for sentimental reasons in deep black and with a band round your hat.[71]

There is no indication Marshall and Warren had to resort to such methods.

In 1891, while he was travelling to Munich, Marshall met Edward Robinson, curator of Classical Antiquities of the Boston Museum who was interested in a sale of Egyptian fabrics Marshall was investigating. Marshall had first inspected finer pieces at the South Kensington Museum (now the Victoria and Albert), and was therefore in a position to advise Robinson that prices being asked in Munich were excessive for what they were being shown. This was to be an auspicious

meeting for both. Robinson went on to become director of Boston in 1902, and became as frustrated as were Warren and Marshall with their purchasing policies. The curator and director had no power to make purchases – all proposals of purchase were discussed by a museum committee which made its recommendations to the whole Board of Trustees.

After only three years as director, Robinson resigned, and was immediately invited to become the assistant director of the Metropolitan in New York. Prichard left Boston at the same time, and Marshall was persuaded by Robinson to become the Met's purchasing agent in Europe. Robinson boasted he 'was able to transfer to the Metropolitan the men and methods by which the collection of Greek and Roman antiquities had been so successfully built up since 1895'.[72] This was no idle boast, for very soon the Met took the place previously occupied by Boston, and would in time have a classical collection with few equals in the world.

Marshall's association with the Met also marks the beginning of an estrangement from Warren. Now he was much more his own man, and several letters survive which indicate a growing tension between the two friends. One is undated and marked 'private' at the top. It begins: 'My dear Robinson, Though much of my experience in Athens is not worth writing, there is one thing about which you should hear at once to prevent any misunderstanding hereafter. As you will see it is a very private matter.'

Marshall goes on to relate how he and Warren with one of Arthur West's sons were shown a number of articles for sale. 'Of everything I had first choice. Warren was buying mainly coins and embroideries. He had no money left for spending.' After they had already booked their passage from Greece, a dealer told Marshall of 'a very important archaic Apollo he was anxious for me to see'. They delayed their trip and were shown the piece. Marshall did not like it at first glance. 'I thought I noticed one mistake. The left leg was advanced, although from the line of the buttocks behind, the weight must have been on that leg . . . The more I looked at it the more settled did my opinion become. We were there a long time till I grew quite tired of the thing.'

Warren and young West, however, quite liked the statue. Marshall admitted, 'We had a long argument and came near a

quarrel.' They agreed to return and see it again the next day. Marshall hated it even more: 'There was no patina on the body save a yellow stain here and there – such as forgers add to their work . . . I do not think it was made in Athens but in Italy or Paris . . . But Ned saw none of these things: he was more convinced than ever that the statue was right.'[73]

Marshall begged Warren not to buy the piece and at least 'consult some person in whose judgment he had confidence'. The price including the exportation was £5,000. We hear no more about the statue, but the episode indicates a widening gulf between two who had happily made many purchases together, and previously had total confidence in each other's judgement.

Matters got much worse soon after this. Following the death of Warren's mother, it was necessary for him to be involved in settling the family estate. Marshall interpreted the long absences as getting away from him: 'It is your own business I suppose, if you choose to spend your life at Cumberland Mills for six months of the year. I at least could not do so. The place is dreadful and the people worse.'[74] Added to that was the fact that Marshall did not like many of Warren's new friends – he was not even on speaking terms with two of them. Marshall began to threaten marriage because he saw so little of his friend: 'You run your own affairs and expect me to follow like a slave any move that you make. You think your duty lies in Boston, and I know you too well to try to stop you.'[75]

The years 1904 to 1906 were bad for them both, physically as well. Ned's eye problems worsened and Marshall imagined he had Bright's disease. He was sent to Carlsbad and discovered he had been eating too many rich things at Lewes House. Clearly life there was detrimental to his health. On 5 November 1907, Marshall married Mary Bliss, a cousin of Edward Warren whom he had met several years earlier. Very little is known about Mary Bliss, and the Burdett–Goddard book says almost nothing. Bernard Ashmole who visited the Marshalls in Rome describes her as 'the gentlest of people, but full of character and of independent interests'.[76]

Warren did not see them for a year, and it was about this time that he took up with Harold Parsons. The marriage was a betrayal of their 'common ideal', but as with all his close friends, Warren took care to see they were provided for. Marshall's salary from the Met was never adequate to match his lifestyle.

In Rome, the Marshalls 'lived in a flat literally overhanging the
Spanish Steps', and Augusto Jandolo describes the establish-
ment as appearing much like that of Karen Stone's in *The
Roman Spring of Mrs Stone*: 'the most spectacular apartment
in all of Rome'.[77] Jandolo's book contains a marvellous photo-
graph of Marshall behind a great antique desk with his pet
carniche (crow) perched on his shoulder.

Mary Marshall appears to have helped in a number of
Warren and Marshall's museum negotiations, as a number of
references occur as to her 'taking care of things' either in Rome
or Lewes. She seems to have died sometime between 1923 and
1925, but this period of both Marshall and Warren's lives is
noticeably absent in the papers at the Ashmolean library. After
Mary's death, Marshall had a severe illness and Ludwig
Curtius relates that he wrote to him saying, 'But for Warren I
should not be alive today.'[78] There was a reconciliation of sorts.
A number of secretary-companions came and went, but no one
'filled the place of Johnny'.[79]

It was at this time that Marshall became increasingly aware
of, and interested in, art forgeries in Italy. Apparently, Warren
had made a number of errors in judgement concerning works of
art. In several diary entries Marshall complained that his
friend was duped on a number of occasions. Unlike Marshall,
Warren was not the type to track down forgers, and his idea of
collecting art, like much else in his life, was far removed from
such mundane matters. His notion of the collector is left in an
unpublished paper:

A collector is thought to be a dreamer on days gone by, a loafer in
idle lands, who culls a vase from a shelf or chooses among many
objects in a shop. By many he is supposed to live a life of
disinterested and luxurious nonchalance, gloating over beautiful
things, free of his time, lavish in his expenditure, a leisurely
grandee. This impression is a mistake. He usually loses his money;
he always loses his time. He is in the thick of danger. He daily sees
forgeries and futilities which he must on no account buy, while
leaving to the owner a satisfied sense which will bring him again
with other things; he daily weighs lie against lie to elicit the truth.[80]

One anonymous observer reading those remarks said that
Warren was speaking far more of Marshall than himself.

Warren was much better at sizing up men and judging their character, but it was Marshall who handled most of the time-consuming negotiations and the boring nitty-gritty. He also had the better eye for what was gold and what was dross. Because of his bad health, Warren urged his friend to give up his purchasing for the Met. Marshall actually drafted a resignation which is in the Ashmolean, but he could never bring himself to post it. There was too much to be done which vitally concerned the future of collecting for American museums. Marshall was determined to track down the origin of a number of forgeries he was encountering – and the path was leading right to the door of Alceo Dossena's Rome studio.

PART TWO

The Crime

8

Bernard Ashmole is 92 and lives in retirement at Peebles, in Scotland, and is perhaps the last person alive who knew both Warren and Marshall well. He and his wife were sometimes invited to lunch when Marshall was a widower, and occasionally Warren joined them. Marshall was 'warm-hearted and a delightful host, with his stories of Italy and the ways of Italian antique-dealers, how some of them tried to pass off forgeries by skilful patination – rolling them in the gutter of the Via del Babuino or burying them under the vines at Orvieto'.[1]

In May 1926, when Dossena's productions in archaic Greek style were first coming on to the market, a 3-foot high statue of a Greek maiden (kore) was brought to Marshall in Rome which the dealer swore was from an ancient Etruscan site. 'The disintegration of surface by age was marvellously imitated, so marvellously that a scientific expert . . . declared that some of the salts beneath the surface could not have penetrated there except in the course of centuries.'[2]

Marshall liked the statue about as much as the Apollo he and Warren had argued over in Athens. He purchased it nevertheless, because he felt it might be related to other suspicious pieces he had recently been offered for the Met. In his notes he states that he was uneasy about 'its excessive slenderness, and the drawing back of the left foot was too far for an archaic statue of this type'.[3] Ashmole went a few steps further, in 1961, when describing the kore: 'The wrong leg is forward, and the figure has the air of a Victorian lady stepping off the pavement and holding up her skirt from the ground.'[4]

The kore was sent to the Met, and after the revelations of Dossena's creations were made public, the museum was proud to boast it had never been taken in by the forger. Russell Lynes says he saw the Dossena kore in the 1950s in a basement room at the Met. 'I remember the maiden as extremely handsome and I wish I owned her. When I inquired about her recently (1968) no one I asked remembered having seen or heard of her.'[5] The same occurred when I visited the vast basement storage area containing a host of fakes, in August 1986. My guide, the delightful Joan Mertens, a curator of Greek and

Roman Art, remembered the piece but had no idea as to what had happened to her.

A year after Marshall purchased the Dossena kore, a noted dealer offered two life-size figures of archaic style for a considerable sum of money.[6] One piece was 'A Striding Athena'; the other 'A Hero Abducting a Woman' in the manner of a famous archaic sculpture. Both were assumed to come from an early pediment, and it was rumoured they had been found on the same site as a splendid seated goddess which was in Berlin. The two sculptures had been sent to the Met for inspection. The first viewings excited museum officials, but 'closer study lasting several days convinced us that they were not Greek works, but modern forgeries'.[7] The museum admitted, however, 'Since they had been sponsored by prominent European archaeologists and were still for sale, we could not, according to professional etiquette, comment on the reasons for declining them unless asked to do so, which we were not. They were, therefore, taken back by the owner.'[8]

After the Met refused the pieces, Marshall notified them that he thought the sculptures might be identical to pieces which had been offered to him in fragments the preceding year from the same vendor who had sold him the Met's kore. Two heads, one male, one female, and a woman's shoulder had been brought to him at Bagni di Lucca where he had been staying for the summer. They were said to be parts of a single group, of which more existed. Marshall insisted upon having a look at everything there was, and the dealer took away the fragments, promising to return with the whole lot in the autumn.

Clearly the dealer was aware that Marshall had seen through the ruse, and nothing happened until April 1927 when the 'Athena' together with the archaic group were offered in New York to the Metropolitan by another dealer, Jacob Hirsch, who had offices in New York and Paris. The Met refused them, but Harold Parsons bought the 'Athena' the next month for the Cleveland Museum for $120,000. Apparently there was no communication between Marshall and Parsons about the piece.

From photographs supplied by Gisela Richter of the Greek and Roman department of the Met, Marshall recognised the works as products of the same workshop as the kore. Dealers involved with the pieces insisted they were from Italian government excavations in southern Italy, 'but because

persons in high positions would be involved, no documentary proof of this could be given'.[9] According to a later account, 'In attempts to sell some of this series of sculptures, a possible buyer was taken by night to an excavation and shown part of them actually lying buried deep in the earth.'[10]

The 'Hero Abducting a Woman' next appeared in Munich where it was deposited by Jacob Hirsch for study and possible purchase. Bizarrely it turned out to be 'that piece of which Marshall had been offered the upper fragment at Bagni di Lucca eight or nine months before'.[11] Now Marshall was certain there was a relationship among the several sculptures and proposed there should be a conference in Munich to discuss the situation.

Bernard Ashmole was at the meeting, and earlier he and Marshall had literally put some of the missing Dossena pieces together.

Whilst negotiations for the sale of the Munich group [Hirsch's] were still going on, yet another piece of alleged archaic sculpture appeared, and provided the first direct evidence that Dossena was the sculptor of the whole series. It had come into the hands of another dealer in Rome, who was emphatic in his assurances that this piece, as well as the Cleveland Athena and the Munich group, had all been made by Dossena. Dossena, he said, encouraged by the success of the other pieces, was now putting this one on the market. It had not turned out so well as the others, and had therefore been buried in a large box of plants on his balcony, where it had lain for some time.[12]

Ashmole continues:

The first fragment to appear was the lower part of a striding woman and the lower legs of a fallen man. Marshall was most anxious to possess a fragment for which there was first-hand evidence of Dossena's authorship, and he bought it there and then. A few days later, the second fragment was announced, the upper part of the woman, and we were able by means of poles and wires to set the two together.[13]

That occurred in the basement of Marshall's flat near the Spanish Steps. It now seems Dossena had projected the completion of an entire Greek temple pediment with figures

portraying the mythological gigantomachy, the battle between gods and giants.

As he had paid £40,000 for the 'Munich group' Hirsch was delighted to have the approval of Franz Studniczka, a well-known German expert on sculpture. At the conference in Munich, Studniczka and a practising sculptor thought the piece genuine, while Marshall and Ashmole were against it. Professor J. D. Beazley from Oxford reserved judgement. 'He did not like it, but felt that he had not evidence enough to condemn it out of hand.'[14]

Marshall died of heart failure shortly after returning from the meeting on 15 February 1928. Burdett–Goddard comment: 'The journey was too much for him, and it was little comfort to Warren to know that Johnny had, as it were, died in the harness, displaying to the end his extraordinary skilful judgement.'[15] Warren had been with Marshall two and a half months that winter, and that 'was a great consolation . . . after the separations and misunderstandings'.[16] On his last day in Rome, after he had taken care of Marshall's effects, Warren 'began to think somewhat anxiously of the new life'.[17] He visited some of the places the two had loved but that became too painful. 'Now I wonder whether I shall ever want to see again a place where I was with him.'[18]

After returning to England, Warren experienced greater self-doubt: 'I ask myself whether I ought to have been with him more: did I guess what strain he was undergoing?'[19] On the other hand, it was not his nature 'to brood over sad facts. It is good to remember his "good-bye, puppy" several times repeated.'[20] Friends saw Marshall's death as a signal for Ned to follow the same road. Beazley added to *The Times* obituary for Warren: 'Last February his friend John Marshall died. He bore it with fortitude: but thereafter he had the air of a man who is quietly putting his house in order before departure.'[21]

Warren spent the summer term at Oxford, but his health rapidly declined, and he too was dead by the end of the year – 28 December 1928. In a diary, Warren says he wanted Marshall to be buried with him, 'but he had made his will just after his wife's death and before he had begun to understand me again'.[22] The last request that Mr Gearing, Warren's last secretary, carried out for his employer was to see that Warren's ashes were interred next to his great friend – and Mary Bliss Marshall – at Bagni di Lucca.

9

Nine months after Marshall's death, the public was made aware of what a closed circuit in the art world had suspected for a couple of years. The news broke with a series of cables from Rome during 24–27 November 1928. Dossena's lawsuit against Fasoli was scheduled for 12 December, but adjourned until 10 January 1929. In the meantime, there were conflicting reports and a seemingly never ending series of revelations of what the forger had created. The Frick collection sent their experts to Rome 'in search of the sculptor who had faked some of their pieces'.[23] *Corriere della Sera* came up with the story that the Boston Museum had purchased a sarcophagus attributed to Mino da Fiesole, suspected to be by Dossena. An editorial in *The New York Times* attacked American museums for being slipshod in acquiring so many fakes. It was suggested that 'a minimum of scientific and archaeological investigation would have kept these imitations out in the cold'.[24] The Metropolitan, the Frick and Boston were named as among those taken in.

The Met responded by admitting that several of Dossena's works had been offered to the museum, but declared: 'we have never owned a Dossena even transiently'.[25] A week later, the museum had to eat these words when an enterprising *Times* reporter

made his way into nether regions of the Met and discovered a skeleton in the closet in the form of an archaic lady ... In the basement of the Met stands a little statue smiling. Perhaps it smiles because it slipped into America's greatest museum past all barriers raised to keep apocryphal works of art out.[26]

The report quoted the previous disclaimers the Met had presented to the public.

On 1 December 1928, *Art News*, 'the quasi-official publication of the American art world' released a page one article summarising the situation and trying to calm the nerves of dealers and buyers: 'An international traffic in spurious sculpture has recently been made public, chiefly through the action of Miss Helen Frick of New York.'[27] John Marshall was given only scant notice, and Captain Piero Tozzi was credited with finding Dossena. At that time, Tozzi was a dealer in New York.

Miss Frick and Captain Tozzi relished the roles given them by the magazine.

Shortly before his death, Marshall asked Tozzi if he could identify the Greek 'Athena'. Neither was able to place it with any of the forgers with whom they were familiar. Following Marshall's further investigations, Tozzi eventually discovered Dossena's studio. Marshall's long-time secretary, Annie Rivier, and Gisela Richter of the Met visited Dossena at his studio. Unfortunately the account does not indicate which one it was, but Miss Rivier did leave a record of her visit in September 1928:

> Miss Richter came to Rome two weeks ago. She was determined she would see, too, and we managed to get to the shop. At first they were suspicious, didn't let us in. But when Miss Richter had explained who she was, listened to Dossena, sympathized with his difficulties, admired his work ('none are copies, none are imitations, I created them all – paintings, sculpture, architecture, wood carvings' he says) he finally let us in. In the shop where they were working: a Mino da Fiesole relief of a Madonna ('not a copy, but an original creation according to the style of Mino'), a Gothic baptismal font, a French seventeenth-century helmeted head, tampered with acid perhaps, but certainly not yet fired: etcetera. Then he said we looked 'simpatiche'! (sympathetic) and he showed us some photos: many Renaissance pieces, the Munich group, the Athena. There were other pieces, but he couldn't show them. After several days going and coming, and broken appointments and waiting in the street, at last he let us into a dark back-shop where, with the help of matches, he showed us two big unfinished pieces, just roughed out in big blocks of marble, a fallen warrior which he said belonged to the Munich group(!) and an Athena which he said was cut in the same block as the group and was the figure whose hands are seen in the group. A light was brought, but we could not make sure that this was all true. Quite certain it was that they were made by the same man: they are quite like the other pieces. They were lying about – the plaster model of Mr Marshall's kore, the hand of the Athena etc. etc., the plaster of the head of the youth in the group before he had been made 'antico'. It is a sight to see, a place like this one, interesting and most disturbing. And always his great refrain 'All my own work'.[28]

It would be many years later that the Metropolitan would release any information concerning Marshall's sleuthing – or

even the observations of someone like Miss Richter. Of Marshall *The New York Times* stated: 'The quality of Dossena's work is emphasized by the fact it deceived Mr Marshall whose authority in the field was not questioned and to whom the fine classical collection at the museum is largely a monument.'[29]

The Times declared:

The disclosures regarding the Dossena imitations have done more to shake the art world than any other single occurrence in recent years. The shock of the discovery in Italy ten days ago is still acute in New York art circles. While secrecy surrounds the situation, there is no effort here to minimize the seriousness of the disclosures. The Dossena works deceived not only eminent archaeologists and connoisseurs of both Europe and America, but geologists as well. It has been learned here that competent geologists declared that the apparent erosion of the fraudulent Greek works was the result of natural processes operating over twenty-four centuries.[30]

Dossena's extraordinary versatility was also noted: 'The audacity of conception of Dossena's works also asserts itself. While other successful fakers have been content to confine their efforts to small works, Dossena conceived his sculptures on a grand scale. Not only were many of his works life size, but he even projected the completion of an entire pediment of an archaic Greek temple.'

The New York Times went on to disclose that it was 'understood' that 'the most recent of Dossena's sculptures' was 'a huge Italian arch in the cinquecento style, built into the wall of an ancient provincial Italian building'.[31] This is pictured in the Lusetti book as 'Colossal portal in marble, with angels in high relief', but no records remain as to what happened to it. The revelations led one observer to remark: 'Left to his own devices Alceo Dossena might have been able to reconstruct the Roman Colosseum.'[32]

American newspapers had a field day with the story, but most of them, unlike *The New York Times*, were short on facts and long on innuendo. Trying to calm down the spreading speculation, *Art News* asserted that 'most of the Greek and Renaissance sculptures have now been traced'.[33] In reality, only the tip of the iceberg had been revealed. The magazine also made public the link between Fasoli and Palesi to Balboni, but

none of the American dealers involved in the affair was named. On 22 December, *Art News* tried to quash 'repeated rumours that the sarcophagus purchased by the Boston Museum . . . was sold to them by Durlacher Brothers'. Durlacher was one of the most prestigious dealers in the world, and *Art News* maintained that the tomb had been 'sold in Vienna directly to a representative of the museum by the Venetian art dealer Balboni'.[34]

Later Durlacher admitted that they did buy a large marble relief attributed to Donatello. After they brought it to New York, it was discovered to be by Dossena, and so it was returned to Balboni. Augusto Jandolo says it was purchased by Durlacher for 3 million lire. Pope-Hennessy calls it 'the most ambitious of Dossena's forgeries'.[35] It is nearly 5 feet high and pictures the Virgin and Child with Saints Elizabeth and John the Baptist. Today it is in a private collection in Venice.

Italian newspapers were not very sympathetic to the troubles of the American museums and dealers, and *Corriere della Sera* was more worried that 'the yachts of American millionaires which lie for weeks about Genoa and Naples may easily carry off masterpieces [as well as the fakes] without port authorities being aware of it'.[36]

Sorting out what Dossena had forged and not forged became, for museums, what Lawrence Jeppson termed 'an exercise in Solomonizing'.[37] At the beginning of 1929, claims were aired worldwide for pieces Dossena had never created. In an interview to reporters in January 1929, Dossena said:

> Antiquarians and important persons have shown me marbles which I never thought of sculpturing. Critics have even found defects in my works, acting on the mistaken supposition that I meant to make false misrepresentations. The truth is that I have never made any but original things, modelling them from nature in an antique character and style.[38]

Much of the problem for museums and dealers was self-inflicted. Their long-time policy of absolute silence regarding their purchasing methods and the subject of forgery meant that little if any information was shared among the various museums and dealers who had been stung. This occurred repeatedly in the Dossena affair, and the attitude continues. T. Cuyler Young, Jr of the Royal Ontario Museum spoke of it

recently: 'There are definitely colleagues who feel it's naughty to talk about forgery. It's a subject experts have been debating *sotto voce* for years, at cocktail parties or between two guys in the privacy of an office. In the past, the pattern tended to be, if you had doubts about specific works, you never mentioned it, or if so, only to close colleagues.'[39]

The speculation was not just troubling museums in America. The curator of sculpture at Berlin's Kaiser-Friedrich Museum felt obliged to state publicly that a newly arrived acquisition, an Attic goddess, purchased for one million marks ($750,000) 'is an original work, definitely not an imitation by Dossena'.[40] Leo Planiscig, curator of sculpture at the Historical Art Museum in Vienna, said he had made a count of forty-five known frauds in museums attributable to the forger. Planiscig claimed he was on to Dossena as early as 1921. Why he had said nothing at the time is not clear, and some commentators have suggested this was only boasting. Even so, Planiscig's observations in *The Illustrated London News* of similarities among seven of Dossena's works went largely unnoticed in America. Included were the Boston tomb, Cleveland's 'Giovanni Pisano Madonna and Child', and the mysterious 'Vecchietta Annunciation' pieces.[41]

Jacob Hirsch was aware that something was wrong in September 1927 when he heard of rumours circulating in the Italian press that a certain Venetian dealer 'had invested heavily in frauds' and that a certain 'unknown sculptor' was their creator. The dealer was, of course, Balboni and Hirsch rushed to Venice to see the man with whom he had had so many dealings.

Later, an article in *Corriere della Sera* added momentum to the rumours. Their art correspondent, the son of the director of a Roman art academy, wrote that he had spotted a truck loaded with statues, and connected the vehicle with the 'wormwood king', Romano Palesi. He reported that Palesi was 'making many sales of such goods abroad' and recognised the truck as 'from the district where Palesi lived'.[42] The reporter alerted several dealers he knew, and apparently one of them was Hirsch.

Hirsch knew of the link between Palesi and Balboni, but refused to believe that he himself had been duped into purchasing Dossenas. It was still assumed in a closed circle of art dealers that the 'certain Roman faker' was only producing

Renaissance works, but the *Corriere della Sera* reporter had indicated Palesi's truck was loaded with Greek works of art. Together Hirsch and Balboni stormed Rome, and, as the oft-repeated tale goes, they traced Dossena to a cheap hotel. Uppermost in Hirsch's mind was the 'Athena' he had sold to Harold Parsons for the Cleveland Museum. It is now impossible to reconstruct accurately just what occurred, but commentators like Fritz Mendax have presented the scene with appropriate drama:

> Dossena was at first too non-plussed to reply. Hirsch became aggressive, and Balboni attempted to carry on the discussion in the street, where it continued with unabated violence. Hirsch then produced a newspaper containing photos of the forger's works . . . 'You may have made this one or that . . . but the Athena?' Hirsch joined his colleague and held up the photograph of his beloved Athena. Dossena decided on a different tactic, and ushered them to his nearby studio. He rummaged through a multitude of debris and produced a hand – Athena's missing hand amputated at Fasoli's insistence to give the work 'a genuine indication of age'.[43]

10

As with other writers, Fritz Mendax relies on Augusto Jandolo's version of the story, and missing in the 'Athena' tale as presented in books on art forgery is the purchasing agent for the Cleveland Museum, Harold Parsons. Shrewdly Parsons remained in the background, and the museum moved swiftly both to return the statue to Hirsch, and to build a wall of silence about the purchase. Parsons was quite close to 'Papa' Hirsch as he liked to call him, and the dealer took his fury out on the forger. Dossena was 'a fraud and a publicity seeker' claiming to have created works far beyond the talents of a 'simple stone mason'.[44]

Hirsch returned to Paris with considerable doubts about his colleague Balboni who had supplied him with other profitable pieces for the New World market. Balboni recognised how he had been taken in by Palesi, and the latter, with Fasoli, determined to lie very low, in the hope that the storm would soon pass. For a while Hirsch presented a case to other dealers

that Dossena was nothing more than a restorer for Palesi and Fasoli. He had done nothing more than clean and repair pieces brought to him. As Frank Arnau puts it:

> There was only one chance of saving what remained to be saved: to insist that all the works of art whose authenticity had been impugned by Dossena's allegations were genuine. The most that might be conceded was that Dossena had carried out restoration work on them, which would explain his detailed knowledge of the pieces in question. He was, in fact, nothing more or less than a craftsman turned megalomaniac.[45]

This presentation melted as the full extent of just how much, and in what variety, had been created by Dossena – and there was that file of photographs the forger kept. Probably more damning to Hirsch than the missing hand of 'Athena' were the photographs of her in Dossena's studio. Hirsch had been enamoured with the piece. One account says that after he had secured her for 30,000,000 lire 'he was so delighted . . . he took the figure in his arms and kissed its stony mouth'.[46] Jandolo thinks 'Athena' was Dossena's best imitation: 'a work of art perfect in every respect, equal to the Apollo of Veii, the Charioteer of Delphi and the Aegina sculptures. It is enough to dumbfound any connoisseur. The false patina is the finest ever seen, yellowish in colour, with here and there traces of a chalky deposit so hard as to be impervious to the sharpest steel.'[47]

Dossena refused to reveal the details of his formula for ageing, but according to some accounts, he had a kind of bath sunk in the floor of his studio filled with acids. Schüller says: 'The statue was dipped in this bath, with the aid of a pulley, about 40 times. It was only by prolonged and troublesome a process that the stone could be thoroughly impregnated by the acid, the dazzling white marble given a warm, golden tone and the effect of an excavated image obtained.'[48]

Cellini added observations heretofore never presented. He says that Dossena did not place the completed statue into the acid bath. Before the final polishing and finishing, he applied a number of chemicals and burned the liquids into the marble. Then it was covered in some black substance which was later removed, and only then was the statue polished. The result of his process was a penetration of the marble simulating the

finish of genuine ancient pieces. Dealers and experts were not accustomed to this possibility. Before Dossena, the usual forgers' 'patina' was only on the surface and easily detected. In Cellini's words, 'Dossena was a master chemist'.

Other observers were not as enthusiastic as Jandolo and Hirsch with the 'Athena'. Otto Kurz says she 'smiles with a slightly irregular face'. It was the celebrated 'archaic smile' which was its undoing for many critics. So much has been suggested on the subject that the facial expression of archaic sculpture appears as elusive as that of the *Mona Lisa*. Kurz states: 'It is impossible to reproduce the appearance of something the meaning of which is not known. The archaic smile is neither a real smile nor a grimace, but its counterfeits are invariably either or both.' Kurz also notes another major complaint with 'Athena' – she has 'a definitely hooked nose'.[49] Every genuine archaic Greek sculpture shows a straight line from brow to nose-tip. Dossena avoided that potential problem with his maiden in the Munich group – he simply broke off her nose.

When Cleveland bought 'Athena' they were in an enviable purchasing position among the American museums, and were developing an admirable classical collection. Frederic Allen Whiting, the director, did not respond to the charges that the museum had been duped until April 1929. He said in the monthly bulletin he had 'refrained from referring to the matter . . . because it seemed wiser to defer publication until the full facts could be given'. He admitted the 1924 purchase and also castigated the press for exaggerated comments about the duplicity. He concluded: 'In time it is hoped that a full account of the transactions connected with the forgeries and others may be published jointly by the museums in America for the benefit of all.'[50] Of course, this never happened – and Cleveland to this day refuses to comment on the affair.

Cleveland was twice-stung by Dossena. One point Whiting was not about to divulge was that in the same month when they were shipping off Dossena's 'Pisano Madonna and Child', they had paid Hirsch $120,000 for his 'Athena'. According to Cellini, Parsons had been set up for the purchase in a remarkable fashion. At a dinner party – presumably at Ugo Jandolo's villa – he was told of a little known work by Pisano kept in a tiny convent chapel in Montefiascone, south of Orvieto. Parsons

went to the convent and was shown the statue 'which reeked of incense'. Cellini gives no more details of how Parsons convinced the nuns to be parted with the piece – or indeed if they knew it was by a forger, but he says that after the experience, Parsons realised what Cellini has come to know after similar occurrences. 'Never, never, be led by the "wrapping" of the forgery – the clever setting where the piece is placed.'

Three years after purchasing the statue for $18,000, Cleveland discovered how Dossena had created the 'Pisano'. He had taken a nondescript seventeenth-century sculpture and transformed it into something 400 years older in manner. Bits of old wood were nailed together internally – as revealed by X-rays – and ancient polychrome was painstakingly removed from old statues and picture frames. Gold leaf was carefully tooled to the work. As with Athena, art critics have generally not liked the piece and assume, as always, that Dossena was going for a direct imitation of a master. Hans Tietze says Dossena sentimentalised 'the savage energy in Pisano's work . . . and what appears as an organic group of mother and child in the original becomes a laboured pose in the counterfeit'.[51] Kurz is less negative: 'the Gothic S-line of the figure was exaggerated only little, and the overdose of softness and sentimentality administered to the two faces is but slight'.[52]

Cleveland would not tell me what became of their Dossenas, but in his papers Parsons says (27 August 1947): 'The [Cleveland] "Giovanni Pisano" is now in the Bencivenga collection in Rome, sold by a relation of Ugo Jandolo.' In 1956, Parsons maintained that many of Dossena's forgeries, including the 'Pisano' were 'being held by dealers who hope their sons will succeed in repeating their old tricks.'[53]

11

To Helen Clay Frick goes the distinction of having paid the largest sum for a Dossena – $225,000 for an 'Annunciation' set in the manner of Simone Martini. The choice was brilliant as Simone Martini was not known ever to have been a sculptor, and the discovery of such a work would be counted among the art world's great treasures. The result was brilliant in another respect. 'It is one thing to be duped by pieces that can be

attributed to a known sculptor or to a school of unnamed sculptors; it is something rather splendid to carve a piece of stone so convincing stylistically that it can only be given to a painter!'[54] Russell Lynes is not exaggerating. Convincingly translating Simone Martini's two dimensions into three was no small achievement.

Actually there were two sets of the 'Annunciation' done by Dossena – the one in marble and another in wood, and they are often confused one for the other.[55] Experts who viewed the wooden version in a Venetian gallery hailed it as a masterpiece, and it was suggested that art historians would have to modify their discussions of Simone Martini to include his mastery as a sculptor.

Leo Planiscig of Vienna later revealed that he had been offered the wooden version in 1921 by Balboni, but it remains unknown as to where it went. But, according to a sleuth, Albert Franz Cochrane, of whom we will hear much concerning the Boston tomb, 'the records of the Frick Collection . . . reveal that back in 1924 Miss Helen C. Frick did exchange a sizeable lump of the coke fortune for a pair of Dossena marbles'.[56] Cochrane does not give the seller, but elsewhere it is found to be Elia Volpi of Florence, who appears to have had close working relations with Balboni. According to Cochrane, Miss Frick's adviser wrote upon the discovery of the marble 'Annunciation': 'Absolutely wonderful . . . unbelievably rare!'[57]

Volpi had a considerable influence on the art market in America, but he remains a very shadowy figure. At the time of his sale to Miss Frick he was 70 and beginning to have a reputation for alleged false attributions – in 1917 he stood trial in New York for fraud. Volpi began his professional life as a restorer for a dealer named Bandini for whom he worked for thirteen years before becoming a dealer himself. Volpi's success was assured by wholesale buying. He discovered aristocrats in financial difficulty and bought the entire contents of their villas. His greatest coup was the purchase of the Palazzo Davanzati in the Via Porta Rossa in Florence. When he acquired the palace in 1904, it was surrounded by humble shops and tenements. In 1916, Volpi shipped the contents of the Palazzo Davanzati to New York where, under the aegis of the American Art Galleries, the grand ballroom of the Plaza Hotel was filled with candlesticks, rugs, cushions, statues, censers,

bronzes, and beds, as well as works attributed to Botticelli, Van Dyck, Titian, Rossellino and the School of Donatello. The catalogue for the New York sale was 623 pages long and Volpi returned to Florence a very rich man, turning the empty palace into Casa Davanzati, with 'showrooms continuously furnished with masterpieces of Italian art'.

So impressed with Volpi's merchandise was Wilhelm Bode, manager of the Prussian Art Collections, that he wrote to Volpi in 1922:

> I would not leave Florence, probably for the last time, without telling you how I have been stupefied at the masterpieces I have been able to see in your collection this time. I believe in the 50 years during which I have been twice a year to Italy I never saw at an antiquarian as many important Renaissance sculptures! Not at Castellani's nor at Grassi's and not even at your place.[58]

According to Russell Lynes, the Volpi 'Annunciation' set 'stood for a time at the foot of a staircase in the Frick Museum'.[59] Facts concerning Dossena sculptures and the Frick are hard to come by, and *Art News* says:

> A detailed study of Frick the collector . . . has yet to be undertaken. Miss Frick, who disliked New York and who severed her association with the Frick Collection in 1951, eventually suing the trustees for violations of her father's will, kept his records in a bank vault in Pittsburgh. She would answer direct queries by mail, but access to the records was, and has remained extremely restricted.[60]

It is said that these records are now being opened and catalogued by the Frick Collection, and they should reveal valuable data about Henry and Helen Clay Frick's business with numerous dealers over many years.

Helen Frick died in 1984 at the age of 96 – it seemed to her adversaries she would live forever. Already the closed doors of her life and that of her father and his controversial attitude towards labour are beginning to open. Robert C. Alberts has just completed a history of the University of Pittsburgh and its sections on the Fricks makes extremely lively reading. Miss Frick's attempts to maintain 'a proprietary and semi-autonomous control' over the operations of the Fine Arts Building as 'a living memorial to her father' produced national

headlines. As Alberts says, 'She had a life-long passion for art
and for protecting her father's memory, and she had the means
to indulge both . . . She was a generous giver, but her philan-
thropy was highly personalized and participatory.'[61] John
McCarten wrote of her in *The New Yorker* in 1939 that she 'has
a straightforward mind, and she defends hotly the right of the
giver to choose the gift and to wrap it up exactly as he wants
to'.[62] The same article also said she disliked wearers of bobbed
hair, New Dealers, and Germans – and that was despite her
German antecedents. She would not allow any German scho-
lars in the department of art at Pittsburgh.

The BBC 'Timewatch' team filmed at the Henry Clay Frick
Fine Arts Building on 4 November 1986, and we were shown
around by David Wilkins, the delightful curator of the museum.
Wilkins kept me entertained with stories about Miss Frick. Her
dinner parties at Clayton, the Frick mansion in Pittsburgh's
Point Breeze district, were memorable. Guests were allowed
only one drink – a choice of a bourbon or a rye whiskey, and
were expected to entertain Miss Frick at table in turn. Idle
chat among dinner guests was frowned upon.
 The setting for Dossena's life-size marble 'Annunciation' is
remarkable and appropriate – the Nicholas Lochoff cloister of
the Fine Arts Building. In 1911, Lochoff was commissioned by
the Moscow Museum of Fine Arts to execute a series of copies of
what he considered the finest examples of early Renaissance
painting. By 1917, because of the conditions in Russia, the
artist was stranded in Italy. Eventually most of the collection
was acquired by Miss Frick through the intervention of
Bernard Berenson, and now graces the cloister.
 Directly across from Dossena'a marbles is Lochoff's copy of
the inspiration – Simone Martini's *Annunciation* at the Uffizi in
Florence. The gold background is too vivid, but it is impressive.
Apparently Miss Frick could not be parted from her $225,000
purchase, and after leaving New York, Dossena's creation was
placed first at the entrance to the Fine Arts Building. Today,
the statues do not appear so convincing. The bases are very
obviously an attempt to make it appear that the pieces were
ripped out from a church wall. There is a sweetness about them
which also dates them. If completed, Gabriel's palm frond would
have to go through his left shoulder, and the Virgin's surface

has odd yellowish streaks throughout. She carries the initials SM and as Sepp Schüller has commented, 'probably intended by the sculptor to stand for "Santa Maria". But certain experts, not content with so simple an explanation, believe the letters to refer to Simone Martini.'[63] Schüller is probably right as Dossena never tried anything as obvious as that. Indeed the only inscriptions he is known to have added were those of his own name, which in some cases were scratched out by dealers.

As we left, Wilkins pointed to an elaborate sculpture which marks the entrance to the building. I do not remember it very well, but pictured is a hero abducting a very unwilling maiden. Wilkins interpreted the scene as 'Miss Frick trying to escape the clutches of her father'.

12

The year 1929 was a momentous one for the art world. Aside from the shock waves created by the Dossena revelations, Wilhelm Bode died. W. R. Valentiner wrote for *Art News*: 'When one speaks of connoisseurship, his name at once takes first place. He was the first to prove the possibility and necessity of such a profession.'[64] The same issue announced the end of 'the world's most celebrated case of art litigation' – the Hahn–Duveen case which argued whether a painting owned by Mrs Harry J. Hahn, a Frenchwoman married to an American Army officer, was by Leonardo da Vinci or not. Joseph Duveen put his reputation on the line by asserting the picture was a copy. That word from Duveen was enough to ensure Mrs Hahn would not get a good price for *La Belle Ferroniere*, so she sued. Duveen presented a formidable group of experts' testimonies, including that of Bernard Berenson. In the trial it was revealed that both Duveen and Berenson had once doubted the authenticity of the Louvre original of which it was suggested that Mrs Hahn's painting was a copy. The trial ended with the jury split, nine to three in favour of Mrs Hahn. Duveen avoided another trial by settling out of court to the tune of $60,000. Both art dealers and experts suffered greatly as they were hauled over the coals by the press as to their inability to judge just what was authentic and what was not.

A German professor of Fine Arts, visiting American

museums shortly after the trial, was asked by the press whether he had found more forgeries in the United States than in Europe. He responded: 'Not more forgeries, but larger, more ambitious ones.' *The Burlington Magazine* which carried the report suggested: 'He might have added, they are more conspicuously displayed in your museums.' The article went on to cite Dossena's tomb which, at the time, was 'handsomely installed in the rotunda of the Boston Museum directly opposite the entrance'.[65]

None of Dossena's creations has been more admired or hotly debated than this so-called 'Mino' tomb at the Boston Museum of Fine Arts. The only place in which the BBC was not allowed to film for the 'Timewatch' programme was Boston, and no amount of persuasion could penetrate the wall of silence regarding that tomb. Though Boston received the piece in 1924, there is no indication that either Marshall or Warren knew anything about it.

Mino da Fiesole (1429–84) carved a number of portrait busts and produced tombs and tabernacles in Florence, and the opportunity to acquire an example of a tomb in almost perfect state of preservation would be pursued by any museum in the world. Those who were first shown such a tomb were very impressed. It was a massive piece carved not from a single slab of marble, but consisted, like a chest, of marble slabs fitted together. One observer describes it as having

> Only one crack ... through the central slab, cutting the marble effigy of the sleeping figure and the sarcophagus on which she rested. And, as so often happens in ancient art, that crack seemed to add the final touch of aesthetic beauty. Age had hall-marked it for its own; the crack whispered softly of passing centuries that had mellowed and stained the Carrara to a rich golden hue.[66]

There are many conflicting accounts of the origin of the tomb, and as with other American museums, Boston is not about to say what they know. One Bostonian, however, a reporter for *The Boston Transcript* started an investigation of the piece in 1929, and presented a well-documented, but curiously over-looked, report in what was then called *Harper's Monthly Magazine* (July 1938). Even Russell Lynes does not refer to this article in his writings about Dossena, and I came across the sleuthing of Albert Franz Cochrane simply by chance.

Romano Palesi is said to have offered the tomb to Miss Frick and 'she was on the verge of buying [it], but her agents were unable to locate the ruined church or the supposed intermediaries, and so she backed off'.[67] Schüller insists this happened in 1921 which would correspond with the time the tomb was offered to someone else – Leo Planiscig, custodian of Vienna's Imperial Museum.[68]

Miss Frick's agents were told the tomb had been found in a ruined church and that 'very highly placed ecclesiastical authorities' had agreed to part with it only in the utmost secrecy. Planiscig said he was shown the tomb in a cemetery near Florence, and given a tale of its provenance similar to those we have heard before – the monument had been found in a half-buried abbey near Siena destroyed by an earthquake. Planiscig did not like it, but when he returned to Vienna he found the tomb had been bought by another Viennese museum, the Hofmuseum.

The head of the Hofmuseum, Gustavo Gluck, understood his latest accession to be from the collection of Baron Oppenheim at Presburgo in Czechoslovakia. The museum had paid Carlo Balboni 6 million lire for it. It appears that after Palesi and Fasoli were unable to convince Miss Frick, the tomb passed into the hands of Balboni and Elia Volpi.

Jeppson maintains the tomb was planted in a dilapidated church 'where it was discovered by a Florentine scholar of suitable repute . . . the expert appears to have been Volpi'.[69] Jeppson also says Volpi was shown a receipt signed by Mino da Fiesole acknowledging payment for the tomb.

When he returned to Vienna, Planiscig says, 'I managed to have it rejected; whereupon it was returned to Italy and later sold to Boston.'[70] Mercifully we are now on less confusing and conflicting ground as Cochrane begins his story with the tomb at the Hofmuseum in 1922. Charles H. Hawes, then associate director of the Boston Museum, visited Gluck and was shown photographs of the 'Mino' tomb. It had not yet arrived for installation, but Cochrane has Hawes displaying more than 'the perfunctory praise expected of well-bred visitors'. Later Hawes probably cursed the day he was shown the tomb which would 'split connoisseurs into openly hostile camps, and . . . be denounced as a fraud'.[71]

Months later, Hawes was to hear that the tomb was again on

the market, and when the museum opened negotiations to buy the piece from Volpi, they were apparently unaware of Miss Frick's rejection, and that of Leo Planiscig. Oddly not a word passed from the Hofmuseum to Hawes either. Cochrane dryly remarks: 'Museum ethics, in which the time-honored principle of *caveat emptor* is neatly balanced against scholarly respect for differing judgments, prevented these details from being known to the Boston Museum.'[72] And so in the spring of 1924, Dossena's tomb came to Boston. They had paid Volpi $100,000, which was a little less than the earlier price.

It had not been there long when some very strange things were noted about the piece. The inscription on the tomb indicated the sleeping nun-like figure to be Maria Caterina Savelli. The receipt of Mino da Fiesole, supposedly shown to Volpi, indicated he had been paid by the Savelli family. The Savellis were one of the most powerful families in Rome. Two of their number became popes, and the summer residence of the popes to this day, Castel Gandolfo, belonged to them in medieval times. The family became extinct in the early part of the fifteenth century, and this both added to the historical interest and created a problem for the tomb. It bore a date of 1430 – and its supposed sculptor, Mino da Fiesole, was not born until 1429! But that was not all. Maria Savelli was termed *prefata* in the inscription, which means 'the aforesaid'. If as one observer noted the term was intended as 'prefecta' it would make Maria a 'captainess'.

Cellini says that Bostonian Harold Parsons showed Cellini's father a photograph of Boston's new acquisition, and he knew at once it was false. He recognised two sources for the piece: the architectural framework was after a work by Mino in Santa Maria sopra Minerva in Rome, and Caterina was derived from Rossellino's *Beata Villana* at Santa Maria Novella in Florence. Cellini's father also recognised 'an idiocy' in the inscription: 'At last the above-mentioned Maria Caterina Savelli died.' This was obviously copied from a biographical text, and Cellini maintains this was done by a high school classics teacher named Father Sola. Walter Lusetti says this was just the type of thing done by Palesi, and Dossena maintained the tomb had left his hands without any inscription whatsoever.

The Dossena storm of 1928–9 included the Boston tomb as one of the forger's works. *Art News* carried the story that

Dossena admitted authorship and had shown a 'semi-official representative of the museum' a photograph of it he had taken himself.[73] 'Semi-official' is more than an understatement in what transpired since the representative was Harold Parsons. Cochrane has Dossena confessing all to Parsons 'over a cafe table amply supplied with good wines'.[74] There is little reason today for doubting that Parsons – and Cellini – were on to Dossena as early as this, but more importantly, no one in the museum world – most especially Boston – was to take them seriously until 1955. The reason why Dossena revealed all to Parsons was his fury at discovering that whereas he had been paid 25,000 lire for the tomb, Palesi had made a profit of 5,975,000 out of it.

Meanwhile, back in Boston, the tomb was removed from exhibition, but, in the words of Cochrane, the subsequent attitude of the museum towards its tomb was 'a lone and unenviable role, stoutly maintaining that it had not fallen victim to the Italians. No one from the Boston Museum ever asked Dossena to prove what he had said about the Mino tomb.' Except for Parsons' report there was no attempt to contact Dossena. As befitting one who knew his city well, Cochrane released a broadside in 1938: 'It is typical of Boston's traditional self-sufficiency that the Museum has not troubled to examine in comparative study any of the acknowledged Dossenas, but an outside observer might think it strange that the Boston tomb should now prove to be the one exception in that master's lengthy and excellent repertoire.'[75]

'Timewatch' was allowed to film a piece by Dossena made for Harold Parsons in 1928, *Noli me tangere* ('Touch me not'), which is kept in the Fogg Art Museum on the Harvard campus at Cambridge. The marble relief 'in the style of Mantegazza' (or as Pope Hennessy suggests, Amadeo) depicts the scene from St John's Gospel where Mary Magdalene recognises Jesus after the Resurrection, and is charged not to touch him as he has not yet ascended. After filming I went to the Fogg archives and asked if they had any records of the piece. I was shown a letter from Parsons written at the Dorset Hotel in New York, on 16 September 1928, to Professor E. W. Forbes.

Parsons says that the relief was made for him in Rome in a few days so that 'I might see the whole method of procedure – consequently it is a hurried piece of work and not as convincing

as some of his other sculptures'. More interestingly, Parsons
says he sent the piece to Hawes 'to examine in relation to the
"Mino" tomb so that he may finally convince himself that the
surface and broken edges and patina of the tomb are identical
with other works by Dossena'. Apparently this was never done.
When we returned to London I wrote to the archivist at the
Fogg Art Museum thanking her for her help and she responded,
saying it was a pity I did not have the time to read other
communications from Parsons. I then requested basic bio-
graphical information about him, but have received no reply to
that or any other query. But that was better than the situation
with the Boston Museum. Not only were we not allowed to film,
but no information whatsoever was forthcoming as to their
intentions concerning the tomb.

In 1929, *Art News* printed some heavy criticisms of the tomb
by Dorothy B. Graves of New York University. She noted the
inspiration given by Cellini's father, but stressed a tell-tale
error with Maria Caterina's feet: 'Dossena has made a faithful
copy of the sandal straps on the Rosellino tomb, but apparently
forgot to include the sole of the sandal. The Italian forger has
broken one of the toes on the tomb to give the appearance of age,
but the omission of the sole on the sandal is in itself sufficient
evidence to brand this work as an attempt to deceive.'[76]

As to the missing toe, Cochrane reminded Boston that that
should have been warning enough with all those missing pieces
– fingers, toes, hands – which Dossena kept with the photo-
graphic file in the inaccessible inner *studio segreto* off the
Ripetta in Rome. Cochrane said of the sandal: 'As for the sandal
missing from one foot of the reclining lady, that too could easily
happen with a sculptor who forgot to fill in the even more
important name plate.'[77] When asked about the missing foot-
wear, Dossena admitted he had worked (as always according to
Lusetti) from photographs. He had made the tomb 'as a compo-
site from various photographs of authentic works, and as the
print from which he copied that section failed to show the sole
of the foot because of the angle from which the view had been
snapped, he too overlooked it'.[78] Cochrane could not resist
adding: 'But then, of course, science has said that Dossena
didn't carve the foot itself.'[79]

Dorothy Graves concluded her criticism by saying: 'It is only
difficult to understand how a work which was copied from such

well-known works in Florence and Rome should have deceived so long art dealers, experts and museum curators.'[80] Miss Graves' remarks were developed further in an article in *Parnassus*, in 1929, with other art experts joining her. Boston's tomb entered texts on art forgery, most of which were written by Germans, but one or two American scholars took note of the piece. Professor Frank Jewett Mather of Princeton announced in *Harper's* rival *The Atlantic Monthly*:[81] 'the heraldry of the "Mino tomb" was preposterously unhistorical'. Boston retaliated by noting they had consulted the great heraldic authority, Pierre La Rose, before they had committed themselves to the purchase of the tomb. La Rose had given the Savelli coat of arms a clean bill of health.

According to Joellen Secondo of the Department of European Decorative Arts and Sculpture at Boston, 'no research has been carried out since the 1937 examination of the tomb'.[82] When George Harold Edgell became Boston's director in 1935 he accepted Dossena's confession and the verdict of art experts who had criticised the work. But, as Cochrane puts it, he 'continued to like it immensely, with that rare catholicity of taste which permits admiration where admiration is due. Forgery, or no forgery, the work was, in his opinion, far too beautiful for basement dust.'[83]

One of Edgell's first acts as the new director was to request permission from the museum's art committee to return the tomb to public exhibition. After all, it had attracted admiration in its former position at the entrance to the museum. Edgell also decided to have tests performed on the tomb. The investigation was led by William Young. Young is another link back to Edward Warren. In 1929, he came to the Boston Museum at the age of 23 to establish a research laboratory for the conservation and study of works of art. He was the third generation of his family to work in this field, and his father had been in charge of conservation at the Ashmolean Museum in Oxford. During one vacation Young was at Lewes House and worked on various pieces for Warren and Frank Gearing. From that experience sprang the idea that he should go to Boston.

Young soon headed a new laboratory and his analyses of the tomb for Edgell involved microscopic examination of the surface from cross-section, and examination under ultra-violet rays. The latter test can be quite effective as newly cut marble

appears brilliantly violet under radiation and ancient pieces a dull reddish terracotta colour. The tomb was discovered to be heavily impregnated with wax – possibly to hold the pieces together. The wax proved that the ultra-violet test would be a futile exercise.

The inscription, the right-hand panel bearing a coat of arms and the two pilaster capitals were seen to be modern. Museum officials said this came as no surprise, and were more interested that the tomb proper, both console brackets and the left-hand panel bearing another Savelli coat of arms and other sections appeared to be medieval. Polarised light established the origin of each component marble in the tomb. Thirteen were quarried from Carrara, but the fourteenth was Greek.

The Boston Museum's report of the tests stated that 'unbelievable was the thought that he [the forger] would carefully use Carrara marble throughout the tomb except for one slab in which he employed marble from Olympia'. Their feeling was that a restorer had used the Greek slab because it was available at the time. Edgell's report in the museum bulletin went on to say: 'The evidence was so striking that the Director became convinced that the tomb was an original of the fifteenth century, rebuilt, partially re-cut, with certain additions or substitutions that did not belong to the original monument.'[84] No mention was made that Dossena might have been the restorer. Indeed there is no mention of Dossena at all. A visit to his studio would have indicated a fact well known to Parsons and others – like any good Roman sculptor there was always a supply of *marmo grecchetto* (Greek marble) around for any number of reasons.

Writing a year after the report, Cochrane asked the Boston Museum a number of questions he felt they had not entertained. 'If, for example, the appearance of the Savelli arms is to be ascribed to opportunism, how then explain the highly significant fact that a decorative flying ribbon with distinctive tassel terminal, which is a prominent and integral feature of the heraldry, also is found in similar placement round the inscription panel of the sarcophagus itself? Could mere accident bring about such a remarkable association of ornamental detail?' Cochrane did not stop there. 'Examination of the chisel strokes, moreover, seems strongly to indicate them to have been cut by the same hand, which means also at the same time

... these important features were designed and executed as a unit'.[85]

Cochrane might also have mentioned the accompanying set of angels Dossena produced for the tomb. They could not have been a secret to the Boston Museum, as the 'guardians' for the tomb were featured as a full page in the Spring supplement of *Art News* in 1924, and it was well known that Elia Volpi had offered them to Boston as the finishing touches for their tomb.[86] Far more damning are the observations of Harold Parsons concerning the tests on the tomb. There appears to be more than a touch of venom towards Warren's associate, Young, in Parsons' remarks. In a letter dated 7 May 1954, complaining about the inefficiency of museum laboratory testing in general he says:

> the epic 'laboratory test' is to be seen [with that of] Mr Young . . . whereby the few genuine fragments used to make that monument complete were pronounced as 'modern' and all of Dossena's tomb figure, sarcophagus and one of the coat of arms were pronounced 'medieval'. The observations and differentiations were correct; the deductions erroneous; which proves that 'technicians' should go and sit on their biselium, leaving matters of style and of interpretation to the connoisseur and art historian.[87]

The museum report issued in December 1937 concluded by saying: 'In any case, the Director would like to emphasize . . . the fact that the tomb is put on exhibition because it is a beautiful object.' And so it was, less than two months after Dossena's death. In his conclusion, Albert Cochrane asked the museum, if it were genuine where did it come from? He also related that George Edgell sought an answer to the question, and had journeyed to Italy during the summer of 1937 to resolve the issue. He did not seek out Dossena 'whom the laboratory had ruled out of the case' but approached Elia Volpi, and another gentleman involved in the early dealings with the tomb. The latter had been quoted by Volpi as having seen the tomb *in situ*, but when queried by Edgell he denied it. 'No, that is not true. I never saw it in place, but I wish to God that I had!'[88] What might have been behind that remark is not revealed by Cochrane, but he did go on to interview Hawes in retirement in Virginia. Hawes said to Cochrane: 'Perhaps someone in Italy will one day leave a record of the whole affair

to be opened after death. Who knows?' However, Cochrane and
everyone else in Boston also remembers Hawes' declaration to
the press: 'If that sarcophagus was ever a forgery, it is worth
preserving. It is beautiful no matter who did it.'[89]

13

The Boston Museum almost came to own one of the most
celebrated pieces of Greek sculpture, the *Ludovisi Throne*,
which today is a star attraction in Rome's Museo Nazionale on
the site of the Baths of Diocletian. The three-sided relief is not a
throne, and more likely part of an ancient altar. The centre-
piece depicts the birth of Aphrodite from the sea. The goddess
emerges into the arms of two nymphs as described in one of the
Homeric hymns. The figures on the side panels are a girl piping
and a veiled bride which represent two aspects of Aphrodite's
cult.

The Ludovisi relief is said to be by an Ionian sculptor from
southern Italy of the fifth century BC, and got its name from
being part of the famous collection in the seventeenth-century
Roman villa of Cardinal Ludovico Ludovisi. Rumours that the
great collection might be sold had come to John Marshall in
1892. By 1894, the owner of the collection was in financial
difficulties, and Warren was eager to secure the principal pieces
for Boston. A letter from Marshall to Warren (14 November
1892) says he went through the collection 'carefully for about 2
hours . . . Of the 5 great pieces I haven't a doubt. The 3-sided
relief [the throne] I like even better this time'. By 1893, there
were almost daily letters crammed with details concerning the
slow and devious progress of negotiations for the purchase. By
1895, Marshall was expressing his fears 'lest his linguistic and
personal limitations should be too great for a matter of such
consequence'.[90]

Warren was busy as well. During a visit in 1897 to see the
Danish brewer and collector, Carl Jacobsen, Warren and the
Dane arrived at a provisional division of spoils if they should
succeed with negotiations over the Ludovisi collection. As it
turned out, this and all Marshall's daily efforts for several years
were an exercise in futility. In 1901, the Italian Government
asserted its right to the collection. In 1896, the trustees of the

Boston Museum produced the money necessary for Warren to purchase what came to be the consolation prize for losing the *Ludovisi Throne* – another three-sided relief which was also said to come from the Villa Ludovisi where it had been set in a wall and used as a fountain.

'The Boston Relief' – as it came to be called – shows a plumpish Eros judging a contest between the two seated figures of Persephone and Aphrodite. On the right wing is a young man playing the lyre, and on the left, a seated old woman. This is the work Rothenstein described in the garden of Lewes House as 'by hook or crook . . . smuggled out of Italy'. It remained at Lewes for several years before being shipped to Boston in 1908, and finally exhibited in the museum's new building in 1909. As J. D. Beazley in his chapter, 'Warren as Collector', in the Burdett–Goddard book says, 'The Boston relief has been much discussed, from every point of view. Shortly after its publication, its genuineness was attacked'.[91] Beazley found that 'hard to understand', and states that 'the invention and execution of the floral decoration are beyond any forger'. He also noted that the Ludovisi Throne itself was not at first recognised as a masterpiece. Some called it 'Roman' and 'archaistic'.

In *King of the Confessors*, Harold Parsons boasted that Boston had 'spurned his news that their vaunted Greek sarcophagus and their Ludovisi throne had been carved by him [Dossena]'.[92] In his *Fakes*, Otto Kurz assumes that both the 'Mino' sarcophagus and the relief are by Dossena. As the relief was offered for sale in 1896, and even assuming he made it that year, that would have Dossena creating the relief at the age of 18 – highly unlikely to say the least. Pico Cellini also maintains it is a fake, but assigns it to other forgers:

> When Rome's Ludovisi Throne was discovered at the turn of the century, Boston was eager to buy it but lost out to the Italian state. A group of local forgers, keen to offer the disappointed client a pendant to the Ludovisi sculpture, sawed one end off an old sarcophagus to imitate a chair, and carved the Eros sculpture as a counter to the Persephone depicted on the Roman marbles.[93]

In 1965, William Young and Bernard Ashmole presented a report on the relief, and Ashmole said in a shortened version of the findings in the museum *Bulletin*: 'Historians of art who

believe the three-sided relief in Boston to be a forgery have lately become so vociferous that the small voice of reason can hardly be heard above the clamor.'[94] Ashmole asked Cornelius Vermeule of the museum whether the relief could be lifted so that he and Young could examine its lower bed. 'This was done on January 25, 1965, and we studied it for some hours inch by inch. The whole surface is covered with a hard deposit, including "root-marks": there is not the slightest doubt of its being both natural and ancient.'[95]

The longer report states that 'the deposit could not possibly have been applied artificially'.[96] The relief was extensively compared with the *Ludovisi Throne*, and small samples from both monuments were made for petrographic study. The two were compared and found to be only slightly dissimilar in structure. The root-marks on both pieces indicated that they 'both were long buried under similar conditions'. In conclusion the report asserts: 'In any case the claim that the Boston Relief is a forgery can, except as a psychological curiosity, now be forgotten, together with the misleading scholarship, the innuendo, and even, lately, the arrogance with which it has been supported.'[97]

The relief can be viewed among the many other Warren–Marshall treasures. The question is why Boston has not done with its sarcophagus what it did with its relief – recent testing and comparisons with related works. Cochrane and Parsons suggested a comparison of the tomb with Dossena's known creations a long time ago – and there is one just across the Charles river.

In 1955, Perry Rathbone came to Boston as the new director from the Saint Louis Museum. He wisely agreed to tests on the relief, but his decision for the tomb was banishment – to the basement 'to diminish the controversy'. As we will see Rathbone had good reason to be wary of anything tainted by the name of Alceo Dossena.

PART THREE

The Legacy

14

Towards the end of 1929, and into the new year Dossena enjoyed a brief period of success in Italy, and attracted attention across Europe, especially in Germany. *The Illustrated London News*, in 1929, recorded the visit of Professor Walter Bombe to Dossena's studio. The academic announced that Dossena was 'not a faker, but a genius'. The afternoon he appeared

> two assistants were busy in the outer studio . . . copying a clay model in marble, and I was looking around inquisitively when Dossena himself appeared. A well-built man with greying hair; brushed back from a powerful brow, the sculptor is pleasant-visaged and courteous in manner. After I had given him an outline of my purpose in calling on him, he led me through the old courtyard into the *studio segreto*, which is kept absolutely barred to lay visitors. Here all those works which deceived the finest experts in the world were created; here this wizard for so he might be called, produced, with an extraordinary sense of feeling.

Bombe goes on to list Dossena's major works.

The professor asked Dossena where he had acquired so much knowledge. 'To my unbounded surprise, he said he had learnt it himself. He worked first with an ordinary mason in Cremona. There he acquired skill in handling marble and in the use of the mallet and chisel, and picked up many technical requirements . . . Beyond this he had ten lessons in anatomy. This was all his training.' Dossena showed Bombe an ancient Greek Athena overcoming a giant which must be the same as shown to Miss Richter and Miss Rivier in 1928. He said he had the pieces photographed, 'but when he learnt the price obtained by the dealer, which was a hundred times more than the sculptor had received, he broke the work to pieces in his wrath'.

After complaining how many other times he had been fooled, Dossena told Bombe that things had suddenly changed. Now he could not cope with the many important commissions he was receiving. 'Baron Fassani has ordered a bust, and so has the Duke of Aosta.' While Bombe sat with Dossena 'and his son Alcide, a clever assistant to his father, in a neighbouring

osteria, an elegant automobile drew up to take him to the Prince
Borghese, who desired the master to model the Princess in the
costume of the Early Renaissance'.[1]

Walter Lusetti showed me the result, and to my taste la
Principessa Angela Borghese decked out as a Renaissance lady
appears a bit silly, but apparently the family liked it. Far more
interesting were other works Dossena created 'in his own right'.
There is an impressive group found in Rome today: a statue of
the Sacred Heart of Jesus executed for the great Jesuit church,
the Gesù; an extremely impressive and large marble Christ for
the Gregorian University, a Saint Anthony for Chiesa Nuova,
and a set of Stations of the Cross for the church of San Patrizio.

I had no difficulty finding the last two. Apparently the Sacred
Heart statue was removed to make room for a Christmas crib
when I was in Rome, and the Gregorian's opening hours were
extremely vague. Saint Anthony has never been a favourite
with me, but Dossena's polychrome wooden version is a delight.
Here Dossena was entirely on his own, and the result fits well
with the Baroque setting of Chiesa Nuova and indicates a
warmth lacking in many of his other efforts. Anthony peers
down at the Christ Child in his right arm; the Bambino looks
back in adulation. Anthony supports the Child with his left
hand clutching the foot of the baby. I was reminded of Lusetti's
photograph as a boy sitting on his father's shoulder. The statue
is schmaltz, but good schmaltz – and that is true of much of the
Baroque.

The Stations of the Cross are another matter. They are to be
found in the rather unattractive Irish church of San Patrizio (St
Patrick's) across from the grounds of the American Embassy.
They are in dramatic high relief and imitate no past master.
The Stations give an indication of Dossena's ability to create in
his own manner, and I wish those critics who suggested he
slavishly copied old masters had viewed them. Unfortunately
the works remain almost unknown, and are now a memorial to
Genevieve Brady Macaulay who died in Rome in 1938. They
were presented to the church by W. G. B. Macaulay, a former
Minister of Ireland to the Vatican. Later added to the memorial
plaque are the words: 'Sculpture by Alceo Dossena', but when
and why the priest has no idea.

Dossena produced a large number of works at this time and,
according to Lusetti, was working on a Madonna of the

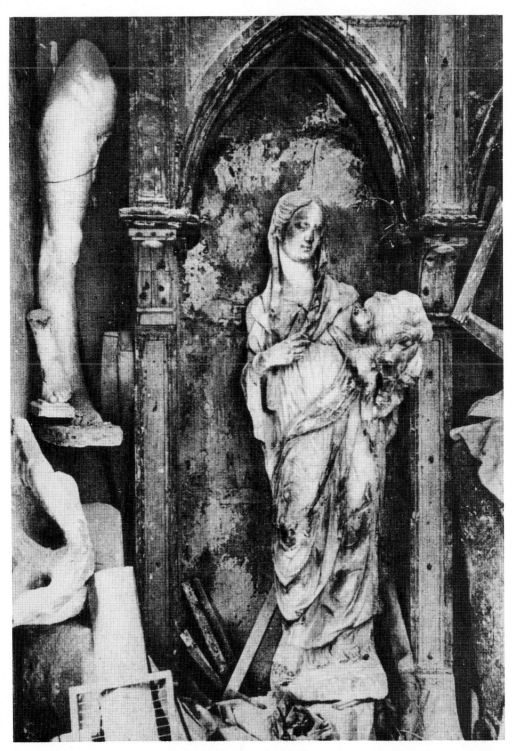

1 Secret chamber of Dossena's studio with one of his many Madonnas.

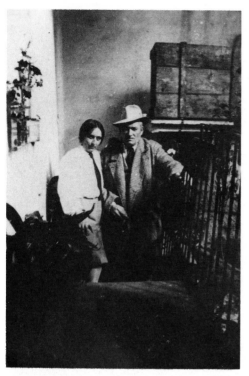

2 Dossena with his younger sister, Amelia.

3 Wooden Madonna and Child by Dossena attributed to Giovanni Pisano, once at the Cleveland Museum.

4 Statue of Athena by Dossena, formerly owned by the Cleveland Museum.

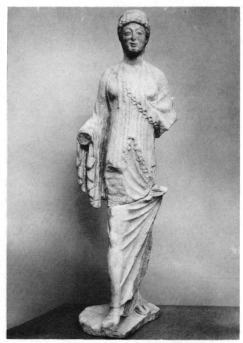

5 Statue of an archaic maiden by Dossena, formerly at the Metropolitan Museum of Art in New York.

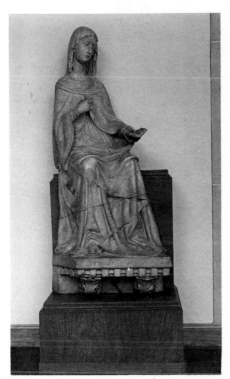
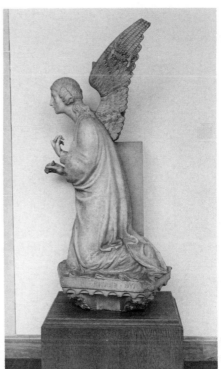

6 Dossena's Annunciation set once owned by Miss Helen Frick.

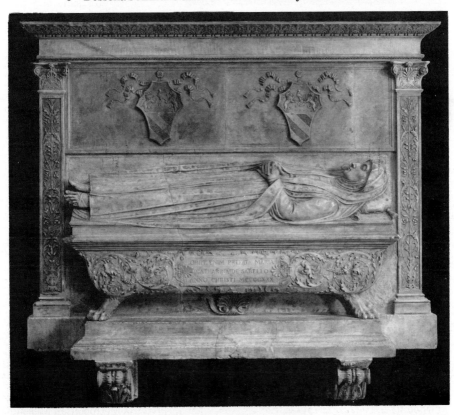

7 Marble tomb by Dossena attributed to Mino da Fiesole, at the Boston Museum of
Fine Arts.

8　Edward Perry Warren.

9　John Marshall.

Pomegranate when he had a heart attack. The last photograph of Dossena shows him working on the Madonna and covered with marble dust. The Stations had just been completed. Some of Dossena's later works are not so successful – especially a female nude in bronze and a marble fountain figure. Mario Prodan has Dossena living these years 'in a sort of tabernacle of fame . . . He had a great passion for women and it seems his attitude toward them was quite Oriental: he would hire a great carriage and drive through the Picino gardens with three or four beauties at a time.'[2]

According to Lusetti, Dossena's greatest vindication as an artist was also his greatest disappointment. It occurred in an extraordinary manner. In late 1929, the civil authorities of Dossena's home town announced the results of an open competition for the erection of their Great War memorial. Designs were submitted, but the name of the winning artist was to remain unknown to all, including the judges. When the envelope containing the name which went with the winning design was opened it was found to be that of Alceo Dossena. It appeared that at last Cremona was to recognise its own – but the memorial was never finished. Walter Lusetti maintains that this was due to his father's well-known anti-Fascist views. Dossena's design showed a funeral urn over which a group of three mothers – Italian, Austrian and Hungarian – is bent in common grief.

In April 1929, an exhibition of twenty-three of Dossena's works occurred at one of Naples' most respected antique firms, the Corona Gallery. An account of the show in *Die Kunstauk-tion* says that 'three owners of the forgeries . . . now saddled with these works after their return from America' had arranged the show in the hope of attracting potential buyers. The report included rumours which had circulated in German newspapers that 'a certain group sought to launch Dossena as a creative artist'.[3] That hardly appears the case as Dossena did not attend the exhibition and was not known to the Corona Gallery.

Newspapers in Germany also reported that they had been led to believe that the admission charges to the Naples show were being donated to a tuberculosis home, but later discovered the money was going to a Fascist youth organisation. The reports interpreted this as an attempt to placate the political

establishment in Naples which had earlier sought to forbid the
exhibition as 'it might reflect upon the Italian art trade and
upon Italy's reputation in general'. The gallery catalogue
heaped praise on Dossena as

> neither forger nor artist who works for material gain, but a great
> artist of the chisel, a marvellous creator of Madonnas and putti . . .
> His path to fame is unusual, and perhaps not recommendable: but
> no one can deny that Dossena . . . is an incomparable artist . . . The
> day will come when Italians will forget the American disturbance
> and honour Dossena according to this merits by according him a
> fame they have thus far denied.[4]

The *Die Kunstauktion* reviewer was not so moved and asked:
'How could this deception have taken place? The first general
impression of these forged originals and original forgeries is not
particularly forceful.' He was particularly critical of works
Dossena had recently created, but also noted that none of
Dossena's most convincing works was there. They were, of
course, in America.[5]

An even larger exhibition was staged in January 1930 at the
Berlin Hall of Art. Dossena had made several works specially
for this show, and the Berlin press made a celebrity of the
forger. Not all the critics were enthusiastic, and writing for
Apollo, Oscar Bie said the show 'produced a considerable
disenchantment'. Bie's parting remark was said to have
affected Dossena greatly: 'The faker Dossena is finished; but
the artist, Dossena does not appear.'[6]

Before the Berlin show, Hans Cürlis, director of the Institute
for Cultural Research, made a film of Dossena at work in his
studio which was shown at the exhibition. Viewers of 'Time-
watch' will remember it. Dossena obviously enjoyed showing off
his talents, and it is said he laughed and sang snatches of opera
as Cürlis filmed. The film shows the Stations Dossena was
completing as well as a charcoal design for an *Ecce Homo*, and
the clay design for the Cremona memorial.

Later Cürlis left a record of his experience of making the film,
and he obviously had great admiration for Dossena:

> We watched Dossena modelling for a long time before we filmed
> him . . . His technique was scrupulously academic. The figures [for

the Cremona memorial] were first modelled accurately from life, a pair of large wooden dividers being frequently used to measure length of limb or head, and distances on the model and to transfer [the measurements] to the clay figure. Later Dossena draped a robe over the model and did the same in clay to his nude figures ... As if for relaxation from this arduous work, he then spent days modelling fourteen reliefs of the Stations of the Cross ... And here we witnessed the most amazing example of a sculptor at work. Unhurriedly, but in the space of a few minutes and without any plastic or two-dimensional sketch, figures in high and medium relief came into being. Everything happened so quickly and unexpectedly that we could scarcely move the camera into position in time. The ancients must have exercised a similar facility when they improvised stucco decorations for the ceilings and walls of castles and churches. With equal unconcern Dossena modelled daring and imaginative architecture, city gates, and walls whose large plane structures projected from the background in bold perspective.

We were naturally very keen to see Dossena at work on an archaic statue. When he inquired what he should make, I asked him for a Greek goddess. He offered us the choice of a standing or seated figure, and, while we were deciding on the former, had already selected a few pieces of wood and was building the armature. Half an hour later we were looking at an Attic goddess, some two feet tall, modelled in clay, with the captivating beauty that springs from the only slightly relieved rigidity that we admire in the best genuine pieces ... The head took shape with equal fluency, and quite suddenly a smile dawned on the face of a woman to whom the Greeks had prayed 2,500 years before.[7]

15

In 1930, the Victoria and Albert Museum in London acquired three terracotta reliefs executed by Dossena in the Florentine style of the fifteenth century. There were purchased by Hildburgh for £12 each, and two of them had been in the Berlin exhibition. All three are signed by Dossena, and portray the Madonna and Child. Two are dated with the Fascist Year VII – 1930. Perhaps the most admired has the Christ Child seated on a cushion with his right hand raised in benediction and a pomegranate in his left. Some have noted a 'Simone Martini

look' to the piece, but in all three, Dossena set out not to imitate any particular artist.

When the new cast court of the V & A was completed, Anthony Radcliffe had the idea of turning the corridor between the two courts into Room 46 – an exhibition of fakes and forgeries. The room remains the only permanent exhibition of forgeries in any art gallery in the world. The setting is spectacular. Room 46 is sandwiched between the massive 46A and 46B galleries which contain plaster casts of what the Victorians considered to be the most important architectural and sculptural feats of Western culture: Trajan's Column in two sections because of its size; Michelangelo's David, the Pórtico de la Gloria, tombs, doorways and Renaissance pulpits. These are all acceptable copies, but next door are the real fakes – some of which fooled the V & A's experts over the years.

Many of the great Italian forgers appear: Bastianini, Fantacchiotti, and, of course, Dossena, represented by the three terracotta reliefs. There is also a bronze 'David' once believed to be a lost work of Michelangelo, and a pastiche of Edward VI worked over the painting of a young Dutch girl. In the many times I have been there I have noticed how few read the labels. Maybe they assume they are real. If so the forgers succeeded after all.

Three years after the Berlin exhibition, there was a public auction of thirty-nine of Dossena's pieces in the same ballroom of the Plaza Hotel where, in 1916, Elia Volpi had sold the contents of the Palazzo Davanzati. The sale was sponsored by New York's National Art Galleries, and the lot fetched only $9,125. The top price for a piece was $675. The wooden 'Simone Martini Annunciation' set was bought by an anonymous agent for $600. It is said that each successful bidder received an official document from the Italian government testifying that the work was 'a genuine fake'.[8] Ironically some of the more important pieces were sold to Italian dealers who brought them back to Rome.

Alfred Frankfurter, the respected art critic and editor of *Art News*, wrote the preface to the sale's catalogue and spoke of those who 'dishonestly capitalized Dossena's marvelous talents'. He found Dossena's sculpture of

absorbing interest not only for its beauty as a work of art, but also

for the imitative work which I have seen in which I have not been disturbed by an obvious intent to copy and deceive It is really this quality of sincerity in Dossena, the almost incredible ability of the man to have worked without affectation and without malevolence in the spirit of the dead past and its masters, which seems to me to make his work as valuable to the collector and museum, for artistic achievement as for scientific documentation.[9]

Alceo Dossena died four years later. His obituary in *The New York Times* on 12 October 1937 says that he suffered a stroke the previous night. Rumours in continental newspapers said he drank himself to death or 'had fretted his later years away on carousing with women'. Others suggested he had died of a broken heart, never able to accept the judgement of critics like Oscar Bie that 'the artist, Dossena does not appear'. Walter Lusetti confirms an element of the latter. He was depressed towards the end, but kept working on his pieces right up to the time of his stroke.

A week after its obituary *The New York Times* added the following touch: 'Those who profess to know best say that Dossena was never a party to the gigantic fraud. He lived and died a poor man, leaving only the treasures of the humble.' That account was later enlarged saying that Dossena had died penniless in a pauper's hospital, his funeral expenses borne by his parish church, and even the place of his burial remained a mystery.

The hospital was San Giacomo which did have many charity cases. By all accounts Dossena had little money when he died, but the family paid for his burial, and his burial place is no mystery. On my map, Walter Lusetti indicated the large cemetery of Campo Verano which is near Tiburtino. A large monument was erected by friends to mark the spot.

The Dossena affair was far from finished in 1937 – eighteen years later it would have its most sensational episode.

16

The Saint Louis (Missouri) Art Museum, as the successor to a gallery founded by Washington University in 1879, is the oldest museum of art west of the Mississippi. Its present building

flanked by a great statue of Saint Louis was the only perma-
nent structure of the Louisiana Purchase Exposition of 1904 –
the Saint Louis World's Fair of 'Meet Me in St Louis' fame.

Perry Townsend Rathbone became the director in 1940, and
returned to the post after his military service in 1945. During
his days a large number of important pieces came to Saint Louis
before he went to Boston as the new director in 1955. The one to
attract the most attention was purchased in December 1952 – a
47½-inch tall terracotta figure of 'Diana the Huntress' from the
Los Angeles dealer Adolph Loewi, for the price of $56,000.

'Diana' was in twenty-one fragments, and represented the
virgin goddess of the moon and the chase. She strode forward
accompanied by a fawn leaping at her side. Rathbone gave a
detailed description of her in the Winter 1953 issue of *Archae-
ology* magazine. In summary he said she was clad in a chiton, an
ivory-coloured undergarment, and a short tunic of earth-red.
Traces of a chequered border appeared at the throat, and the
garments were edged with an earth-red border. The hair, also
earth-red was in numerous curls and bound with an ivory and
red fillet. Little button earrings adorned her ears. In her left
hand was a bow, and with the right she gathered up the hems of
her garment. The fawn straddled a graceful *anthemion*, an
ornamentation giving additional support to the terracotta, and
well known in Etruscan art.[10]

Rathbone also gave the provenance for the piece:

> In modern times the Diana first saw the light in 1872 when she was
> excavated near Civita Castellana in the territory of Falisco north of
> Rome. Her discoverer was Count Francesco Mancinelli-Scotti, a
> landed aristocrat and amateur archaeologist of considerable re-
> nown. His interest in his amazing discovery, however, did not
> extend to having his prize properly put together or even cleaned.
> Nor did he have the sculpture published or exhibited. In her original
> condition she was sold by the heirs of the Count many years ago to a
> Swiss collector. From him the sculpture was acquired for St Louis.[11]

Saint Louis decided to have 'Diana''s pieces put together
again by Joseph Ternbach who had also restored a Greek
helmet in their collection in 1950. The museum insisted that
Ternbach 'avoid over-zealous restoration'. The twenty-one
fragments consisted of one major piece which was about 80 per

cent of the total figure; the head, arms, hands of 'Diana'; the head and front legs of the fawn; plus an assortment of bits of the goddess's clothing. The museum's catalogue identification for 'Diana' lists the restorations as threefold:

(1) Figure assembled on an armature; all breaks joined. (2) Permanent restorations: Base extended in a curve from remains of right side to toes of right foot, back to heel, and from there to remaining base. Inner edge of right heel completed. Holes filled at neck on both sides. Hair locks restored to give continuity over joints. (3) Removable restorations, attached by screws. Left hind leg of fawn, bow (front and back), quiver, with three removable arrows, tips of first three toes on left foot, filling of large hole at right shoulder, upper outer edge of left ear.[12]

To the delight of the museum, Ternbach had discovered the reason for the disfiguring hole in 'Diana's' back. It was a slot for the goddess's quiver for which he made a removable replica in terracotta as point (3) indicates.

'Diana' was now ready for display and this occurred in the autumn of 1953 accompanied by a fanfare of publicity. In September, *The Illustrated London News* presented her in full colour, and Rathbone was ecstatic about Saint Louis's coup: 'the statue is one of the most important revelations of the art of antiquity that has been made in the twentieth century'.[13] He compared his 'Diana' with the Metropolitan Museum's monumental terracotta warrior as the two 'best-preserved Etruscan sculptures in existence'. This was highly unfortunate as we will see.

The Christmas edition of *Art News* had 'Diana' in colour as well, but on the cover, and the comparison was far more impressive: 'Diana' was 'the most important Etruscan revelation since the discovery of the famous Apollo of Veii in 1916', which the Swiss expert Hans Muhlestein considered 'the only artistically worthy parallel known'.[14] The Apollo is the centrepiece of the Etruscan collection in Rome's Villa Giulia, and is an Etruscan terracotta of the sixth century BC. It was not long before 'Diana' was being viewed as his sculptural sister. The oldest museum west of the Mississippi had really arrived.

Another expert who enjoined the comparison of 'Diana' to the Met's terracotta warrior was Reinhard Herbig, former rector of

Heidelberg University and the then director of the German Archaeological Institute in Rome. His observations, in a lengthy and scholarly article in 1956, were welcomed by Saint Louis's new director, Charles Nagel, at a time when a barrage of rumours were suggesting 'Diana' was a fake. Herbig's discourse was translated and reprinted in the museum bulletin in 1958.

Referring to the 1872 story of discovery, Herbig says: 'I trust that it will not be believed that I swallowed hook, line and sinker, a romantic story which might have been deliberately manufactured to obscure the origin of the statue'. He goes on to note that 'in the present case there is a considerable group of affidavits of reputable persons of Italian origin whose trustworthiness there is no reason to question; these documents are, of course, available at any time, to any one interested'.

Herbig did not consider 'Diana' to be Etruscan, but rather 'Latian' (other precursors to the Romans), but she was undoubtedly genuine: 'I should really like to meet the forger who possesses such skill that he can smash up a complicated work and yet see to it every single fragment is completely believable. Not one single break is new and sharp; they all show the same equal, typical abrasion of the broken surfaces.' In conclusion, 'Diana' was 'a stepping stone toward the understanding of the history of antique art as the also once-suspected mighty terracotta figures of the armed warriors in New York'.[15]

Herbig's authentication was attacked by Massimo Pallotino, Professor of Etruscology at the University of Rome in *Archeologia Classica* the next year. There were other Italian grumblings, but American museums had become accustomed to the dissenting Italian views, and German archaeological expertise was considered far more impressive.

More important for the future of 'Diana' in Saint Louis was the publication in 1955 of a slim volume by the Roman publishers, De Luca Editore.

17

Alceo Dossena, Scultore by Walter Lusetti remained almost unnoticed both in Italy and America until the full implications of what it portrayed became apparent to those most stung by the Dossena affair. Writing in 1959, Sepp Schüller refers to it as 'an appreciation of that extraordinary artist . . . by his son',[16]

museums with whom Parsons was associated
any information concerning him. Two sugg
Thomas Hoving. Fortunately, like John Ma
kept several copies of his papers and today
survive in private collections in Rome. With
individuals who wish to remain anonymous
reconstruct a partial picture of the enigmatic F

One reason why many in the art establishm
talk about Parsons is that he managed to irr
important people. Irritate is a gross understate
cases as we will see. Thomas Hoving gives a bre
purchasing agent in *King of the Confessors*, and
what he says reconfirmed by others' opinions. F
Parsons as 'Like meeting in the flesh a gentler
right out of an elegant portrait of the turn
perhaps of John Singer Sargent . . . [he] tu
courtly, soft-spoken, witty – and charmingly d

Parsons was born in Boston in 1883, th
graduated from Harvard and went to Oxfor
went to Harvard and specialised in science, b
after graduating in 1904. He boasted to How
been 'a gentleman of leisure ever since I gr
bypasses his dependence on Warren. He als
had settled on Rome as a future home on a tr
mother in 1895: 'I remember being taken t
Janiculum hill within a day or two of my arriv
glorious impression of the auburn-and-gold
forth beneath me never left my mind or my he
life to art.'[21]

Hoving describes Parsons' 'first formal job'
he was 37 – the official art adviser in Europe f
Museum of Art. This relationship became pa
ficant when William Milliken, 'a friend . . . fro
of time', became director. Parsons did for
Warren and Marshall had done for Bosto
Parsons' official tenure for Cleveland is given
30 June 1941. Unofficially he continued to
Milliken's retirement in 1958. In *King of*
Parsons explained that his work for Clevelan
after the war: 'Why the official arrangemen
somewhat of an enigma. My dear friend Willi

and art historians like Pope-Hennessy take it to be the biography of Walter Lusetti.

And that is exactly what it was supposed to look like. Its appearance in Rome even coincided with an exhibition of Dossena's works, on 4–14 February 1956 at the Palazzo Marignoli. Even 'the author' thought the book was to honour his father and his works. A little exploration into the contents reveals quite a different intent.

Barely three pages – in Italian followed by an English translation – give Lusetti's biography. Despite the brevity and occasional melodrama it remains an accurate statement of biographical data on Dossena. The publisher's note goes along with the orchestration: 'We are most happy to be able to contribute to a better understanding of a sculptor, who, in his way, was an extraordinary artist . . . the present publication, intended as a homage to a man who was abused and vilified'.[17]

The dynamite was to be found in the fifty-one illustrations. Here is almost the total repertoire of Dossena: the Munich group; the Metropolitan's kore; Cleveland's 'Athena' and 'Pisano Madonna'; Miss Frick's marble 'Annunciation'; Boston's 'Mino' tomb – and the angels which were made by Dossena to flank it – the Fogg Museum's *Noli Me Tangere*; and an assortment of other works which were largely created by Dossena after his exposure. The adverb 'Formerly' preceded the name of only one museum in the list – Cleveland. That was clue enough that a certain person had something to do with the book.

Illustrations 7, 8 and 9 were of 'Diana', but no mention was given of the Saint Louis Museum. Here was 'Diana' roped together as she had appeared in Dossena's studio in the winter of 1936–7. These photographs themselves would later become a matter of controversy. But it took an even more explicit publication seven years later to convince Saint Louis to do a thermoluminescence dating test in 1968.

To this day, few know that Pico Cellini and Harold Parsons wrote the book, and the reason for its publication was to vindicate their views on 'Diana' and display the full extent of Dossena's creations. As will be intimated, there were also other motives involved, but no one can deny how clever the presentation was. The person most duped by the publication was Walter Lusetti. Naively he had cooperated with Cellini and Parsons by

supplying biographical data and a lar
from his own collection of his father's
he realises the full truth behind the b
myself to inform him when he proudl
book' in Rome.

18

Harold Woodbury Parsons continue
started by John Marshall regarding I
In later years, Parsons presented I
handedly unmasking Dossena, and
much of a relationship between Par
papers which survive. I found no mer
of the materials left in the Ashmole
there is nothing about Marshall in th
Parsons' hand. We know of Parson
mentionings in the Warren biograph
one notation of Warren in a letter fror
1948, where he speaks in passing of
Lewes House . . . a great friend of mir

As we have seen, little is said of
companion-secretary to Warren. W
seeming lack of communication betwe
concerning Dossena's 'Athena' which
Met, but immediately picked up by
Bernard Ashmole says 'Marshall con
have become virtually a dealer', ar
having been a falling out between th
was true of all Warren's 'replacement

Parsons often speaks of Bernard I
reference to Parsons in the several b
letters of Bernard and Mary Berensc
presents a remark BB made to friend
devil – here, there and everywher
Hoving, Parsons, when speaking of
riors, said they were bought 'throu
colleague Johnny Marshall here in R

Parsons emulated Marshall and eve
in the Palazzo Stroganoff at Via S

becoming a little crusty. Perhaps he wanted to make all the discoveries on his own. Perhaps he thought I was getting too old. At any rate, I was promptly retained by the William Rockhill Nelson Gallery in Kansas City and also by the Joslyn Memorial Museum in Omaha, Nebraska.'[22]

Actually Parsons' relationship with what is now the Nelson-Atkins Museum of Art began in 1930, and that with Joslyn somewhat later. The bulk of the Nelson collection was made within three years – 1930–3. Parsons was European adviser and two others worked on Oriental and American art. Thirty-six months later the gallery announced a collection 'in every way sound, in some lavish'. Parsons was prouder of what he did for Cleveland. In a letter to Milliken after the director had announced his retirement, he reminded his boss of 'the lush years of 1927–1953 when you and I could still make great acquisitions'. He went on to enumerate some of the treasures brought to Cleveland: a Filippo Lippi, El Greco's *Holy Family*, a Tintoretto *Madonna and Child*, medieval griffins, the Stroganoff ivory, the Assyrian slab and a canvas by Claude Monet.

According to Hoving, Parsons' agreement with Cleveland allowed him to place certain works of art elsewhere, and Parsons said he had found 'the pride of (the Met's) Greek and Roman department, the sleeping child in bronze, most certainly Hellenistic'. This was despite the fact that the Met's director, Francis Henry Taylor, viewed Parsons as 'a snob . . . superficial . . . probably devious, possibly not crooked, but shifty, weak, intellectually and morally flabby'.[23]

Up to the Second World War, Parsons had great success in collecting. There were traumas, however, and in a note of 21 November 1932 he says that the American minister in Morocco 'had just discovered to his horror that he had introduced me to a notorious crook, who was a fugitive from justice in England, and that lately he had robbed the firm of Harris in London of the sale of some tapestries entrusted to him'.[24]

Parsons certainly knew how to live, and his various letters carry letterheads from the best of hotels and yacht clubs all down the Italian coastline. He possessed a 'small' yacht, the *Saharet*, and as well as access to Palazzo Stroganoff in Rome, there was the Palazzo Moro-Lin in Venice. He sprinkled his letters with advice to Americans who were planning visits to Rome out of season: 'Never sit in drafts; wear thick socks and

underwear, heavy-soled shoes – remember marble floors are everywhere.' He recommended the restaurants Ranieri and I Tre Scalini and the Albergo del Orso where Dante and Montaigne had been guests. Parsons hated snobs but was one himself, and his letters are cluttered with name-dropping.

He had to leave Rome during the war, but returned in the spring of 1946 as soon as expatriates were allowed back. He found it a depressing place, and the art market was struggling with a scarcity of good works and a profusion of fakes. From the Porto di San Remo on 27 August 1947 he made a report to several museum directors as to conditions:

I've been appalled at the great scarcity of works of art, as well as the enormous number of forgeries of every kind, some frighteningly skilful; but the latter state of affairs depends, of course, on the former. Rich manufacturers and producers in Northern Italy, mostly Milan and Turin, have made incredible fortunes out of Italy's misery. They have plunged into art collecting, partly as 'safe' investment; partly for the love of possessing what the aristocracy used to own.

Parsons warned American museums of 'the sinister side of the situation' which was 'that many of the old picture restorers have turned forgers. They find it more profitable to create Old Masters than to restore them. I regard with suspicion almost any object which has not been known for 20 years or so. Old University professors caught between the anvil and hammer of high living costs and stationary salaries have turned to writing "expertises" which fall "thick as the leaves which strew the brooks of the Valambrosa".' Parsons loved this expression from Dante and used it excessively. He also warned that

Paintings are by no means the only objects being forged. There has been a run of 'Romanesque' bronzes fused from casts taken from reputable objects and patinated electrolytically. I saw one relief, and have the photo of six Apostles with inset eyes. It is said to have come from Dalmatia. It has evidently been fused from a cast taken off one of the cathedrals . . . Many of these bronzes have the expertises of Planiscig and others. One comes reluctantly to the conclusion that an eye can be lost with advancing years and with a desire, possibly rather subconsciously, to acquire fees.[25]

Soon after this in a note to Milliken, Parsons hopes the director will return to Italy, but warns

> it will sadden you to see so many false ivories, Limoges enamels, silver book-covers – even one was recommended to the Morgan Library! . . . I'm not terribly worried about forgeries, for I think that sooner or later they reveal themselves to the enquiring eye; and we certainly now have many lab tests which make their detection almost inevitable; but it is better to know the facts earlier than later. I guess that when the new collectors of Turin and Milan begin to unload, as I imagine some of them ultimately will, there will be some very *brutte sorprese* [ugly surprises]. Already one or two lawsuits have been initiated.

He reminds Milliken that 'No more early Italian sculpture will ever leave Italy; nor will any second C.M.A. [Cleveland] ever be assembled'. Italy was getting very much 'back to normal' in Parsons' estimation, and the American worries over the Italian Communists was excessive. 'Il popolo, always are content with bread, macaroni, vegetables, olive oil, and now and then a little meat.' He concluded what he termed 'the observations of Childe Harold in Italy' in typical Parsons' fashion: 'When I held the Princess Pallavioini's little Botticelli, that strange little panel of the outcast, on my knees in the Palazzo Rospigliosi in Rome, it seemed to symbolize the fate of Italy. You will make a great mistake if you do not come to refresh your soul with all the great things we used to see together by another year.'[26] I did not come across any other letters to Milliken or from him – until a bombshell from the director written on 3 May 1954.

19

My dear Harold,

I have been very much disturbed and may I say shocked by the way in which you have treated the matter of the kouros. Our first word that any one had raised a question of its authenticity came from a dealer in New York, Mr Paul Mallon, who stated that you questioned it very gravely in a letter to him. I also got word from another source that you had been talking quite widely about it. Why should you write to Mr Mallon, a dealer, or anyone else on a

matter which concerns us materially before you had laid the matter before us?

Then simultaneously I get a chatty letter from you with no mention of it, which, I regret to say, made me very angry . . . I cannot understand this lapse in one whom we have been honored to have associated with us . . . If you had written your suspicions to us immediately and kept quiet until you received our answer, you would have been helpful . . . You know yourself that certain objects which have come through your hands have been questioned. We have protected you at all times and have kept our mouths shut . . . I am profoundly disturbed as you can see and I am sorry after so many years association this blight has come upon it.[27]

I do not know anything about the kouros in question but this letter marks a break from which Parsons never fully recovered, and his life became increasingly obsessed with forgeries and a feeling that he was very much on his own. There are several drafts of responses that Parsons made to his old friend, but they all begin with: 'Your letter of 3 May rocked me back onto my heels in pained surprise, for I was intent – as always – on being of service to the museum and to you according to my lights. I'm sorry if I bungled . . .' Parsons goes on to suggest that a secretary may have failed to put proper postage on the letter to Milliken which went out the same day as that to Paul Mallon. He also speaks of 'other loyalties in life' – 'Papa' Hirsch and Mallon 'from whom CMA have had many of our greatest works of art'. Both Mallon and Hirsch 'have been friends for a quarter of a century. Both have let me be among the very first to see their newly acquired treasures'. Parsons tried to convince Milliken that his 'natural instinct was to run up a red light of warning to . . . the museum at the earliest possible moment'.[28]

It was a sad and weak reply, and also marked the beginning of a period of red light warnings from Parsons to others in the American art establishment. Their attitude to Parsons was similar to that expressed in one of the few letters from Milliken after 3 May 1954. When telling Harold that he would be retiring on 1 April 1958, he said: 'I think it only fair to tell you that some of your letters have disturbed me greatly. I have made it a point over several years not to answer those portions of your letters which have dealt with forgeries, or mentioned individuals as having bought them. I frankly wish to keep out of this, and most of your friends, I am afraid to say feel the same way.'[29]

Increasingly Parsons turned to two Italians who would remain his closest friends until his death in 1968 – Alessandro Brass and Pico Cellini. Alessandro was the son of Italico Brass who was born near the Yugoslav border – hence his rather Slavic surname. Italico married a Russian and settled in Venice. Both father and son were ardent Fascists, but by 1940 had become greatly disillusioned with Mussolini. Italico died four years later, but due to heavy inheritance taxes, little was left to his son. Alessandro became a successful lawyer and a connoisseur of art. Luckily for Parsons, who got to know Brass during his frequent trips to Venice, the collector sold various pieces to acquire a disintegrating abbey which he restored. Some of the objects were of major importance.

Brass was also a trustworthy contact for pieces appearing on the Italian art market – and so was Pico Cellini. The first reference I came across to Cellini in Parsons' papers was for 10 October 1948, not long after Parsons started warning American museums of the great proliferation of forgeries in post-war Italy. In *King of the Confessors*, Parsons speaks of Cellini as 'the find of his life'.[30] In an interview in 1986, Cellini described himself as 'one of the few surviving *conoscitori* . . . a breed in extinction'.[31] At 81, he remains one of the few surviving links to the world of Dossena.

Cellini is quick to relate that his grandfather, whose portrait hangs majestically in the sitting room of his flat at Via Monte Zebio, was Pope Pius IX's chief miniaturist, and his father, Giuseppe, for whom he was named, was a painter and a professor at the Fine Arts Academy in Rome. Pico is the youngest and only survivor of six children and, like Walter Lusetti, was his father's pet. His flat which is in a residential area north-east of the Vatican is a comfortable shrine to the Cellini family tradition of involvement in the arts. It contains an impressive collection of paintings and statuary.

Parsons knew both Giuseppe senior and junior, and his secretary in the Red Cross (which he served during the Second World War) was the daughter of a close friend of Cellini's father. In a set of notes from 1948 to 1949 Parsons told Milliken: 'I think we have in Cellini a very valuable source of correct information and reliable advice as regards all that occurs or emanates from Italy.' Not too subtly he added: 'Cellini is a man of very limited financial means, and supports a wife and

children, and his very aged mother (an Orsini) by his highly concentrated life of restoring, writing, and trafficking in the world of art, largely by telling dealers in Italy what is what.'[32]

Parsons went on to relate that Cellini 'knows all the forgers and their wiles and is hated by dealers like Jandolo and Barsanti for he says what he thinks and openly attacks their tripe or fakes'. That 'saying what he thinks' has continued unabated to this day, and in the 1986 interview he said that 'once when abroad, as a major transaction hung in the balance', he was offered 'the choice of a passage to Italy all in one piece, or in tomato-sauce cans'.[33]

In 1948, Cellini joined Parsons on a visit to America to see various museums and collections, and, according to Parsons, the tour left 'my few remaining hairs standing on end . . . The fakes he found! And most of them are still displayed, their curators and directors being too stupid to see the true light . . . The "harvest" of fake medieval pieces at Detroit was great; of Renaissance at the Metropolitan, even greater.'[34]

At tour's end in New York, in January 1949, Parsons wrote: 'How Cellini ever finds time for his studies and writing has always been a mystery to me – at least until he stayed with me here at close quarters. He works incessantly and burns much midnight oil.' When they returned to Italy, Parsons was increasingly influenced by Cellini, and attributes his conversion to Catholicism indirectly to Cellini. 'What a thing for a proper Bostonian to do,' he later told Hoving.[35] Parsons showed Hoving what had led to his conversion – an extraordinary sixth-century ikon of the Madonna now kept over the high altar of Santa Maria Nuova near the Roman Forum.

Cellini had discovered it under a far less interesting thirteenth-century painting. 'This divine image was the key reason I decided to convert . . . On a particular October morning Pico took me, Bernard Berenson, his secretary Mariano, K. Clark and Lady Clark to see the miracle he had brought to life . . . BB was mesmerized.'[36] And so was Parsons – the image remained an important talisman to the end of his life.

The year 1956 was a bad one for Parsons. In a letter to a friend on 12 June 1956, he wrote from a hospital that he was 'recuperating from a slight thrombosis which I suffered while at the Excelsior in Florence – a few days after I had a pleasant lunch with BB'. In the winter of the same year he relates in

King of the Confessors that he had suffered from 'a light heart attack'[37] and a letter to another friend on 12 November stated: 'Your delightful letter overtook me here in the Salvator Mundi Clinic where I was brought a fortnight ago suffering from bronchitis, which I neglected for some days and which produced a temporary state of mental confusion.'[38]

Cellini told me in Rome that Parsons attempted to take his life on two different occasions. The first was with a long needle in front of a mirror, but he did not get very far. The second attempt was far more serious and extremely dramatic. Parsons carefully orchestrated his departure. Seating himself in his favourite antique chair and with two large ornate vases at either side, he slit his wrists. As he later confided to Cellini, he became worried as he looked down and saw that the blood flowing into the vases would spill over and make a mess on his fine carpet, and he became hysterical. Parsons fainted, and in the meantime, the blood clotted. When he regained consciousness, he first called Clare Boothe Luce who was the American ambassador to Italy and a friend. She sent an ambulance over to Palazzo Stroganoff. Parsons next called Cellini.

While he was recuperating (and this must be the experience at Salvator Mundi) Cellini brought him a sliver of wood from his beloved Madonna. When Parsons died from a stroke in 1968, Cellini says that his right hand was found tightly clutched and when opened was found to contain the sliver.

20

It was also in 1956 that the Lusetti book was beginning to be noticed in the United States. At the same time, Cellini published some heavy criticism of Saint Louis's 'Diana', and there were two other objects in the museum he maintained were forgeries: 'a curious contraption which purports to be an archaic Greek helmet', and an Assyrian ivory relief. Cellini followed Professor Pallotino's earlier line of arguments against 'Diana', but his style of attack was abrasive.[39] Parsons commented on the *Paragone* article: 'I could have wished that Pico's article ... had been less personal in tone, but he is an uncompromising person. It has certainly produced an extraordinary effect here.'[40] Apparently a lavish and expensive book

on Etruscan art sponsored by German archaeologists, which presented 'Diana' as the *pièce de résistance*, had to be withdrawn from publication at the last minute.

Cellini maintains the sale of 'Diana' to the Saint Louis Museum was pretty much a set-up. A dealer in California who was a Venetian Jew, who had fled from Italy during the war, was the American contact for Italian dealers handling the statue. The outrageous provenance of the 1872 'discovery' by Count Mancinelli-Scotti was carefully contrived and endorsed by several experts, and Dossena's 'Diana' passed through what Parsons liked to call Rome's 'nether world art market'. Later Parsons was more explicit about 'Diana's' 'ignominious departure from Italy': 'A passport was granted by the government's art export office of Bologna in the following terms, entered on the register of that office by the officials of the Fine Arts Department – "Modern forgery in the style of the ancient Etruscan sculptures of Veii. Declared value L.80,000." That is approximately $125.'[41] Saint Louis bought her for $56,000 which was its fourth highest purchase price ever after works by Rembrandt, Holbein and Pieter de Hooch.

Both Cellini and Parsons received threats from the dealers who had master-minded the sale. The police were going to be informed that they were dealing in forgeries. In a letter to Milliken on 18 October 1956, Parsons speaks of 'this present unpleasantness which I have probably brought upon myself in trying to put on record those subtle forgeries of Dossena'. He also relates that the dealers were able to carry through a few of their threats. Parsons' 'little yacht' was seized by the authorities and he was 'imputed with having smuggled a golden bull – presumably life-size – out of the country. The case was quashed at once; but it only goes to show how strange the Italian law really is'.[42]

Parsons could not resist adding: 'The smartest thing we ever did, Guglielmo mio [my William] was to move swiftly in the Athena and Pisano matters and protect the museum. What a pity that the BFA [Boston] and Helen Frick, and the Met would not follow suit – although I pleaded with them to do so.'[43]

Art News (February 1962) featured Harold Parsons' last and most ambitious attempt to expose Italian forgery. The piece was also an angry swan song to all those directors and curators who had not paid attention to his former warnings. In the

article Parsons also takes the lion's share of credit for exposing Dossena: 'it was reserved for the present writer to discover the factual evidence ... with the colossal output of Alceo Dossena'.[44] Marshall's name never appears, but Cellini is featured prominently. As a trump-card Parsons released a photograph of 'Diana' which had been taken in Dossena's studio after the forger had smashed the statue in the winter of 1936–7, and then roped it together again. Walter Lusetti had given the picture to Parsons at the time the collection for the 1955 book was being made. It had been taken with the same old studio camera which Dossena had used as far back as 1918. Unfortunately it was a double exposure, and would later be referred to as a 'photographic trick' by some observers. To the side of 'Diana' was another Dossena fake, one Parsons also knew well – a terracotta gorgon antefix which Parsons sent to the Nelson Gallery as a study of a forgery. It is remarkably similar to a genuine Etruscan antefix in the Villa Giulia.

This time Saint Louis reacted strongly. In a letter to the editor of *Art News*, the director, Charles Nagel, said he had read the article 'with interest, if not complete detachment'. And then he took on Parsons: 'Mr Parsons is a man of considerable artistic discernment but he is – or was – also a dealer. As such his opinion of objects acquired by institutions from sources other than himself is somewhat suspect. One is familiar with the intense rivalries of the dealer world.'

Nagel maintained that Parsons stated 'as bald fact opinions which are still debatable', and that the museum was 'aware that there were differences of opinion among scholars about some of its objects'. He observed that 'It is remarkable Mr Alfredo [sic] Dossena was so hopelessly inept with his camera ... one of the easiest things in the world to falsify is a photograph.' Nagel admitted, however, that 'these photographs and more have been in the Museum's archives for several years'. In parting Nagel also took a shot at Lusetti as well: 'One can feel little but pity for Walter Lusetti trying to build up the reputation of a forger father by attributing to him some first-rate works of art.'[45] The real pity was that Nagel did not know the truth about the 1955 book.

Art News allowed Parsons to comment, and he just hints at the real genesis of the book: 'The photographs mentioned by Mr Nagel were given to me in part by the elder Dossena at the time

of the 1928 denouement, others by his son at the time we published the book referred to.' Elsewhere Parsons said: 'Since the publication of the little book on Dossena's works, I do not know of any archaeologist of standing, on either side of the Atlantic, who still believes the Diana to be ancient. It is sad that Mr Nagel cannot read the evidence of the poor little photographs made so many years ago, with a wretched little old studio camera, by Dossena as a personal *ricordo* of his creations.'[46]

21

Very little transpired concerning 'Diana' as a result of Parsons' *Art News* article. He died six years later, and I have found absolutely nothing about his last years. Even Cellini is curiously vague about this period. The year Parsons died, Saint Louis sent samples of 'Diana' to two laboratories for the moluminescence testing – the University of Pennsylvania and the Research Laboratory for Archaeology at Oxford. Apparently Saint Louis was not pleased with the date given by Pennsylvania and supplied larger and larger samples in the hope of a better result.

The Oxford lab was a pioneer in thermoluminescence testing, and its first major test was on 'Diana'. The 'Timewatch' team filmed there and Mrs Doreen Stoneham was extremely co-operative. She has earned an excellent reputation in the field and her best client is Christie's where 40 per cent of the items she tests turn out to be fakes. Mrs Stoneham ran a mock test for the cameras, and the atmosphere in the dim red light was almost Heath Robinson. Holes were made in the samples with what looked like a dentist's drill. The powder obtained from the drilling was placed in an aluminium disc and then heated in a light-proof box. As the powder sample heated up, it gave off light – the more light, the older the sample. The crystals in terracotta store light generated by internal radioactivity, and when the crystallised powder was heated the light was released. Clay baked in ancient times would send the instrument needle shooting up the scale, whereas a piece made in 1936 – as with 'Diana' – would hardly move the needle at all. 'Diana' was dated to forty years which, given the usual leeway allowed, fitted the Dossena circumstances very well.

Dossena had created a large number of pieces in terracotta which made them easy to detect, but an even greater number were made of marble. These works – like others in marble – are difficult to date by scientific testing. Detecting marble fakes depends largely on what Bernard Ashmole has said is 'an almost laughably simple method, the method of surface-examination'.[47] The surface is all important with marble sculpture, and 'not the smallest area must be left unexamined, for that minute point may contain the vital clue'. Unfortunately for the museums involved, Dossena's patina was so extraordinary that the surface examination had to rely even more heavily on expert knowledge of stylistic considerations. That is why a number of Dossena's marble creations have gone undetected to this day.

22

To its credit the Saint Louis Museum was extremely helpful in the filming of 'Timewatch'. I am not certain that they knew exactly what we had in mind, but we all ended up liking the museum and its general attitude. During the three days we were in Saint Louis, I visited the museum on several occasions and, as a teacher, greatly admired the way it promoted itself as an educational institution. I watched several classes being taken round various exhibits at hours when the general public was not admitted – which makes for more sense for those involved.

Saint Louis's present attitude towards what would have been a major attraction in the museum is also fairly enlightened. No other American museum was more generous in reply – even regarding catalogue identification data that is usually unavailable from any museum. Sydney M. Goldstein, Associate Director of the museum, was given the task of dealing with the BBC, and all was prepared to the last detail. It took three men to lift the 'Diana' – which indicates there is more to less than 4 feet of terracotta than meets the eye. She was placed in a basement studio for the filming and we had to pass through an unreal security system for the set-up. I kept noticing signs saying 'Security D area – Call security before entering' – it was just like a military operation.

Before the filming I managed to look around the area and was fascinated by the sheer number of treasures in storage – huge amounts of silver, a number of archaic fragments here and there, and oddest of all, Victorian furniture.

Goldstein was far more candid off screen than on. In our preparatory session before filming 'Diana', I mentioned the Parsons' *Art News* article and I noticed he had it with him the next day. During the film Goldstein said he had always assumed the piece was a fake, but had heard from colleagues that that might not be the case. This was the beginning of an orchestration of which I would hear more later. In hindsight it all smells of 'now this is what we will tell the BBC'.

Earlier Goldstein and I had discussed some obvious problems with 'Diana', but on camera most of those were attributed to Joseph Ternbach's restoration. Goldstein mentioned that he was wary of 'Diana's' size and its surface appeared dull. 'Boston' had suggested that 'Diana' might have been 'a votive goddess', and the problems with the cracks on the surface might be due to painting done during restoration. According to Goldstein, 'Diana' had been 'heavily restored', but as we have noted this is not what the official notes in the catalogue identification indicate. Even more serious was the notion presented that the thermoluminescence test might have been invalidated if the samples used were from Ternbach's restoration. In the first place, I find it hard to believe there would be any doubt as to where the samples came from, and laboratory technicians would certainly avoid samples from questionable areas. Anyway, if 'restoration samples' were used the date produced would scarcely be forty years as the restoration occurred in 1953 – the needle would not have moved at all!

At least I was prepared for some of what we would next hear at Christie's in New York. When Perry Rathbone left the directorship at Boston, in 1972, he went on to be a Vice President and Director of Christie's. Rathbone had been alerted that we were coming to film, but when we arrived he appeared surprised by the filming equipment. It took several agonising moments to get him to agree. I assured him 'Timewatch' was nothing like American television's '60 Minutes' where those interviewed are hauled over the coals.

When he was reassured that our major concern was Dossena and his creations, and that we had just been to Saint Louis, he

said something about 'all these attempts to make a hero out of Dossena . . . He was a crook!' The interview which appeared on television was a considerably abbreviated form of what turned out to be a deluge from Rathbone. When I eventually listened to the full tape, which was well after I had completed my research on Marshall, Warren, and Parsons, I could not believe my ears. On 6 November 1986, Rathbone had hinted at what took me two months to piece together. What follows is pretty much verbatim, but repetitions of other material have been deleted.

My opening question was: 'Mr Rathbone, after all these years, what would you say your feelings are now about the Saint Louis "Diana"?'

Rathbone gave pretty much the same line as that of Goldstein. 'I think there's a real possibility that one day it may be accepted as perfectly genuine.' He went on to list the 'scholarly experts who believe so and who encourage me to think so'. The experts – all German, of course – were those who had 'authenticated' 'Diana' back in the 1950s. They 'know more about those things than those who attacked it'.

'Who were they?'

'Harold W. Parsons . . .' Rathbone paused, and added . . . 'whose reputation was not totally savory, and not known for his veracity.' We were off and running. 'The same goes for his henchman, an Italian called Pico Cellini.'

I asked what they had against 'Diana'. 'Parsons was hip on Dossena.' Rathbone dropped his voice at this point, and it is not easy to make out his exact words, but he said something about after discovering that the Cleveland 'Athena' was by Dossena, 'he went on a witch-hunt . . . Parsons did not like the dealer who sold 'Diana' to Saint Louis – Adolph Loewi. He was lined up to be shot down . . . He [Parsons] also had a nemesis in the person of John Marshall.'

I managed, 'How's that?'

'For some personal reason Parsons resented him. [He] had been successful selling works of art to the Metropolitan and Boston.' Again Rathbone dropped his voice. 'There were others . . . part of Perry Warren's group at Lewes . . . but, of course, you know all this background.'

I wish I did at the time. Rathbone knew I was researching the Marshall–Warren papers, so must have assumed I had come

across Parsons – and quite a bit more.

I asked why Parsons might have had it in for Marshall, and Rathbone said he did not know. 'It was a hostile attitude for personal reasons . . . They [Parsons and Cellini] didn't mind destroying reputations – like Gisela Richter – to advance the fortunes of Mr Parsons and to destroy the reputation of Mr Marshall . . .'

I received a glare from the producer that we were getting off the subject of 'Diana', so I got back to her. Rathbone continued: 'I was, therefore, suspect when all these attacks started coming.' Rathbone was at Boston when the Lusetti book and Parsons' *Art News* article were published, and he gave the impression he viewed both as personal attacks. Rathbone also added: 'With further study, fresh evidence . . . "Diana" would be vindicated. But it would not be easy. Once a woman's honor has been questioned, it is hard to have it re-established.'

Rathbone returned to the restoration issue, and was stronger than Goldstein in suggesting that Ternbach had 'just about remade the thing'. I mentioned the photographs in the Lusetti book, and *Art News*, and they were dismissed as 'a Parsons–Cellini trick'. Rathbone also got in a parting shot at Italians: 'It's hard to rely on what Italians will tell you. I find it better to rely on German scholarship.'[48]

It is difficult for the outside observer to accept that Rathbone and others could really believe that 'fresh new evidence' will see that the 47½-inch terracotta, with its absurd galloping fawn, will one day be reclassified as an ancient piece. Placing the blame at Ternbach's door is both passing the buck and overlooking what Saint Louis has previously said about his efforts.

We can have empathy with Perry Rathbone, however, in another respect. He thought he was bringing a truly remarkable sculpture to Saint Louis, and the set-up by dealers selling it was despicable. The 1955 book was indeed 'a Parsons–Cellini trick' – and a very clever one at that. Surely another method could have been found for dealing with the matter. Rathbone has good reason to feel that he and his museum were tricked – but, as previously noted, even more so should Walter Lusetti.

The deeper the Dossena forgery scandals are plumbed, the clearer is the importance of the curious backdrop established at Lewes House so many years ago. The connections of Warren–

Marshall–Parsons go far and offer a bizarre subplot to much of modern Italian forgery. There is yet another affair in which Marshall and Parsons were involved, and the eventual revelation of that forgery tarnished the memory of John Marshall and some of his associates irrevocably – apparently to the delight of the enigmatic Harold Parsons.

PART FOUR

The Italian Connection

23

In his *Art News* article, Harold Parsons began his survey of 'The Art of Fake Etruscan Art' with what he termed 'the most audacious art forgeries ever perpetuated'[1] – the Metropolitan's terracotta warriors. The two most responsible for those purchases were John Marshall and Gisela Richter. Neither are mentioned by Parsons who nurtures the impression that he was largely responsible for their unmasking a year earlier.

Parsons minced no words in describing the 4½-foot colossal head, the 6½-foot old warrior, and the 8-foot colossal warrior: 'these pretentious, flaccid warriors are incapable of standing on their own legs without the disturbing aid of modern brass stanchions'. The creators had eliminated the usual palmatiform as an architectonic support which is essential for any large undraped terracotta figure. 'Their proportions are inharmonious, their ferocious gestures static, their faces but deathlike masks. They could not possibly roll their eyeballs or unstick their frozen lips or flex a muscle; they are lifeless.'[2]

Gisela Richter had introduced her 1937 monograph on the warriors by alluding to the discovery of the *Apollo of Veii* in 1916, and it was no accident that Parsons told the admirers of the Met's pieces (there were still a few even after the exposure) to 'make a pilgrimage to Rome and stand before the Etruscan Apollo . . . in the Villa Giulia . . . This Apollo is alive with tense energy and has convincing structure beneath his skin. His lips part, his nostrils distend, his eyes roll, his hair lifts with the breeze. This is genuine Etruscan sculpture.'[3]

As with Dossena, Parsons insisted he knew the truth of the Etruscan warriors long before anyone else, and had informed the director of the Met, James Rorimer, on many occasions of his doubts. In *King of the Confessors* he told Hoving: 'Jimsie [Rorimer] hates me because I am trying to tell him and his curators of Greek and Roman Art that the Etruscan warriors . . . are fakes.'[4] Dietrich von Bothmer appears to confirm Parsons' early alarm in the Met's comprehensive inquiry into the forgeries in 1961: 'Harold W. Parsons first expressed his doubts in the early forties.'[5]

Probably the most irritating aspect of Parsons' attempts to

dominate the limelight when the Met announced the warriors were fakes was his interview with *Time* magazine on 24 February 1961. Whereas *Newsweek*'s story is a straightforward museum story; *Time* pictures Parsons, who was then 78, with a model of one of the forgeries. There is no doubt as to who was the star.

Parsons told *Time* his investigation had begun two years earlier, and described himself as having retired from active dealing in art. He began to talk to other dealers in Rome about the warriors. 'There are no secrets in Rome. It's the most gossipy city in the world.' Parsons kept hearing the name of Alfredo Fioravanti. He was the same age as Parsons, and was 'eking out a living as a repairman of antiques and jewelry'.[6] Parsons tracked him down, and it was not long before Fioravanti told him the story of how he and two others had created the Met's warriors many years ago.

24

The story of Italian forgery is an old one. In 1974, Sir John Pope-Hennessy wrote a definitive study of the forging of Italian Renaissance sculpture, and concluded it by asserting: 'from a broader standpoint dubiety is an unhealthy state, and I believe that it will be dispelled only if we adopt the view that I have advocated here, that the history of forgery is part of the history of Italian sculpture'.[7] One curator commented off camera during our 'Timewatch' filming: 'Let's face it. No one in the history of art forgery has done it as well as the Italians.'

The antecedents for 'doing it well' go far back and involved the highest register of art mastery. In 1967, *The Washington Post* presented a survey of art forgery under the title: 'That Kid Michelangelo Set a Bad Example'. Actually the example had been set for Italians centuries before 'that kid'. There were forgers in the Italian peninsula before Hadrian, but we find the first great proliferation during his reign. The emperor himself led the growing imperial obsession with anything Greek. With his Greek-style beard and favourite youth, Antinous, Hadrian restored Athens to its ancient glory, and pursued a policy of recapturing the perfection and beauty of classical Greece in Rome. The upper classes imitated him by sending their sons to

Greece for cultural polishing and decorating their villas with any works of Greek art they could lay their hands on. It was not long before a class of 'forgers' made this very easy for them. Copies of Greek masters abounded, many of the finest fill prized collections in museums today.

When classical art came back into fashion during the Renaissance, the forger's art had a rebirth as well. Its best known practitioner was Michelangelo. Giorgio Vasari records examples of well-known artists creating in the ancient manner. The young Michelangelo produced a perfect copy of an early Greek statue, *Cupid Asleep*. When Lorenzo di Pierfrancesco de' Medici saw it, he told the sculptor: 'If you arrange to make it look as if it had been buried under earth, I will send it to Rome and it will pass as an antique, and you'll sell it much more easily.'

Michelangelo complied, adding the final touch of 'antiquing'; his method was a temporary burial in moist earth. An early biography (1553) by Ascanio Condivi, continues the story:

> Then it was sent to Rome. The Cardinal di San Giorgio bought it as an antique for 200 ducats, although the man who took so much money wrote to Florence that Michelangelo should receive 30 ducats, such being what he had received for the Cupid, deceiving both Lorenzo di Pierfrancesco and Michelangelo.

Michelangelo later discovered he had been underpaid and went to the Cardinal in Rome and recovered his fake.[8]

The story has a modern ring and we are reminded of Dossena's youthful trick with his statue of Venus. By Michelangelo's time, we have all the ingredients seen in modern cases of forgery: the desire to emulate past masters, and the perfecting of forging techniques; the unscrupulous art dealers, and the willing buyer.

25

In 1860, two Etruscan sarcophagi were found at the Etruscan site of Cerveteri, twenty-two miles north-west of Rome. The tombs were in a seemingly hopeless number of pieces. The job of

putting them together was given to the brothers Pietro and Enrico Pinelli, who came from a family of stonemasons. They succeeded very well. One tomb went to the Villa Giulia museum; another to the Louvre, where Enrico later worked as a restorer. There he repaired much of the *maiolica* of the Campana collection. These pieces had been acquired by Napoleon III in 1861, and contained not a few forgeries and doubtful objects.

Before the work at the Louvre, Enrico and Pietro, flushed with success, wondered that if they could repair an Etruscan tomb so convincingly, could they perhaps create one from scratch? Their effort was completed in 1873 and it was sold to the British Museum by Domenico Fuschini, a successful dealer in reconstructed vases in Orvieto, and Alessandro Castellani of Rome who had purchased it from Pietro. It came to be known as the Castellani Tomb, and was soon the most popular Etruscan sculpture in the world.

For sixty years (until 1936) the sarcophagus was viewed as the masterpiece of Etruscan art. The story of its creation surfaced only when Enrico Pinelli boasted to the archaeologist, Salomon Reinach, that he and his brother had made the pride of the British Museum. He related that they had buried it at Cerveteri, and were around to see it later 'excavated'.

When the tomb is viewed today in the magazines of the British Museum, it has to be remembered how little was known about Etruscan art when the Pinellis created it. Many today see it as ridiculous, and it is easy to refer to the nude male figure's head as 'shaped much like that of an Easter Island tiki', and the pointing gesture of his spouse 'in a gesture more appropriate to a Bali dancer'.[9] Harold Parsons said they were 'ludicrous' – 'life-size connubial figures . . . in animated conversation . . . the spouse in a strange garment with ample sleeves and bulging pantaloons.'[10]

At the risk of sounding like Parsons, if you have viewed the extraordinary Etruscan sarcophagus at the Villa Giulia across from the *Apollo of Veii*, you would think the Pinelli creation a cartoon production. I was shown the Pinelli tomb in November 1986, and was most struck by the Popeye-the-Sailor feet and hands for both figures. The once celebrated exhibit is now in the extensive storerooms of the British Museum surrounded by an eerie host of statues and busts. One of the latter is another famous fake – a bust of Julius Caesar which once was so

influential that it appeared as the definitive likeness of Caesar in schoolboy texts.

Otto Kurz notes features regarding the tomb which have been overlooked today: 'The whole monument is so impressive that misgivings are overruled . . . The reliefs on the sarcophagus are remarkable imitations of archaic art. The inscription is copied from an Etruscan brooch in the Louvre, a fact thinly disguised by the omission of part of the letters.'[11]

Fuschini recognised that he was on to a good thing with the Pinellis, but apparently after the affair of the tomb, they appear to have fallen out. Fuschini discovered two other brothers, Pio and Alfonso Riccardi, who agreed to work for him. The major work was reconstructing old ceramic pieces. *Maiolica*, the glazed and richly coloured Renaissance pottery, appeared in great quantities in the long-abandoned wells and cemeteries of Orvieto.

The Riccardi brothers and their sons, Riccardo, Amedeo, Gino, Fausto, Teodoro, and Virgilio Angelino, had left their ancestral home near Assisi and set up a workshop in Rome. Fuschini persuaded the large family to move to Orvieto to be near the scene of the excavations. Orvieto is an extraordinary town built on a high bastion of reddish volcanic rock, and stands on the site of the ancient Etruscan stronghold of Volsinii. The Etruscans made good use of its rich clays in their pottery and other terracotta pieces, some of which were quite impressive. Pliny recorded, in 509 BC, that an Etruscan sculptor named Vulca had been ordered to Rome to create a clay statue of Jupiter for the temple on the Capitoline Hill. The colossal scale of Etruscan statues became legendary, and Rome was accused of taking the city of Volsini to seize its 2,000 statues. Archaeologists have always expected to find important artefacts in and around Orvieto, and Fuschini with his new workforce did not disappoint them.

The first known Riccardi concoction to make its way into a museum was a Roman biga, a bronze two-horse chariot which joined the Pinelli tomb at the British Museum in 1912. It was said to have been discovered in the vicinity of Prodo on the road leading from Orvieto to Todi. The British Museum was told that Pio Riccardi had restored the chariot, and Fuschini was the dealer for the piece. This information rested unnoticed until January 1961 when its significance as a link to the Metropolitan's warriors became apparent.[12]

Pio died the year the British Museum announced its acquisition of the biga, and his son, Riccardo, with his nephews Teodoro and Virgilio, turned their energies to greater things. Riccardo assumed his father's role as leader, and came to rely more and more on his boyhood friend, Alfredo Fioravanti, who was but a few months younger than himself. Fioravanti had been apprenticed as a tailor, but was far more interested in art, and Riccardo. The two became life-long lovers, and later served in the same army regiment. Apparently Riccardo was bisexual, and enjoyed impressing Alfredo with tales of conquest with the opposite sex.

Pio and Alfonso Riccardi had recognised early on that there was a good market in producing terracotta pieces, which to this day are sold in Orvieto as genuine reproductions. They specialised in *maiolica* and revetment plaques, but they were sold as 'ancient finds'. The Riccardis learned to consult records in the archaeological museum at Orvieto, and it was not long before museums took an interest in their new discoveries. A large number of plaques appeared at the National Museum in Copenhagen in 1910, and seven were purchased by John Marshall for the Metropolitan.

The Danish pieces had been acquired by the Roman dealers, Ugo and Elio Jandolo, who had acquired them from Pietro Stettiner. Danes from another museum in Copenhagen, the Ny Carlsberg Glyptotek – purchasing agent Wolfgang Helbig and museum founder Carl Jacobsen – bought major items of Riccardi art from Stettiner. Warren had dealt with the latter over the possible Ludovisi sale, and Helbig was a great friend of both Warren and Marshall. He was a bit of a dandy, and in a letter to Warren on 1 November 1892, regarding the sale of a large Russian collection being negotiated in Rome, Marshall relates how Helbig decked himself out with 'silk hat and new gloves' to have breakfast at the Russian Embassy.[13]

Stettiner's dealings in art still remain shadowy, but he was later identified as a high official of the Italian post office, and was well known for a 1911 book on Roman monuments. According to his diary, Marshall first met him on 24 October 1913 at the Stettiner residence in the Via del Boschetto. That day Marshall noted his doubts about a bust of a goddess which he was shown, but according to Dietrich von Bothmer's

account, he went on to buy 'fifteen objects from Mr Stettiner between 1914 and 1920'.[14]

A series of terracotta slabs with sea monsters, dolphins, and scallops were purchased in 1914. They were said to come from the Etruscan centre of Cerveteri. As with the British Museum information on their Roman biga, the plaques were an over-looked clue which led back to the Riccardi workshop, and it was not until after the Metropolitan was certain of Stettiner's involvement with the Riccardis that the museum tested them. According to von Bothmer: 'It did not take long to unmask them as forgeries. The mistake in the details of the dolphins [equipped with extra fins] and the poor rendering of the crests of the sea monsters . . . came under the heading of stylistic grounds, but the more revealing . . . arguments were produced by an examination of the technique. It was discovered that several of these plaques had been broken *before* firing.'[15] Spectrographic analysis of the paint revealed that manganese and zinc were used as colouring agents, and these were only employed in modern times. If this test had been carried out much earlier, the Met might have spared itself a great deal of embarrassment.

Another early warning is found in notes from Harold Parsons, writing in 1948 where he speaks of 'looking through my files of suspected pieces' and coming across some old photographs of ivories owned by one of Warren's heirs. 'I recall that he purchased these objects for his own private collection in Italy about 1910. They were promptly condemned by the authorities at the Victoria and Albert. They came from Teodoro Riccardi of Orvieto through whose hands, and *from* whose hands many false ivories, enamels, and terracottas emanated.'[16]

26

I first saw the Met's Etruscan warriors in 1958 when I was a student at Union Theological Seminary. I remember them as star attractions in a gallery almost entirely given over to them, and also recall how school children were delighted to see so much male genitalia on open view. The next time I saw them was in August 1986 in the magazines of the Met. The colossal

head and old warrior were in a cage-like closet, but the colossal warrior was behind some official's desk, and could not be missed by anyone who ventured into the basement.

As with the Pinelli sarcophagus, it is difficult today to believe that anyone was taken in by them – to my eye the warriors are far more outrageous than the British Museum's tomb. And they have not aged well. They are cracking and fading more quickly than their supposed contemporaries in other Etruscan collections. It is difficult to accept that John Marshall, with such an exacting eye for detail, and otherwise impeccable skill at detecting forgery, could have made those purchases in 1915, 1916 and 1921. One can see why someone with a grudge or two against Marshall, like Harold Parsons, would never let the world forget this.

Riccardo Riccardi and Alfredo Fioravanti decided before the outbreak of the Great War that everything was right to launch into the big time, and their first effort was a thin, old warrior in terracotta. No model is actually known for the piece, but it has been suggested that they used a photograph of the lanky male nude of the Pinelli tomb, which would make their creation a forgery based on a forgery. The British Museum tomb had yet to fall from grace. It became known as the 'old warrior' because of his white beard, and with his plumed helmet and left foot in a great stride, he is the least objectionable of the three. Iris C. Love, now a respected Greek art expert, thought so back in 1955 when she contended in her B.A. thesis at Smith College that the old warrior was genuine, but the other two pieces were fakes.[17]

Fioravanti said the old warrior and the colossal head were finished before he and Riccardo went into the army together. They were made and fired at the Riccardi workshop in Orvieto. Though otherwise intact, the old warrior has no right arm, and the interior of his trunk is so thin in places that a crack soon developed after it came to New York. Fioravanti later explained that he and Riccardo could not agree on the position of the arm, and so their solution was to break it off. Fioravanti warned Riccardo that too much clay had been scraped away in modelling the figure, and he was right as the thin walls showed.

Despite the imperfections, Marshall was ecstatic about the warrior in a letter to Gisela Richter on 14 November 1915: 'One thing I have arranged for, if a permesso for it can be obtained. It

will make you groan to hear of it: the biggest T.C. [terracotta] you or any reasonable being ever saw.'[18]

The warrior arrived in twenty fragments on February 1916 in the middle of the war. German U-boats were active in the Atlantic, but, as with other treasures Marshall shipped, he must have felt they were safer on the high seas than in Italy. Richter notified Marshall: 'The Etruscan terracotta statue has arrived safely, and is at present being put together. I think it is quite exciting and will be one of the most dramatic things in the museum.' She ended her letter with a note she would return to again and again: 'Do you know anything of its provenance?'[19]

Edward Warren answered for Marshall: 'Please delay publication of large terracotta.'[20] Before going into the army, Fioravanti and Riccardi had also completed a large head. Pliny's description of Jupiter in the Roman temple indicate it might have been 25 feet high, and perhaps that might have been the inspiration for a 4½-foot head.

Communications between Marshall and the Met say little about the head. On 25 July 1916, the sculpture arrived in 178 fragments placed in four cases, and repair work began immediately. It was completed in October, and the Met's director, Edward Robinson, cabled Marshall in January 1917: 'When may terracottas be exhibited and published?' Again Marshall and Warren advised: 'Publication must be delayed, exhibition undesirable.'[21] In the meantime, the museum was heartened by Charles F. Binns' analysis of a fragment of the head. Binns was director of the New York State School of clay-working and ceramics at Alfred University, and he saw nothing wrong with the piece. He maintained, however, that the firing of the terracotta must have been maintained at a continuously diminishing temperature for several months so that the head could cool slowly. Only later would the incredible truth about the firing be revealed.

As the war accelerated, Marshall found it increasingly difficult to maintain contact with the museum. In 1917, he received permission from the Italian authorities to go to England for the sale of the celebrated Hope collection at Christie's. While in London, Marshall posted Robinson a twenty-two page letter about the old warrior and colossal head. As with other communications, several drafts remain. Often Marshall agonised over the phrasing of one sentence four or five

times. He reported the head had been found at Boccaporco, just off the main road from Orvieto to Bolsena, and the excavators had reported that they also found large tiles coming from what was supposed to be a huge temple. They fired Marshall's imagination with visions of discovering terracotta figures corresponding to Pliny's dimensions.

There was a snag, however. Local farmers demanded that the site had to be covered up and sown with wheat. Nothing could be done until the harvest was completed. This was a clever delaying tactic and Marshall, still unaware of any chicanery, wrote to Robinson: 'This business has occupied most of my time.' But he also reminded his employer: 'At any rate the head is pure Ionic work . . . I can find nothing approaching it in importance . . . The discovery of your head simply demolishes whole volumes of Paio's *History of Rome*.'[22]

27

Immediately after the armistice of November 1918, Fioravanti and Riccardi embarked on what would be their last joint effort – the colossal warrior. It was a logical combination of the old warrior and the head – a great Etruscan god of war. The inspiration for this piece was quite clear – a photograph of a genuine bronze warrior barely 5 inches in height which can be seen in the Berlin State Museum. The new statue was made in a small room on the ground floor of a rented house in the Via dei Magoni in Orvieto. During the winter Riccardo Riccardi (though an expert horseman) was thrown from his horse and killed instantly. This was a devastating blow to Fioravanti, and the completion of the new warrior left him alone to deal with Riccardo's less able cousins, Teodoro and Virgilio. Their efforts together ended in a disagreement.

One story has it that Teodoro posed for the big warrior, but that the statue's privates (the figure is naked from crotch to thigh) were those of Riccardo. Before the 1961 unmasking, gossip in Rome said that any number of young women already knew the warrior was of modern origin as they recognised the privates as those of the great lover Riccardo.

Alfred Frankfurter in an *Art News* editorial, in 1961, added 'an historical footnote' to the Italian gossip:

Among the shards and fragments from which the Met reassembled the statues, there was also included – in keeping with the never satisfactory explained imagery of the Etruscans, who represented their warriors half-armored and half-nude – a phallus of the same black-glazed terracotta and in the same over-life-size scale, which precisely fits the fighting warrior. Nevertheless it was not attached to the figure in the restoration, because of maidenly propriety which, to the Metropolitan's Classical department, seemed to outweigh demands of completeness and iconology. There may have been other reasons too; if they were ones of safety and tact, they were borne out by subsequent events.

Six or seven years ago, when one curator retired, her successor – who had found the unreplaced member gathering dust in a storage drawer – immediately attached it to its warrior with proper ceramic adhesive and thus completed the statue on exhibition. Imagine his surprise only months later when he passed the warrior in the museum gallery and suddenly noticed that the phallus was once again missing. Inspection revealed it had been surreptiously broken off exactly where it had only recently been mended. Its present whereabouts are, of course, unknown; it is left to conjecture how shocked must be some nameless fetichist at the news he now possesses merely a part of a fake.[23]

In 1961, Fioravanti recalled to Dietrich von Bothmer the arduous creating process:

The warrior was being built from ground up, but by the time the waist had been reached, it became obvious that the elegant proportions of [the Berlin bronze] could not be kept because the ceiling was too low. Adjustments had to be made from the waist up, and these account for its stocky build. The difficulty of judging the proportions also explains the overlong left arm: there was no possibility of stepping far enough back to judge the results from a decent distance. Moreover, the lower part of the body was mostly hidden by the moist rags wrapped around it, and by the many sticks and slats which formed a scaffolding, so the relation of the arm to the rest of the statue could not be judged. The glaze and colored decoration were applied while the warrior was still in one piece; the supports were shifted during this operation. Afterwards, it was allowed to crack in the drying and was pushed to the floor, so that it broke into many fragments. Originally the plinth on which the warrior stands was much bigger, but Fioravanti tells me that only part of the plinth was fired; the rest was thrown away.[24]

Before drying, the warrior must have weighed about 450 kilograms since the finished piece, when reconstructed in New York, was 360 kilograms in weight. 'The firing of the big warrior, in several batches of broken pieces, took two nights and one day.' Von Bothmer learned from Fioravanti what that entailed:

> The kilns for this and the other warriors were of the traditional Orvieto type; not more than four feet in height and about three feet deep and less than three feet wide. In these kilns, of which I saw one of the few still left in Orvieto, there are no doors; the whole front of the kiln is open and is bricked up for the firing. The fuel is wood, and the right temperature – about 900°C – is judged by looking through a peephole at the color of the kiln and by drawpieces attached to long iron pokers.[25]

While trying to track down any parallels in museums and reference books (his notebooks are crammed with possibilities), John Marshall heard some rumours that a colossal piece had been excavated. This was early in the summer of 1919, and C. Densmore Curtis of the American Academy in Rome wrote to Robinson on 19 July 1919: 'Mr Marshall is still hoping to get a huge terracotta figure from the same place.' In August, Curtis expanded his report by saying that the figure was 'of a different type than the one in New York, of very heavy build . . . The site is being worked by three brothers of whom the capable one died in an accident last winter. The one with whom we deal is apparently half crazy.'[26] Ricardo was, of course, the former; and the latter might have been Teodoro.

A cablegram sent by Warren for Marshall on 13 August 1919 to Robinson stated: 'Have seen the new Mars. 260 to 270 centimetres high. Wonderful preservation. Same artist as big head. Most important thing ever offered us. Cannot get photographs. Price quite fantastic.'[27] Fioravanti and the Riccardis demanded $40,000 for the new effort, and according to the Metropolitan records, its purchasing committee met on 26 February 1921, and allocated the asking price from the Kennedy Fund. Previously the Riccardis and Fioravanti had received only a few hundred dollars from Stettiner. It appears he must have died in 1920, and remembering past experiences, Fioravanti decided the time had come to eliminate the middle

man. Now the Met had all three of the major Riccardi–
Fioravanti forgeries.

28

Marshall's health deteriorated in 1921, and he went to Chian-
ciano, a fashionable thermal spa north of Orvieto known to the
Etruscans and Romans, and used by both to cure disorders of
the liver. While there Marshall hoped to explore the country-
side down towards Bolsena and Orvieto, thinking he might be
able to discover archaeological clues for the terracotta warriors.
In hindsight it is sad to think of the energy the ailing Marshall
expended trying to authenticate the ridiculous warriors. In his
notebooks he says he examined the Pinelli tomb at the British
Museum and the Louvre's Campana tomb which Enrico Pinelli
had restored. He expressed his doubts about the former, but
accepted (correctly) the latter as genuine.

By the end of 1921, Marshall had yet to see the spot where the
warriors were said to have been found. He wrote in his diary
that his 'friends' (the excavators) were sick, and then on 26
October 1924, he reported to Robinson they had carried out new
sales behind his back – a huge collection of vases and bronzes to
the Ny Carlsberg Glyptotek.[28] In August 1926, Marshall said
he had 'cut all relations with my Orvietans for good'.[29] For the
next two years he would be absorbed in tracking down Dossena,
and when he died in 1928, he had no idea that the Met's
warriors were far more contrived concoctions than anything he
had seen from the hand of Alceo Dossena.

In his chapter on 'Warren as Collector' in the Warren
biography, J. D. Beazley makes this observation of Marshall
which unfortunately is only partially applicable to the warriors'
affair:

Marshall said that there was only one way of learning to distinguish
between a forged antique and a genuine: to buy one, pay plenty, and
find it false. He said that you learned more by one such incident
than by poring for years over selected antiquities in a great
museum. He added that to get full benefit of the treatment it should
be your own money you lose, and not public money. It is possible, of
course, to return the object to the vendor, if he can be found, but this

Warren and Marshall never did: they took the risk, and cut their losses.[30]

As she had continued Marshall's tracking down of Dossena, Annie Rivier, his secretary, tried to work out the murky loose ends of the Met's terracotta warriors. On 27 June 1928, she reported to Miss Richter: 'Have heard nothing about them [the Riccardis] for a long time . . . They are watched by the government because they are known to know Etruria thoroughly and to have made excavations with and often without a permit. They had to quit Orvieto: one is now in Florence; another in Siena; of the third I know nothing.'[31]

The installation of the south wing of the Met where the warriors would be exhibited was finished, and the new Etruscan gallery was opened to the public in February 1933. Miss Richter held off official publication of the finds, still hoping for more information from Amedeo Riccardi who remained her only link to 'the Orvietans'. Amedeo continued to supply her with evasive replies and false hopes of 'discovering the archaeological site'.[32] As she completed her monograph on the warriors, she heard from Piero Tozzi, who had a gallery in New York, and, of course, had claimed to have unmasked Dossena. In the Ashmolean papers, there is one reference to Tozzi indicating that Marshall knew him a few years before his death, but nothing suggesting Tozzi then had either direct leads to Dossena's studio or knew anything about the warriors.

In his note to Gisela Richter, on 7 April 1936, Tozzi said: 'If sometime you happen to be in the neighborhood, I would appreciate very much if you would come to see me . . . I have something to tell you which I am sure will interest you to know.' At the bottom he mysteriously added: 'Fioravanti – Riccardi Brothers. Teodoro.'[33]

Tozzi was hearing the same rumours as Harold Parsons about the Fioravanti–Riccardi connection. Miss Richter wrote to Annie Rivier: 'There is an absurd story going around that our t.c. dollies are modern and the work of Fioravanti . . . It is easy to see why such a story should be told, as it makes it more comfortable for many people. And I don't propose to pay any attention to it except to ask you to find out who this Fioravanti is, and what kind of things he makes, so that if I am confronted with such a theory I may know about this man.'[34]

Miss Rivier replied that Fioravanti 'began work as a tailor, went on as a car driver; for some time had a small business in old furniture; went back to his cars; he has been for many years, and still is a taxi driver in Rome. It does not sound much like an artist . . .'[35]

Miss Richter decided to pay no more attention to the rumours, and in July 1937, her monograph appeared as the sixth number of the museum *Papers*. According to von Bothmer: 'this monograph, fully illustrated, received much attention. The findings were accepted and the author was congratulated in numerous reviews.'[36] That seemed to be the end of the matter.

Despite the academic accolades awarded to Miss Richter's paper in America, Italian scholars dissented. Massimo Palloti-no condemned the sculptures in the journal *Roma*,[37] and Pico Cellini offered what must have been no more than Roman gossip that the statues' clay contained ground-up glass from Peroni beer bottles. Mr Binns' terracotta analysis had easily ruled that charge as absurd. More serious was the remark given to von Bothmer by Michelangelo Cagiano de Azevedo in the autumn of 1959. During a brief visit to the museum, the professor would not even look closely at the warriors exclaim-ing: 'How can I, when I know the man who made them?'[38]

In 1960, Joseph V. Noble, operating administrator of the Met, had a series of spectrographic tests carried out using scrapings from the warriors. He stated in the 1961 *Inquiry*: 'It had been assumed by Mr Robinson, Miss Richter, and Mr Binns that the black glaze that covered all three statues was similar to the ancient black glaze used on Attic, Etruscan, and other classical vases.'[39] Noble's testing indicated the figures were coloured with manganese dioxide and that colouring agent was not discovered until the seventeenth century.

The new Met director, James Rorimer, dispatched von Bothmer to Rome. On 5 January 1961, Parsons had persuaded Fioravanti to sign a confession confirming his involvement with the warriors before the American Consul. Von Bothmer arrived in Rome in February, and Parsons arranged for him to have two talks with Fioravanti. The curator had brought a plaster cast of the left hand of the colossal warrior with him. It had a missing thumb. As with Dossena and his 'Athena', Fioravanti had kept the missing piece all those years. Placed to the cast, the thumb and hand fitted perfectly.

On Saint Valentine's Day morning, New Yorkers read about the warriors in *The New York Times*, and in an interview Rorimer said: 'I've had an open mind about them for more than a dozen years. But the fact that I didn't have anything to do with buying them doesn't make me any happier.'[40]

In his *Art News* editorial, Alfred Frankfurter praised Parsons' efforts in tracking down Fioravanti 'through the lengthy Ariadne thread of Roman cafe gossip', and asserted that 'it appears it was Parsons' letter about his discovery to the Metropolitan's director, rather than the subsequent corroborative "scientific and technical analyses", which prompted the Museum's sudden statement on February 13.' Frankfurter mused: 'one wonders what would have happened if Parsons hadn't tracked the forger down'.[41]

Parsons, of course, loved the adulation from *Art News*, and could not care less that the Met's own version of events avoided mentioning his efforts. He had a third attack to make in his 1962 *Art News* swan song: 'During the same afternoon in Rome when Dr von Bothmer, the present writer and the old forger . . . transferred the Metropolitan's warriors definitively from the long annals of classical art history to those of modern art forgery, another so-called Etruscan terracotta masterpiece entered our discussions.'[42]

The piece was a rather shapely kore which had been purchased by the Ny Carlsberg Glyptotek in 1930. Parsons continued: 'For long years the present writer had cherished among the photographs he had collected of art objects whose authenticity he had suspected on purely stylistic grounds . . . pictures of the Glyptotek's Greek maiden.'[43] Fioravanti told von Bothmer and Parsons that he had created her. Apparently after Riccardo Riccardi's death, Fioravanti decided to have a go in creating in the Etruscan manner on his own, and the kore passed through the hands of various dealers before entering the marble halls of the Glyptotek in Copenhagen. As with Dossena, Fioravanti had kept 'modest studio photographs' made at the time of her creation, and gave them to Parsons as a *ricordo* the afternoon he confessed to his involvement with Marshall's warriors.

Parsons added this third touch to his 1962 article, and could not resist a snipe at Jacobsen's Glyptotek – it was 'rich in false "Roman" portrait busts'.[44] According to Cellini, the statue was

made from a Florentine tailor's mannequin, but he does not say why he thinks so. After forty years of exhibition, the Glyptotek removed its kore from exhibit after the Parsons' article, and, following Saint Louis's lead, sent her in for thermolumi-nescence testing. She was a bit older than 'Diana' – 48 years.

That fitted Fioravanti's story quite well. The old forger died a year after the *Art News* article, and is buried in the same cemetery as Alceo Dossena.

PART FIVE

The Precursor

29

The Pinellis, the Riccardis and Fioravanti are hardly remembered by name today, even in the texts on art forgery. The forger with whom Dossena is most often compared is another of the all-time 'celebrities' of forgery – Giovanni Bastianini, who was born near Florence in 1830.

Their lives and success have several parallels, and Max Friedländer singled them out as 'the aristocrats among forgers'. But at the time of his exposure, more on the minds of the art establishment than Bastianini was Icilio Federico Ioni (or Joni as it sometimes appears). Kenneth Clark called Ioni 'an impudent rascal', and more than any other forger he was personally known to art experts and connoisseurs. Ioni left a fascinating record of his career in what Clark called 'a Cellinesque autobiography', *The Affairs of a Painter*, which appeared a year before Dossena's death.

In his book Ioni refers to Dossena only once, and reminds those who were so indignant at the revelations coming from his studio in Rome 'how often such things were done centuries ago'.[1] Ioni decided on his *apologia* because 'there are still people who can bear witness to the unhappy events of my childhood. I am telling the story, then, without ceremony or pretension, of the ups and downs of my life . . . And if some timid soul is shocked by it, let him bear with me, for in this modern work of mine the reader must expect only one virtue – sincerity.'[2]

Modest it is not, and we have to hear more than necessary about his tormented boyhood. There are, however, some interesting titbits about various important clients. Ioni recalls having once seen two fragments by the fourteenth-century Sienese painter, Duccio, which 'belonged to a gentleman who had had fine things'. He decided to sell them, and they were in a Sienese dealer's shop long enough 'to become damned as modern fakes'.

The gentleman decided to sell them himself, and they passed through various hands until they

finally emigrated to America, having been bought by Miss Frick. I knew nothing about all this, until one evening a gentleman

announced himself, with a certain air of mystery, and asked me if I was the author of the [two] fragments ... They had been repudiated by Miss Frick, because a friend had written to tell her these fragments were the work of Ioni. I asked the gentleman at once if he could put it within my power to defend myself against this gratuitous charge of paternity; but all he would say was that his business was simply to ask me if I had painted them; and anything further would require the consent of the people who had last had the pictures in their hands, and had therefore suffered the loss. I wrote to Miss Frick herself, and had a kind reply, but in the end she did not give me any of the information I wanted.[3]

Kenneth Clark relates that a few of Ioni's works ended up in the Berenson collection 'although whether he bought them as originals or as warnings is not at all clear'.[4] True to form, Pico Cellini tells more. There are a number of references to Berenson in the Ioni autobiography, but Cellini insists that a mysterious 'Mr Somberen' who appears even more often is 'the great BB himself when engaged in rather unorthodox deals'.[5]

According to Cellini, 'no one has ever tried to identify' Ioni's works in the Berenson collection 'or elsewhere for that matter'. Cellini mentions two: the gilt panel paintings of Saint Lucy and Saint Catherine attributed to Simone Martini which still hangs at Berenson's villa, *I Tatti*, and the large Verrocchio in the Robert Lehman collection in the Metropolitan.[6]

There is no doubt that Ioni was well known in the Berenson household. Ernest Samuels says: 'Despite all their expertise, Bernard and Mary had been taken in by various unscrupulous dealers in at least half a dozen instances, as Mary calculated in October 1899, to the tune of nearly $3,500. One of the most embarrassing acquisitions was a beautiful copy of Pinturicchio's fresco of a kneeling knight purportedly executed by Benevenuto di Giovanni, a 15th-century Sienese painter.' Mrs Gardner agreed to buy it, but 'awful doubts assailed them because their agent was bringing *too many* B. di Giovannis'. They took it to an expert restorer in Milan who 'recognized it as a forgery and put them on the track of the forgers, Joni and his associates'.[7]

Mary Berenson learned that Ioni also dealt in original paintings, and on one occasion took Roger Fry, the art historian, and his wife to see one. 'They made their way to an

out-of-the-way rural farmhouse and were greeted by "a rollicking band of young men, cousins and friends" who ran the workshop. Mary, perceiving that the alleged original which they were shown was a fake, said she would prefer "a genuine Joni" to this picture.'[8]

Clark, who spent a number of years under the tutelage of Berenson, recalls how Ioni made the Berensons

> take a long journey in a *carozza* to a small 15th-century church in a remote part of the Siena countryside to see a picture he remembered many years previously. 'This time, my friends, it is genuine . . .' The church was overgrown, the door was locked, the sacristan could not be found, and when discovered, had lost the key – all the usual things. When at last they got in, there over the altar was an Ioni. All they said was 'Ioni, you old scoundrel, you'll pay for the *carozza*.'[9]

Ioni's relationship with yet another connoisseur has recently come to light. Frederick Mason Perkins spent most of his 81 years in Italy, and became one of Berenson's earliest disciples. Like BB he was an American expatriate and settled in Siena several years after Berenson came to Florence. Possibly remembering his financial debt to Edward Warren, Berenson helped the young Perkins until he became established in his own right. Perkins cycled relentlessly around the hill towns of Tuscany and Umbria looking for masterpieces, and when he died in 1955 he left a remarkable collection to the Franciscan order in Assisi. The collection was open to the public in the autumn of 1986, and Federico Zeri is cataloguing it at present. Nigel McGilchrist reveals that Perkins 'had quite close relations with . . . Ioni' and asks, 'Does this cast a menacing light on Perkins's collection, valued at around £700 million?'[10] Art historian Zeri should be able to answer that shortly.

Ioni's writing is most useful for the vigorous detail he has left on the art of forgery. Like Dossena, Ioni's career was extremely versatile. He worked in restoration, painting, and perhaps most successfully in evolving his own version of primitive Sienese bookbindings. Ioni takes the reader step-by-step through the various stages of invention. Despite the possible exaggerations of some observers, there is little doubt that several of Ioni's restorations still grace museum walls as Renaissance master-

pieces. One restoration of which he was especially proud was of an old painting bought by a 'Signor Angeli' at a sale in Siena.

> Signor Angeli brought it straight to me; he told me that he had paid a high price for it, although it seemed to him to be much repainted, and he was afraid he had made a bad bargain. To avoid all responsibility I cleaned it in his presence, and we found that, apart from a nice gold background, and the original frame, there was nothing left but the pale ghost of a fine picture by Bernardino Fungai. Signor Angeli was rather depressed at the sight of the wreck; and I felt uncomfortable myself. I had advised him to buy it, and I did not want him to lose his money. My work was most successful and Signor Angeli was really pleased with it ... A foreigner, who saw the picture, was enthusiastic about it, and especially satisfied with the restoration. He found a buyer for it, worked up quite a reputation for the picture, and published it together with another Fungai in the *Rassegna d'Arte*.[11]

Otto Kurz adds to Ioni's account: 'Indeed, the picture now resembles closely the other Madonnas attributed to Fungai.'[12]

Clark suggests Ioni was motivated 'less by greed than by a natural naughtiness. He enjoyed the fun of fooling the experts and museum directors, and would go to any lengths to achieve it.'[13] Clark insists that 'only the Italian can forge with the elaborate devotion to mischief',[14] and one sees a touch of this with Dossena as well. You see it in his eyes as he performs before Hans Cürlis's camera.

Also similar to Dossena, Ioni had his own justification for his career:

> And yet, my dear sirs, they are not forgeries. You can say that a man who makes false bank notes is a forger, because he uses a printing press, or a man who makes false coins, because he uses a die. But an artist who creates a work of art of his own, in imitation of the style of an old master, is not a forger; he is at worst an imitator, and he is creating something of his own. And if he produces something that merely reflects the style of the fourteenth or fifteenth century, without any particular master, then it cannot even be called an imitation, it is something really and truly creative. Some of you, who have turned sticklers for honesty in your palmy days, may turn up your noses at my defence, and say it is absurd. But if some of you could remember the beginning of your own careers ... other things besides false pictures![15]

30

Kenneth Clark called Bastianini 'the greatest forger who has ever lived',[16] and he had an early exposure to the forger's work at Winchester College where he was taught drawing 'in a small, ill-proportioned room . . . known as the Museum'. The Museum was 'the only ugly building at Winchester and contained a shelf full of casts, most of them from the hand of . . . Bastianini. On account of their academic naturalism, these 19th-century imitations were more to the taste of art teachers than genuine works by Donatello, Desiderio da Settignano, or Rossellino.' The latter 'would all have contained an element of style that would have upset my drawing master'. Clark says he got to know Bastianini well as he drew the busts every week for four years. He was certain this use of Bastianini busts 'was true of art schools all over the country'.[17]

Giovanni Bastianini arrived at a high level of appreciation in an incredibly short amount of time: he was only 37 when he died in 1868. He was born to a poor peasant family at Ponte alla Badia near the church and convent of St Dominic of Fiesole, just south of the city of Fiesole. The convent was where Fra Angelico had made his vows in the fifteenth century. For a young man who displayed an early interest in art, Fiesole 'the mother of Florence', was an ideal place in which to grow up.

The Bastianini family, however, could not afford a proper education for their talented son. But when he was 13, he attracted the notice of a Professor Inghirami who was writing his work on the Etruscans. The professor was from an important local family with a villa near Fiesole, and he taught Giovanni the basics of drawing. After this experience, Giovanni became an errand boy for the Florentine sculptor, Torrini.

Torrini gave the boy no formal lessons, but doubtless Giovanni learned much by observation as he did from his frequent visits to the galleries of Florence. The turning-point in Bastianini's life came when he was 17. Giovanni Freppa, a one-time charcoal-seller who had become something of an antiquarian, saw potential in the youth who spent so much time sketching the great masters of the Renaissance. Freppa offered Bastianini a meagre salary, but he had access to facilities for moulding his ideas into clay or chiselling them into marble.

More importantly he was able to return some money to the family back at Ponte alla Badia.

In 1885, Nina Barstow put the events of Bastianini's life in Dickensian fashion in the *Magazine of Art*: 'Thus the poor boy, not knowing the power that was in him, entered the bondage that was his doom.'[18] We know little of Bastianini's twenty years of creating in Freppa's 'dingy workshop' in the Borgo Ognissanti. From the extraordinary output, Freppa must have supplied the youth with good suggestions. The Florentine dealer who would later take an interest in Bastianini, Alessandro Foresi, said the boy (like Michelangelo) worked directly upon the marble without any preliminary modelling in clay.

Several pieces in the Fakes and Forgeries Gallery (Room 46) of the Victoria and Albert Museum indicate the range of Bastianini's skill. One is a marble Virgin and Child relief purchased as an authentic work by Rossellino, an artist also favoured by Dossenà. Rossellino's sweet style was well appreciated in the nineteenth century. The piece was bought in Paris for £80 and had previously been in Freppa's hands. Bastianini derived the Madonna for his relief from a stucco relief by Rossellino of which many versions exist. The V & A has one. For the Christ Child, Bastianini's inspiration was a marble fragment by Desiderio da Settignano which Freppa had discovered around 1850. It is now in the Museé de Lyon.[19]

As Pope-Hennessy sees it: 'To our style-conscious eyes ... Rossellino's Virgin and Desiderio's Child seem not to marry up particularly well, but when it was finished in 1857, it was sufficiently convincing to be sold to an extremely experienced buyer as a work by Antonio Rossellino'.[20] Bastianini used Desiderio's Child in another piece which also hangs in Room 46 – a wax piece with its Virgin inspired by a famous marble relief known as the Turin Madonna, which hangs in Turin's Galleria Sabauda.

In the eyes of many, the best work by Bastianini is also in the V & A. It is a marble bust of Lucrezia Donati, the mistress of Lorenzo the Magnificent. Pope-Hennessy thinks 'It is an extremely pretty work, and it is rather surprising that it found no purchaser before its authorship was recognised.'[21] This was not before the art historian, Cavalcaselle, greeted it as a masterpiece by Mino da Fiesole and 'offered to exhibit it under a glass shade in the Bargello'.[22] Foresi exposed it as a forgery in 1868, and the V & A purchased it from him for £84.

There is a strong family resemblance between 'Lucrezia Donati' and other busts by Bastianini. His terracotta 'Portrait of a Lady' is extremely similar to a polychrome terracotta made by the Florentine reproduction company, Manifattura di Signa. The two terracottas sit side by side in Room 46, but the company's catalogue described the polychrome bust as a copy of a work by Desiderio da Settignano in the Louvre. Bastianini's terracotta has been explained by some as a copy of the Louvre bust, but Pope-Hennessy says: 'the more I look at the two works, the more prone I am to wonder whether one is not really a study for the other, and to ask myself if the bust in the Louvre . . . is not also by Bastianini'.[23] The Louvre stoutly defends its Lady, saying they have subjected her to any number of tests, and she has passed them all.

In 1861, the Victoria and Albert purchased a terracotta relief, 'A Monk Writing', as a work by Luca della Robbia, but it was later disclosed to be by Bastianini. A second version of the relief is owned by the Philadelphia Museum of Art, but more interesting is an ivory copy which can be seen in a display case only a few feet from its inspiration by Bastianini. The ivory was created by an English forger active in the 1860s, J. W. Bentley. Bentley's ivory was a prize object at the Society of Arts Exhibition in 1863, and only later did the V & A come to realise they possessed a forgery of one of their forgeries.

It was none of these pieces which brought Bastianini to prominence and final exposure. His greatest success and eventual fall were due to two related terracotta pieces – one of the fiery Dominican preacher and reformer, Savonarola, and another of his friend, Girolamo Benivieni. Bastianini was able to provide a small subsidy for the family, but as they had now increased to six, and his father had become infirm, more money was needed. Giovanni was forced to work even harder, in accordance with the old Italian custom of the one in the family with the means supporting the rest.[24]

When Nina Barstow wrote her account of Bastianini in 1885, his youngest brother was still living in Florence, and he remembered 'Giovanni chipping at his marble amongst the straw and sleeping beasts in his father's stable as the rest of the family slept'.[25] Freppa's choice of Savonarola as a subject for Bastianini was brilliant. As there were no busts of the reformer, the model for the piece came from his celebrated portrait on a well-known medal. It is asserted that Bastianini turned to

the sculptor Gaiarinini for assistance in colouring the bust and
giving it a look of age. The forgery was placed in the appropriate
setting of a villa in Fiesole, and ironically it belonged to the
Inghirami family. Unfortunately the records give no hint as to
Professor Inghirami having anything to do with it or not.

The planting produced the desired effect, however, and the
Florentine picture dealer, Capponi, purchased 'Savonarola'. In
turn he sold it to two artists, Giovanni Costa and Cristiano
Banti for 10,000 lire, and they arranged for it to be exhibited in
the Palazzo Medici-Riccardi. For a while, the piece was highly
praised by collectors and experts. The Tuscan art critic, Diego
Martelli, recalls in a letter the excitement of Costa's discovery
at a dinner at Banti's house:

> Do you remember-the fuss there was that evening at the Caffè
> Michelangelo, when everyone was talking of the bust ... We,
> moved by a scrupulous spirit of research, rushed off to every gallery
> and museum in Florence in order to be able to compare the newly
> discovered bust with all the other authenticated likenesses of the
> monk and after having examined ... everything that was to be
> seen, we came to the conclusion that none showed such evidence of
> veracity, as the bust in the Borgo Ognissanti.[26]

Among its many admirers was Giovanni Dupré, a respected
artist of the time, who later dabbled on the edges of art forgery
himself. He was overwhelmed with admiration, and 'could only
attribute this work to Michelangelo for its force and to Luca
della Robbia for its exquisite handling ... at any rate he
considered it was the most beautiful thing he had ever seen, and
went so far to say that it determined him to attempt a fresh
departure in art'.

Frederick Leighton, the English painter, sent a telegram to
Costa asking for permission to make a drawing of 'Savonarola',
and 'for answer received a photograph, which he placed, like a
sacred image at the head of his bed'.[27] For many, Bastianini
was creating what Renaissance art was supposed to look like.
Otto Kurz explains: 'Nobody seemed to care for the fact that
this kind of realism was unknown in the Renaissance, when
artists believed in a more general characterisation of the

individual. Quite on the contrary, people evidently wished that Renaissance artists had been more like Bastianini.'[28]

The 'Savonarola' bust on view in Room 46 was purchased as a fake in London from Costa and Banti for £328 9s 4d. Foresi went on 'to atone for his mistake' (having praised the forger) by conducting an angry polemic in *The Tower of Babel*. Foresi says the V & A bought the original 'Savonarola' by Bastianini, but others insist it was presented to the monastery of San Marco in 1869 when it was opened as a museum. Schüller says: 'The work was given a place of honour in the cell formerly occupied by its subject when prior of the establishment.'[29] I only noted the bronze bust and monument by Dupré in the cell on a recent visit.

For several years all went well for Freppa's enterprise. An increasing number of portrait busts by Bastianini were admired by experts and it was assumed that the works of a late fifteenth-century studio had been discovered. Each piece was inscribed at the rim around the base with the sitter's name: Lucrezia Donati, Savonarola, Marsilio Ficino. The last was president of the Platonic Society in Florence in 1492, and for this creation a cast was taken by Freppa from Ficino's bust in the Duomo at Florence.

The adulation did not last long. As Pope-Hennessy says: 'What blew the carefully constructed edifice sky-high was a bust that was not based on a 15th-century model.'[30] The new subject was of Savonarola's friend, the poet, Girolamo Benivieni. In his search for inspiration, Freppa could only find an engraving of Benivieni made in 1766. That was not much to go on, so Freppa and Bastianini looked around the neighbourhood for a man who looked like the engraving. Their choice was Giuseppe Bonaiuti, a tobacco factory worker.

The new bust was extraordinary – a vivid recreation of the factory worker's craggy old face – 'every wrinkle in the clean-shaven face, every vein, was reproduced with absolute truth to appearance'.[31] Freppa wisely insisted upon adding a recognisable Renaissance garment for the upper part of the torso and a convincing headgear.

Count Novilos, a Parisian collector, who regularly travelled through Italy in search of treasures, bought the 'Benivieni' bust from Freppa for 700 francs in 1864. The following year, the bust was exhibited in the Paris Hall of Industry and it attracted a

great deal of attention. In the *Gazette des Beaux Arts* Paul Mantz wrote: 'All the subtlety of the Italian character is disclosed in this expressive countenance ... The age of the subject and above all the style of the execution suggest that the work should be dated at earliest in the last years of the 15th-century or preferably at the beginning of the 16th.'[32] The German periodical *Plastic Arts* added: 'it [is] the portrait of a thinker, represented with all the simplicity, honesty and captivating naturalism of 15th-century Florentine art.'[33] Several artists were suggested as the creator: Donatello, Verrocchio, Desiderio da Settignano, Mino da Fiesole and Antonio Rossellino.

In 1866, at the Hôtel Drouot, the great Parisian auction house, Novilos's entire collection was offered for sale. Count de Nieuwekerke, a protégé of Princess Mathilde de Bonaparte, and Baron de Triquetti bid against each other for the 'Benivieni'. Eventually the former obtained it for 14,000 francs. The count was director of the Imperial Museums of Paris, and with the support of Princess Mathilde the bust went to the Louvre. It is interesting to note that the previous highest price paid by the Louvre for a masterpiece was only 6,000 francs, and that was for the *Venus de Milo* in 1820. 'Benivieni' was placed in the centre of a room containing Michelangelo's *Slave*, a nymph by Cellini, and a portrait bust by Desiderio da Settignano.

31

The glory was short-lived. Rumours began to circulate that the Louvre was making a fuss over a forgery. The *Gazette des Beaux Arts* was the first newspaper to hint that something was wrong. One story said that Foresi had brought a number of genuine antiques to Paris and offered them to the Louvre, but Count de Nieuwekerke declined to meet Foresi's asking prices – and suggested some of the wares might be fakes. Foresi was incensed and shouted that the count wouldn't recognise a fake if it were under his nose. Foresi went further – it was under his nose and he had just forked out 14,000 francs for it.

The rumours continued, and Nina Barstow presents Giuseppe Bonaiuti, the model for 'Benivieni', holding court before his fellow workers and chuckling over the newspaper reports from

Paris. On 15 December 1867, Freppa dropped a bomb in *Chronique des Arts* by declaring that the bust was not 300 years old but only three. He explained he had ordered the bust from Bastianini and paid him 350 francs for it. He went on to relate that Novilos had bought it for twice that amount, and 'not as an antique', but 'on the evidence of his own eyes'. As an extra touch, Freppa also revealed the identity of the model, and the news that the old man had just died.[34]

The Louvre refused to believe the story and suggested it was only the arrogant boasts of an Italian art dealer. The feud then became a battle of nationalistic pride. French newspapers suggested no modern-day Italian could have created such a masterpiece. Italian writers retaliated by charging that half the paintings in the Louvre had been stolen from Italy by Napoleon. The French sculptor, Eugène Louis Lequesne, offered 'to knead Bastianini's clay for him for the rest of his life if the Italian could produce evidence he had executed the bust'.

Lequesne presented his case in the Parisian *Patrie* that the 'Benivieni' was the work of 'a Florentine Old Master'. Bastianini responded in the *Gazzetta di Firenze*. Lequesne said: 'The bust was produced by an antique process, the clay being pressed in a mould and modelled subsequently. Seams are visible on both shoulders and on the back of the neck, where sections of the mould came together. The hair also shows traces of the liquid clay with which the interior of the mould was smeared.'

Bastianini replied: 'The bust was modelled freehand, leaving as much of it as hollow as possible. The cast was taken after firing and that is why the seams and slip show.'

Lequesne was not convinced: 'On one of the curls on the left side of the head the clay was insufficiently bound in, and a small piece dropped off. The place still shows the original fingerprint by which it was replaced.'

Bastianini simply retorted: 'Aren't fingers always used for modelling?'

Lequesne: 'The clay differs from that used in Italy today. It has become porous with age.'

Bastianini: 'What makes you say that? I'll send you a specimen of the clay ordinarily used here. Neither chemically nor from the artistic point of view does it differ from that used in the Benivieni bust.'

Lequesne: 'Patina was applied to the surface by tobacco smoke.'

Bastianini: 'Well, as you haven't guessed my method, I'm not giving any secrets away. But I shall be happy to apply the same patina to any terracotta you like. I can hardly believe that you use tobacco smoke for that purpose in France. One dealer in antiquities, at least, smiled when he heard of it.'[35]

The debate continued in like manner in the press with more experts joining the chorus, but Count de Nieuwekerke remained unmoved. One newspaper learned that the count had offered in private conversation 15,000 francs to Bastianini to produce a companion piece of equal merit. When Bastianini was told of the offer he proposed:

> Deposit your 15,000 francs in safe hands. We will then choose between us a jury, not composed entirely of Frenchmen, and I will for my part guarantee to make a bust, for 3,000 francs, as good as the *Benivieni*. As for the other 12,000 francs, I will undertake to meet you half way, since you are one of the pillars of the Second Empire, by modelling for you busts of the Twelve Caesars at a price of 1,000 francs a piece.[36]

The count did not take up the offer, and Bastianini died six months after Freppa had made his revelation. The 'Benivieni' scandal brought Bastianini down, and some observers say the pressures of the debate contributed to his early death.

32

Such was Bastianini's standing that a number of impressive pieces were automatically attributed to him after his death. The most celebrated was an extraordinary wax figure, 'Flora', which was purchased in 1909 by Wilhelm Bode for the Berlin Museum. Bode and others were convinced it was by Leonardo da Vinci. The piece depicts the goddess Flora in life-size but she was missing both her forearms. Bode said 'Flora' had been sold in a London auction for a small sum, but by the time the German firm Durlacher purchased her, the price had risen to £150. When Bode bought her he paid 150,000 marks.

'Flora' had not been long in Berlin before charges circulated that Germany's foremost art expert had bought a fake. *The Times* reported that she had been created by a minor English

sculptor, Richard Cockle Lucas. His son, Albert Dürer Lucas, recalled how he had helped his father with the bust.[37] Scientists at Bode's museum tested fragments of paint from the wax figure, and were satisfied they were all contemporary with the time of Leonardo da Vinci. A number of German scholars attacked Lucas's claim, and belittled his father's abilities to have done more than perfunctory attempts at restoring such a masterpiece.

Martin Schauss, a Berlin sculptor, was asked by Bode to examine the bust, and his opinion was that Bastianini probably had something to do with it. In an article published in 1910, Schauss gave detailed reasons for supposing the piece had originated in the studio of Bastianini's teacher, Torrini, in 1845, and that Bastianini might have been its creator. He also suggested that Lucas attempted to put some of the damaged pieces back together when the piece came to England.[38] Although Bode could not accept a Bastianini connection for his beloved 'Flora' he had great admiration for the forger, and in his autobiography claims to have bought two genuine fifteenth-century sculptures from him.[39]

'Flora' remained in the Prussian Royal Collections as a work by Leonardo for seventy years. In 1984, Josef Riederer, professor of archaeometry and head of the Rathgen Research Laboratory in West Berlin, finally laid the 'Flora' case to rest. He took a closer look at the figure's wax which turned out to contain a synthetic organic acid which was not produced until 1833. I met Riederer in October 1986, and was impressed by his good sense and remarkable laboratory. He showed me two shelves of Mexican ceramic fakes which a wealthy German had purchased as genuine pre-Columbian pieces. According to Riederer, the odds for the collector getting a genuine piece in Mexico today are about 9 to 1 against him.

I had just seen 'Flora' in the Dahlem Museum before meeting Riederer, and told him there was no indication given at Dahlem that she was anything but a Leonardo – or of 'his school'. He smiled and said 'Flora' was a popular exhibit and that it will take time for her 'reclassification'. Riederer's date of 1833 for the tell-tale acid's inception still gives Schauss's verdict of a Bastianini connection more than an outside chance.

From all sides it appears that like Dossena, Bastianini did not set out to deceive. He was enamoured of the past, and loved

recreating in the manner of the Renaissance, and he certainly did not profit from his work. Neither did Freppa for that matter. Freppa was astonished how much money was spent by the Louvre for 'Benivieni', and quite voluntarily told the whole story of its creation. Bastianini also stood up well to the charges in the French newspapers and was quite willing to take Count de Nieuwekerke up on his offer. As always, the real villains in the case were the dealers who carried suggestions of age to assertions of fact to make money.

The 'Benivieni' scandal stung the Louvre mightily, but Bastianini soon entered the history books of forgery as similar sensations took the limelight. In 1952, however, an exhibition of forgeries called 'False or True' was shown in Holland, Switzerland, Germany and the United States, and those who saw it were reminded of Bastianini's extraordinary talent. Many critics singled out his works as the most convincing, but also noted that when placed side by side there was also a strong family resemblance among some of his busts. Bastianini's realism in sculpture was also much stronger than that attempted by any other master forger.

In comparing Bastianini with Dossena, art experts have usually cited the former as superior to the latter in artistic skill. Many, however, have limited their observations to only a portion of Dossena's work, not taking into consideration his 'Diana' or some of his later works. Some writers have forgotten that whereas Bastianini worked totally in the manner of the Renaissance, Dossena had the audacity to go back and forth from Etruscan and archaic Greek to Renaissance and even to modern modes. And as one museum curator put it to me, whereas Bastianini conscientiously imitated Rossellino, Mino da Fiesole and others, Dossena was more imaginative by picking up 'a bit of Mino, a touch of Desiderio da Settignano'. Dossena's works are not good imitations of any particular artist. It is all more of a mix. And, of course, Dossena went on to fool a larger number of experts.

Had he lived longer, there is no telling just where Bastianini's talent would have taken him. Though Bastianini left sketches and models for some of his creations, there is no complete record of just how much he produced. When Samuel Sachs II, director of the Minneapolis Institute of Arts, organised an impressive 'Fakes and Forgeries' exhibition in 1973, a number of previously

unknown Bastianinis were offered as exhibits by private
collectors. A number of his works made their way across the
Atlantic. A 'Portrait of a Lady' in white enamelled terracotta
was bought by Mrs Gardner from Duveen in 1910 on the
recommendation of Berenson. BB had declared the Bastianini
'a 15th-century Della Robbia bust of Marietta Strozzi'.[40]

A bizarre recognition of Bastianini's talent comes in a
catalogue from Eleganza Ltd, 'Importers of Fine Statuary' at
Magnolia Village in Seattle. Advertised is 'a polychrome
terracotta by Giovanni Bastianini whose sculpture has graced
the Louvre, the Isabella Gardner and Andrew Mellon collec-
tions'. The piece was offered for $773 'postpaid and with
unqualified guarantee'. Leafing through the vast Eleganza
collection it is obvious that Bastianini really has arrived. He is
the only forger whose works are offered in 'museum quality
reproductions' and he is in the company of Myron, Praxiteles,
Michelangelo, Bernini, Cellini, etcetera.[41]

Pope-Hennessy has rightly commented: 'I doubt . . . whether
we have heard the end of Bastianini . . . there is reason to
believe that Bastianini . . . became a more resourceful, more
ambitious sculptor.'[42] His impressive marble 'Virgin and Child'
is still exhibited in the Hermitage in Leningrad as a work by
Rossellino. It is quite large – 69 cm × 50 cm, and the Virgin and
angels are quite similar to the smaller 'Virgin and Child' in the
Victoria and Albert noted earlier. Pope-Hennessy relates that
the Hermitage piece 'was sold to a Russian, Mme Bibikow.
[She] offered it to the Hermitage but it was turned down as
what it was, a forgery, and it was then sold to a collector called
Yourawlew. At that time it was patinated, and the new owner
made the mistake of washing it. It came out, according to an
eyewitness account, "as white as sugar", and in 1915 was again
offered to the Hermitage. This time it was accepted.'[43]

Earlier in his study of forged sculptures, Pope-Hennessy
reminds us: 'In Italy there was nothing discreditable in the art
of forgery. The forging of Renaissance sculptures was simply an
extension of the immemorial trade in forged antiques.' He notes
that Vasari alludes to the manufacture of antiques, and
'Tommaso della Porta . . . is commended for his fabrication on
the ground that they did what they were designed to do, took
people in. If antiques could be forged without shame and
without rancour, so could Renaissance sculptures.'[44]

In 1884, sixteen years after Bastianini's death, the art historian, Cavalucci applied to Bastianini the same criterion Vasari applied to Tommaso della Porta. Bastianini executed 'works which the expert eyes of the most reputable connoisseurs ascribed to the best Tuscan masters of the quattrocento'.[45]

The 1973 exhibition at the Minneapolis Institute of Arts was the most extensive gathering of fakes and forgeries ever assembled. There were 310 pieces displayed. 'Diana' was there and a copy of Berlin's 'Flora' as well as exhibit number one – what the catalogue called 'one of the single most famous fakes of all time' – the 'Tiara of Siataphernes'. The gold tiara was purchased by the Louvre in 1896, and created as much fuss for the museum as had Bastianini's 'Benivieni'. Also on exhibition were two works by Ioni and three by Bastianini. Looking at the catalogue it is evident how pre-eminent Italians have been in forging ancient and Renaissance works.[46]

'Italy, without question, has been the world's premiere fake factory,'[47] observed Karl Meyer in 1973. Roman copies of Greek originals, Michelangelo's 'Cupid', Ioni, Bastianini, Dossena – is it all in the past tense? We will now see that Meyer could have added that the Italian forger is alive and well – and still very much in operation.

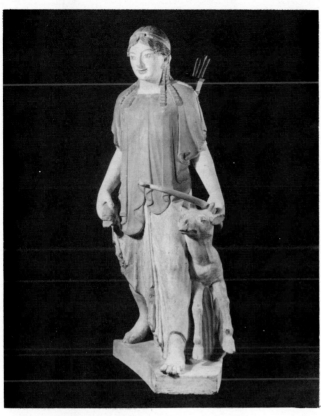

10 Diana the Huntress, in terracotta, at the Saint Louis Museum of Art.

11 Wooden Archangel Gabriel and the Madonna, the Annunciation set by Dossena once attributed to Simone Martini.

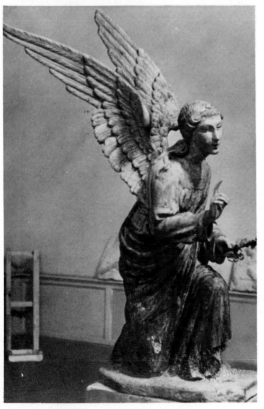

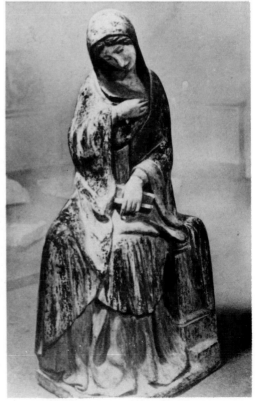

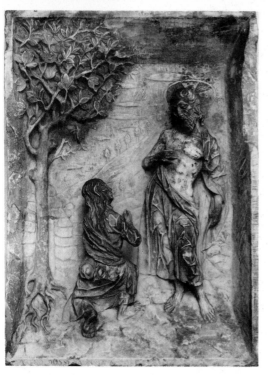

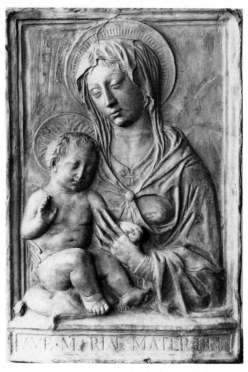

12 *Noli me tangere* by Dossena, given by Harold Parsons to the Fogg Art Museum.

13 Terracotta Madonna and Child by Dossena in the fakes gallery at the Victoria and Albert Museum.

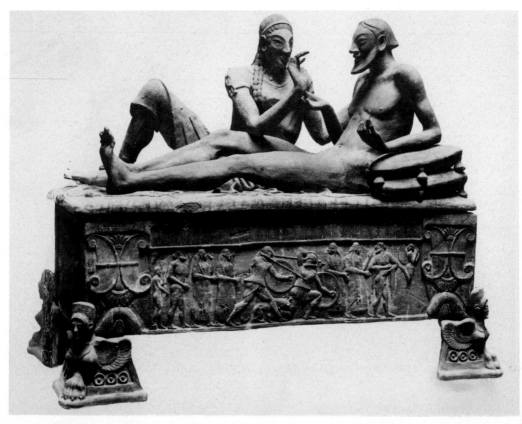

14 The Pinelli sarcophagus, at the British Museum.

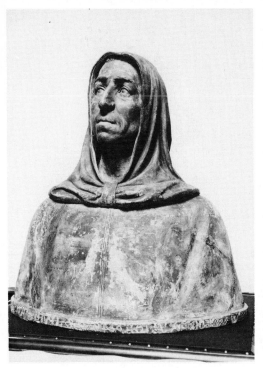

15 Terracotta bust of Savonarola by Bastianini, in the fakes gallery at the Victoria and Albert Museum.

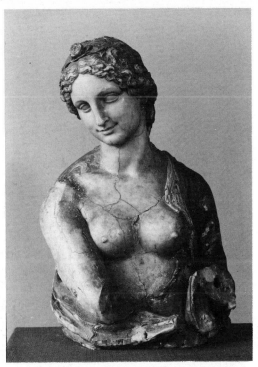

16 Wax bust of Flora by Bastianini, once attributed to Leonardo da Vinci.

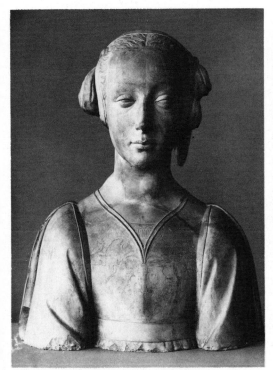

17 Portrait of a Lady by Bastianini, in the fakes gallery at the Victoria and Albert Museum.

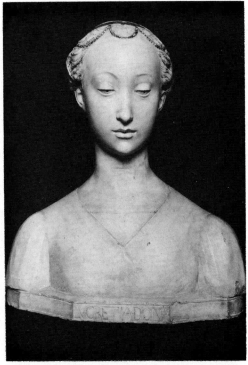

18 Lucrezia Donati by Bastianini, in the fakes gallery at the Victoria and Albert Museum.

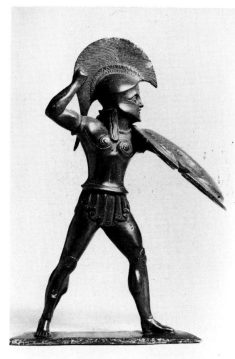

19 Harold Parsons with a model of a
Metropolitan Etruscan warrior.

20 Inspiration for the Metropolitan's
colossal warrior.

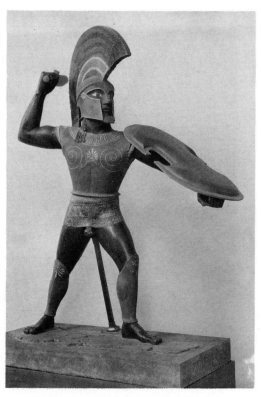

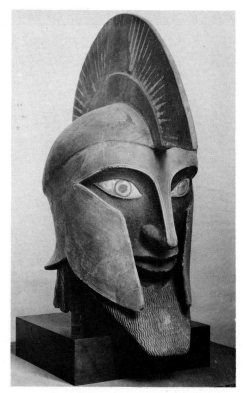

21 Terracotta colossal warrior at the
Metropolitan Museum.

22 Terracotta colossal head.

PART SIX

The Survivors

33

On 30 March 1986, *The Sunday Times* ran a piece under the title 'New Old Masters Faked to Order':

> More than 300 of Italy's most distinguished picture fakers have decided to come into the open and set up an art gallery in the northern town of Cremona to exhibit and sell their works legally. The Art Fakers' Collective was founded two years ago and has had successful exhibitions in the Rome and Milan Hilton hotels. An exhibition is planned in London later this year, probably at the Hilton. The organisers hope to base it on fake Canalettos.[1]

The London show never materialised, but the article went on to report that Bettino Craxi, Italy's prime minister, was one of the collective's customers as was Imelda Marcos, wife of the deposed president of the Philippines. She commissioned thirty-seven faked Impressionist paintings, the originals of which she owned before going into exile. Imelda was apparently no stranger to forgery, as another report says she purchased 'real' fakes from Mario Bellini who has been under investigation by the Italian government.[2]

Daniele Ermes Dondé, a former shoe salesman and manager of the collective's art gallery in Cremona – the Imaginary Museum – told Dalbert Hallenstein: 'All of our sales are perfectly legal . . . Every picture we sell is legally documented, bearing a back-stamp saying it is an authentic work of fake art. We issue a certificate stating that the painting is a genuine copy executed by one of our artists.'

Hallenstein went on to report:

> Dondé is convinced that his initiative is helping to destroy the hidden world of criminal art fakers. 'Many, but by no means all, our members come from the world of conventional art faking. Now, by selling their works legally they can make a decent living and be acknowledged as true artists.' But many established gallery owners are sceptical about Dondé's new initiative. One said: 'Many of the professional fakers could benefit from the chance to display their works. I wouldn't mind betting that their commissions from criminal dealers will treble.'[3]

I was excited by the report as Cremona was, of course, Dossena's home town – a fact that had been missed. The sceptical note at the article's end was well founded as I discovered when I went to Cremona in January 1987. No address had been given for the Imaginary Museum, but with all the publicity I thought it would be simple to locate. No luck in the telephone book, and my first visit to the local Italian State Tourist office elicited a blank response. A visit to galleries in the city centre was even more frustrating. I was beginning to think the Imaginary Museum was just that.

I returned to the tourist office and there was a new man on duty. I showed him a photocopy of the article and he went to a back room. He returned with Dondé's telephone number and said he understood the gallery was closed. I asked what had happened. He looked at the photocopy, and frowned. I wondered if he thought I was from *The Sunday Times* because he now acted as if he were being interviewed. He was never impressed by what they had to sell. 'But, of course, that is only my opinion.' He indicated where the shop had been, and I went to see.

The gallery had been well located just off the major shopping street of Cremona, but it was indeed *chiuso*, and workmen were cleaning out the remains of the Imaginary to make room for a new gallery which would be like all the others in Cremona – high priced and free of fakes. Dondé must have left town as his telephone emitted a disconnected recording. One art dealer in Cremona did say that he thought the fakers' collective was doomed from the beginning – especially in Cremona. 'We don't have that many foreigners coming here.'

You search in vain for any reminder that Alceo Dossena ever lived in Cremona. Unlike Rome where you would get one or two old dealers to give at least a nod of 'Yes – but that was a long time ago . . .' or churches with some of his wares, no one in Cremona appears to know anything. Like the fakers' gallery he does not fit the city's well-groomed image of trying to be a *citta della arte*. The nearest link I found was in a covered arcade, the *Galleria 25 Aprile* where I met a young German named Hans who creates large chalk drawings on the pavement translating Rubens and Botticelli from tiny photographs.

I began to think my trek to Cremona a colossal waste of energy regarding Dossena – and was only thankful the BBC

had wisely decided not to film there. I returned to the tourist office and asked my man on duty if he knew of anyone who might have some information on Dossena. His reply was negative – maybe Dossena was a forbidden subject in Cremona. I showed him an old article and he managed a smile and a phone call to the municipal museum. The man on duty returned proudly, announcing he had arranged an appointment with a Doctor Ebani who was the curator.

Ebani was delightful and reminded me of the spinsters from whom you would ask information in the British Library. Yes, she had heard of Dossena, and related that a few years back a wealthy lady in Milan had approached the museum with the offer to give or sell (for some reason she was not certain which) a Madonna and Child by Dossena, thinking that Cremona was the natural place for it. Apparently nothing came of the offer and feeling like the advocate for the hometown forger I said it was a pity there was nothing in Cremona commemorating Dossena. Ebani and translator looked at each other as if this was an extraordinarily novel suggestion, and Ebani made some notes on the papers before her. She looked up and said that Dossena was a very clever fellow, and that today no one in forgery had his talent. She suggested that I write to the local newspaper saying perhaps the time had come to remember Dossena in some fashion in Cremona.

I composed a letter to *La Provincia* that evening in my hotel room as the worst snow storm in many years kept everyone indoors. I added an appeal to anyone who might have remembered Dossena or, by chance, be related to him. I felt much better about Cremona when the replies arrived back in London. There were six, but only two contained significant data. One writer's husband was 'distantly related to the famous sculptor' – how distant was not said. Another was a pensioner who kindly sent an old newspaper article about Dossena, adding it was sad that 'a man who had made such an impact was not recognised in some fashion in his home town'.

Luisella Baruffini said her father who was a sculptor knew Dossena and had purchased a relief from him in 1935. She enclosed a photograph of the piece she said was originally made for the Palazzo Farnese in Rome. It is an odd work for Dossena, but not too unlike some of his later pieces. The relief has a modern-day Venus surrounded by drapery which is partially

pulled aside by an overplump cupid. Signorina Baruffini said her father had bought the relief 'because Dossena needed the money'. She was moving into a smaller flat and wondered if I would like to buy the piece. Later, an article in *La Provincia*, put together in response to my inquiry, pictured the relief and I would imagine she has had some reponse.

Ercole Priori also wrote and was a major source for the article on Dossena's life in Cremona. He is the son of Amelia Dossena, Alceo's youngest sister. Apparently Priori's uncle along with Walter Lusetti and two others – Patrizio Incarnati and a restorer, Sciancalepore – kept Dossena's studio going until the beginning of the Second World War. There was also an attempt to have a 'Dossena studio' in Cremona, but that appears to have collapsed with Alcide's death in 1946. Priori has become a successful sculptor himself and created Cremona's monuments to its famous sons, Monteverdi and Stradivari. In his brochure on his career he lists Alceo Dossena as one of his 'maestros'.

On 10 March 1987, *La Provincia* published the article in which I was credited with reminding Cremona of its famous son. Several of those who had responded to my letter contributed their insights, and someone had the foresight to check local school and statistical records. *La Provincia* recalled that when the Dossena affair became international news in 1928, the director of the municipal museum was often quoted in the local press as having known the forger, but was not about to allow his creations to be displayed there. All sorts of rumours swept Cremona that Dossena had created this and that. Bas reliefs on the portico of a local patrician's house were attributed to him – apparently to the horror of the owner.

Nowadays it is difficult to know just what remains of the forger in Cremona. Various letters assured me that Dossenas were 'in many private hands' and 'in several churches', but the only sculpture pictured in *La Provincia* is in the local cemetery. It is part of a memorial to a local hero – and is none other than the completion of Dossena's winning design for the proposed First World War memorial. There they are – the three weeping women which had impressed the judges so many years ago, but they have been used to grace a private grave.

A sad memorial to Dossena – and so is the Piazza Dossena in Cremona. When Priori wrote he said that a mayor had honoured Dossena years ago by naming a tiny piazza after him, but

he added: 'it is in the periphery of town'. Indeed it is. I looked for it on a detailed map of Cremona and finally found it – in what we would call a housing estate on the edge of town. Before I knew he was buried in Rome, I also looked for Dossena's resting place in Cremona. A marvellously efficient cemetery official went through seemingly endless records and then discovered Giovanni and Giuseppe Dossena in plot 169. As it turned out, they were cousins, but ironically just below 169 was someone named Palmira *Fasoli* who died the same year as Dossena – 1937.

34

In 1973, Karl Meyer wrote about what he called 'the reigning master' of Italian forgery to whom he gave the name 'Alfredo Kappa'. I was intrigued by the account, and a couple of sources in Rome not only assured me that it was true but insisted Kappa had gone on to other involvements which have been more recently reported.

Kappa sounds very much like the heir to the Pinellis, the Riccardis, and Alfredo Fioravanti. Meyer says: 'His work is on display in many museums, and he made some Etruscan wall paintings on terracotta which cost a European collector $1,200,000.'[4] As with our other Italian forgers, Kappa learned his skills outside school. In his case, he picked up the tricks of the trade while employed as a furnace worker in a tile factory. Kappa went on to become friends with a breed which has caused consternation in Italy recently – the *tombaroli* – tomb robbers and illegal excavators who have come to supply the world's major museums with Greek, Roman and Etruscan treasures.

One of the *tombaroli*, Luigi Perticarari, has become something of a celebrity in Italy after he published his memoirs in 1986 – *I Segreti di un Tombarolo*. Perticarari divulged how, over the past twenty years, an incredible number of artefacts – vases, bronze ornaments, gold and jewellery – have been taken from graves and made their way into the hands of international dealers. As in Dossena's day, most of the goods are taken into Switzerland where they enter the legitimate art market to be sold to museums and private collectors. According to Geraldine

Norman, the Getty Museum 'has formed a superb collection of antiquities over the last ten years, mostly from illicit excavations'. She also reports that 'The Metropolitan Museum in New York has made several spectacular purchases over the same period, including the famous $1 million Euphronios vase. "Every scholar knows it can only come from Cerveteri," complains Professor Palottino of Rome's Tuscia Institute, "but they continue to pretend it was found in Lebanon." '[5]

Kappa veered away from tomb robbing and like the Riccardi boys decided to have a go at making fake Greek vases and Etruscan terracottas, but he came up against the usual problem – provenance. With more imagination than the Riccardis or Fioravanti he fabricated his own Etruscan site. According to Meyer:

> In the 1960s, working with twelve other men, he began to dig a tomb; as luck would have it, he hit the remains of an authentic ancient chamber. Now he had a place to which he could bring dealers, and he sowed it with his own wares, coating his pots with the site's distinctive earth. In a four-year period, he sold hundreds of objects to leading dealers. He followed the progress of his art with satisfaction; sometimes pictures of it appeared on the covers of archaeological books or magazines.[6]

Kappa discovered an important Swiss dealer who was willing to bypass the usual middlemen and buy directly from source. He was taken to Kappa's underground treasure house and shown a collection of Etruscan plaques. The sum of $1,200,000 changed hands and the plaques were taken back to Geneva. Later the dealer showed them to Dietrich von Bothmer of the Metropolitan Museum who recognised them as clever fakes. He was unwilling to accept von Bothmer's verdict, but allowed some to undergo thermoluminescence testing. The result confirmed von Bothmer's suspicions.

Meyer says Kappa was unmoved by the result, and 'has since told me he has figured out a method of defeating the thermoluminescence test'.[7] Those in Rome who appear to know, say Kappa is still active – but has gone in more for the less taxing and more lucrative occupation of tomb robbery.

Defeating the thermoluminescence test appears highly unlikely to laboratory directors like Josef Riederer. He says, 'Only

a very small group of ceramics, made from a type of clay which does not give evaluable data, cannot be examined in this way.' Some who questioned the TL tests performed on Saint Louis's 'Diana' later maintained TL is invalidated if the object has been subjected to heat in modern times. I asked Riederer about this, and he exclaimed: 'It would have to be a great deal of heat – and why would anyone reheat an ancient object unless they wanted to destroy it?' I have no idea what is behind this apparently inane suggestion.

I also enquired if there were any substances that defied the tests his laboratory could perform. He mentioned granite and ivory which do not appear to undergo changes through ageing as happens with wood and terracotta. In an interview Riederer gave in 1985, he also said, 'It is hard to tell the difference between Renaissance and neoclassical imitations of Greco-Roman sculpture [in the lab].'[8]

Forgery is alive and well today, and not just in Italy. These days there is a new breed of forgers who have an arrogance not seen in the 'old school'. They need it, however, to face an increasing scientific expertise to unmask them. Riederer maintains, 'the question is whether the forger wants to go to the trouble and the expense to fool us. That's why I say we're winning the race.'[9] Christian Goller, a West German restorer who insists he is 'an imitator, not a forger', is well known to Riederer and one of the new breed. Like Kappa he feels he can outwit the men in the white coats. Goller was trained at Stuttgart's Institute of Restoration and Painting Technology, and thinks 'any determined forger, at least of paintings and polychrome wood sculpture, can easily outwit the archaeometric sleuths – if he is careful and willing to invest enough time and effort'.[10]

Archaeometry is a term increasingly used these days for the scientific pooling of resources of the physicist, chemist, geologist, art historian, restorer and archaeologist in the arena of art sleuthing and forgery detection.

Goller says he makes his own pigments – 'exactly the way the Old Masters did. We were taught how at the academy, and it is something every art restorer must know.' He also claims, 'Everything can be synthesized . . . a good forger will also examine X-ray studies of the master's works to see how he built them up, analyze the pigments and reproduce everything

exactly. He will get old, hand-spun, hand-woven canvas, which is not hard to obtain, or old worm-eaten wood, which is even easier to find.'[11]

Craquelure, the network of fine cracks which covers the surface of an old painting, develops a different pattern from one age to another, and from one artist to another. This has been a downfall for many a forger, and that fine network has been a useful indicator of whether you are facing a fake or not. Goller maintains: 'I can duplicate any craquelure by first removing the finished painting from its flexible support, then remounting it on the old canvas or wood, and baking it in the oven. That is delicate, painstaking work, but a standard restoration task. The end result will defy almost any authenticity test. It's all a question of how much effort a forger wants – and needs – to make.'[12]

With this self-confidence, Goller has imitated every period of art from Byzantine to modern, and has been most successful with Grünewald. One of his creations in that artist's manner, a wooden tablet of Saint Catherine, was sold to the Cleveland Museum in the 1970s for $1 million.

35

Not many forgers today would attempt as broad a repertoire as that of Christian Goller, and Meryle Secrest in *Memo to a Forger*, in 1983, advised against such audacity:

> if you are a man of lesser ambition, content with relatively modest ill-gotten gains, opportunity still beckons in that most chancy of all worlds, the art market. The winds of fortune are bound to blow in the direction of some hitherto neglected artist whose oeuvre contains some wonderful gaps, whose canvases tend to be small (small fakes are easier to pass off than large ones), and whose works are now selling for between $10,000 and $100,000, which is enough to make a fake worthwhile but not enough to make people suspicious. He's a natural.[13]

How would you best succeed in picture forgery today? Secrest and others have these suggestions:

1. The intelligent forger will avoid Great Masters like the plague – too many problems imitating and too much attention drawn to them.
2. If the forger restricts himself to works of the last hundred years (for which he can duplicate the pigments and materials with little anxiety) he must be careful to know exactly *all* that is available on that artist's known works.
3. The successful forger will know which markets to avoid. The drawings of Dali, for example, are unreliable as investments, and Rodin has been so imitated during his lifetime that nine out of ten of his works now appearing are fakes.
4. The sophisticated forger will study the little known areas of his master's life – that is the ripest field for 'new works'.
5. The forger must keep his fakes widely separated, so that the trained eye will not discern a family resemblance. *Never* keep them hanging side by side with the real thing for comparison.
6. The setting for the sale is important. Much better an up-market store window or the wall of a well-heeled collector than in the back room of a junk shop.
7. Finally – and depressingly – faking successfully means that every nerve must be keyed up to its highest pitch – and yet the result must look effortless.[14]

Secrest says, 'Gone are the days, as in the case of . . . Alceo Dossena, when a phenomenally gifted artist could suggest any historical style in sculpture from antiquity to the Renaissance and be believed. Buyers are less credulous nowadays.'[15] And 'forgers are less talented', remarked a speaker at a seminar on art forgery at the Metropolitan Museum. In the discussions about the problems dealers faced today it was evident the forger now has an advantage of better hardware and materials, but faces a new battery of sophisticated high-tec tricks which show up mistakes largely undetected in Dossena's day. But a museum curator insisted, 'We simply are not seeing fakers today with the talent of Ioni, Dossena or van Meegeren. Art experts also have come to be far more cautious in their appraisals. Notice how few are willing to go out on a limb for a piece under question. They're more like the careful solicitor who hedges his opinion with some escape clauses. They're

determined not to get stung again like in the days of van Meegeren.'

Han van Meegeren is undoubtedly the best known forger of modern times. His rise to – and fall from – fame is like a television soap opera. In the 1930s, the Dutch artist tired of painting portraits for rich American and British tourists in the south of France and decided on a new career. His choice of Vermeer was brilliant as his works were a very limited commodity. Van Meegeren supplied the creation of Vermeer's early 'missing years' with some convincing religious paintings. He imitated the predominant blue tones and characteristic pointillist brush work to perfection. He was also careful to purchase the costliest raw materials; all his ochres were ground and washed by hand. Van Meegeren used only the best burnt sienna and Venetian red. Vermeer's most notable blue was ultramarine made from powdered lapis lazuli, which van Meegeren obtained at great expense from a London firm.

The results were hailed as masterpieces and like Dossena he lived to read the lavish praise of experts. Abraham Bredius's words concerning his most celebrated work, 'The Supper at Emmaus', in *The Burlington Magazine* remain the most quoted kudos for a forgery: 'It is a wonderful moment in the life of a lover of art when he finds himself suddenly confronted with a hitherto unknown painting of a great master . . . just as it left the painter's studio! And what a picture! Neither the beautiful signature "I. V. Meer" . . . nor the *pointillé* on the bread which Christ is blessing, is necessary to convince us that we have here a – I am inclined to say – *the* masterpiece of Johannes Vermeer of Delft.'[16] Again like Dossena, van Meegeren was largely responsible for his own unmasking, and was not finally believed by some until he executed his final Vermeer under police supervision in 1945.

36

The most spectacular forgeries in more recent times have not come with sculpture or painting, but in documentary forgery. It is very much back in favour and involves some audacious efforts: the Vinland Map which to the horror of Italians appeared to indicate that the Vikings reached America before

Columbus; Clifford Irving's 'autobiography' of Howard Hughes picked up by McGraw-Hill for $650,000; the 'Hitler Diaries' which made fools of both a major German periodical and some important historians; and a case which has just been revealed in America and which for sheer imagination outdistances them all.

There are obvious differences between literary and artistic forgery, but their creators are remarkably similar in their need to be skilful, ambitious and full of gall. Charles Hamilton's shop off Madison Avenue has been known to New Yorkers for what must be decades, and nowhere in the world are you more likely to come across a better assortment of important autographs or signed historical documents for sale. Hamilton has also come to be recognised as one of the world's pre-eminent detectors of forged documents. He was the first to determine that the 'Hitler Diaries' were fakes.

Recently, however, he admitted to being taken in by one that he calls 'unquestionably the most skilled forger this country has ever seen'.[17] The forgeries which fooled him are among the most bizarre ever created, and surfaced in the spring of 1985 when the Mormon Church made public a group of letters which appeared to challenge the very foundations of their sect. The Church of Jesus Christ of Latter-day Saints is one of the most successful religious institutions in the world, but unlike liberal Protestant groups is not known for open debate of religious matters, to say the least. Obviously the church authorities were taking the materials very seriously.

The Mormons started in 1820 when young Joseph Smith had a series of heavenly visitations from God and Jesus Christ in New York State. He was informed that all existing churches were in error, that the true gospel would be revealed to him, and that he was to re-establish the true church on earth. An angel led Smith to discover some golden plates buried in a hill which had been left by an ancient prophet. The plates contained the true word of God.

With the use of some sort of supplied headgear (as he was illiterate), Smith translated the hieroglyphics on the golden plates into the Book of Mormon – hence the sect's common name. The discovered letters in 1985 appeared to conflict with the details of that oft-told beginning. One of the letters was reported to be the oldest ever found in Smith's own handwriting,

and suggested he was enamoured by folk magic and the occult. Far more damning was another which said young Smith was not guided to the golden plates by an angel but by an old man who changed into a white salamander. The difference between an angel and a salamander was not missed by those acquainted with nineteenth-century rural occult practices – the reptile appeared prominently in the latter. Smith was beginning to sound very much like any number of crank occult preachers of the day.

As one worried Mormon scholar put it, the effect was 'as if a letter from St Peter casting doubt on the truth of the Resurrection had been found'.[18] Some Mormons left the faith in disgust while the hierarchy tried to close a Pandora's box they themselves had opened. A few were saying the letters were fakes, but as a Brigham Young history professor retorted: 'How can the letters be genuine one day – and forgeries the next?'[19]

The situation was complicated in October when a series of murderous bombings occurred in Salt Lake City. The first bombs killed a businessman, Steven Christensen, who picked up a package when he arrived at work, and was consequently blown through his office door. Another killed the wife of Christensen's business associate, Gary Sheets. A third explosion in a car nearly killed Mark Hofmann, a dealer in old Mormon documents.

Police soon discovered some connections. In 1983, Christensen had paid Hofmann $40,000 for the 'salamander letter', and a search of Hofmann's wrecked car and his home revealed that he had certainly built the first two bombs, and possibly the third which injured him. In the boot of Hofmann's car, the police also found a bunch of other remarkable documents of early Mormon church history – and $270,000 in bank drafts and money orders.

Among the papers discovered were letters written by William McLellin, an early Mormon leader and a close associate of Smith. One report said these mentioned Egyptian papyri from which Smith had translated the Book of Abraham, a lesser known Mormon text. It appeared that Hofmann had been going to the Mormon hierarchy for some time with documents which might be embarrassing to the faith. Christensen and the wife of his business associate had been researching the 'salamander letter' and other Mormon documents. *The Deseret News*, a

paper owned by the Mormon Church, claimed that the 'salamander letter' and other papers were forgeries, and that Hofmann was desperate to prevent this from being revealed.

The hierarchy decided silence was the best approach, and let the police get on with their investigation. As it turned out they were right, but the faithful did not need to be reminded how duped just about everyone in authority had been by Hofmann. On 23 January 1987, Hofmann was sentenced to life imprisonment after he finally pleaded guilty to two counts of second-degree murder and two of theft by deception. The trial revealed that he had not only fooled the hierarchy, but virtually all the nation's top forgery experts who had been brought in on the case. It was the latter who had kept the investigation going for so long.

Robert Lindsey, reporting for *The New York Times*, also disclosed that Hofmann 'was as successful in selling forged documents in New York as he was in Utah. They say he may have collected more than $2 million selling rare documents purportedly written or signed by such literary and historical figures as Charles Dickens, Mark Twain, Jack London and Jim Bridger, the fur trader who is believed to have been the first white man to see the Great Salt Lake.'[20] And that was not all. The Schiller-Wapner Gallery in New York acted as intermediary between Hofmann and the Library of Congress in

what nearly became the costliest transaction ever involving a historical document. According to investigators, Mr Hofmann contended in 1985 that he had found first one and then two copies of the 'Oath of a Free Man', a long-vanished broadside printed in 1639 that was drafted by members of the Massachusetts Bay Colony to promote freedom of conscience. The document is regarded as a pivotal artefact in the evolution of democracy in America.[21]

Hofmann learned his materials well, and employed an ink developed in the sixteenth century composed of excretions of the oak tree. He carefully avoided a mistake made by the forger of the 'Hitler Diaries' by getting the correct paper as well. Hofmann utilised fly-leaves or other blank pages from books of the right periods for his forgeries. Still smarting from the shock of being so duped, Charles Hamilton gave a good assessment of Hofmann: 'In a way, two murders are pedestrian crimes. But to

fool me . . . to fool the whole world, requires not only forgery but
a packaging of himself. He packaged himself as a bespectacled,
sweet, unobtrusive, hard-working, highly intelligent scholar
dedicated to the uncovering of history. Now we know he's more
than he appeared to be.'[22]

37

Max Friedländer maintains that the life of a fake seldom lasts
thirty years, or its own generation, but of course, the best
forgeries remain undetected in museums. The dominant
figures of art forgery have been presented in the following
manner: Bastianini, the first modern forger to appear by name,
dominated the latter part of the nineteenth century. Dossena
was the next major figure, and was followed by van Meegeren
in the 1930s. The fifties 'star' was Jean Pierre Schecrown; the
sixties had Henri Haddad ('David Stein'); the seventies Elmyr
de Hory; and the eighties Tom Keating.

There were others, but these are the ones most frequently
mentioned. Keating remains the best known British forger, but
this is due more to his television performances than to his
particular creations. The forgers who have emerged in the last
twenty years or so are a rather mundane lot when compared to
van Meegeren or the flamboyant de Hory. The literary forger,
Clifford Irving, presented the story of de Hory in *Fake!*, in 1970.
De Hory was an expatriate Hungarian who allegedly painted
hundreds of Picassos and Matisses which still fetch high prices
in Texas and California.

An interesting phenomenon has been developing over the
past few years – the appearance of a number of works judged by
some to be forgeries but difficult to assign to any known forger.
Dossena would be either amused or proud to know how certain
remarkable objects have recently been suggested as from his
hand.

The first to come to my attention was offered to an important
gallery in New York as 'a genuine Greek head of the Archaic
Period'. The gallery was suspicious, but 'found it so beautiful it
felt it should be considered'. Some scholars they asked to
examine it thought it was not likely to be ancient and suggested
it might be by Dossena. I showed photographs of the piece to

several museum experts and they all agreed it was a fake, citing its apparent combination of styles dating from various periods. The break – with so much of the neck attached to the head – was also suspicious. This is not what happens with ancient pieces. Also noted was its 'Cypriot appearance'.

Just about everyone who has viewed the head admires the handsome face, and the patination is extremely convincing. However, Cellini and Walter Lusetti both feel the piece was not the type of creation Dossena ever attempted. Dossena was never comfortable with the male form which is especially evident with his 'abducting hero' in the Munich group. There is a feminine quality to the hero and several other young males Dossena sculpted. Otto Kurz says the hero 'has the same weak and fleshy roundness of face as the woman'.[23]

A more likely candidate for the Cypriot-looking head woul ʲ be Gildo Pedrazzoni who helped Dossena with his acid baths for statuary, and, according to Parsons, went on to create Greek works himself which 'fooled' Italian archaeologists when they were exhibited in Rome in 1947. I have encountered a number of scattered references to Pedrazzoni in the research for this book, and there is no doubt he tried to continue the success of his 'maestro' on his own. One dealer in Rome told me that Pedrazzoni was responsible for some very convincing pieces 'which made their way to the New World'. I tried to get him to be more specific, but all he would add was, 'Someday soon Pedrazzoni's efforts will be disclosed, but you have to remember that he learned from the mistakes of Dossena – and covered his tracks very well.'

One of the archaeometric sleuths we interviewed for the BBC programme said that an influential gallery in London (which insists upon remaining anonymous) had recently come across a group of marbles they were certain were 'either by Dossena – or of his school'. Two others showed me photographs from their files of an accompanying angel Dossena had made for the Boston tomb which has come up for sale again – as a genuine Renaissance work. Parsons, it will be remembered, had noted in 1956 that some of Dossena's works, including the Cleveland Museum's 'Pisano Madonna', were being held by Roman dealers who hoped their sons would succeed 'in repeating their old tricks'.[24] There is no doubt there are any number of Dossenas still out there for sale, and I have been surprised by

the number of pieces which have surfaced which are not pictured in the 1955 book, or even in Lusetti's collection of photographs in Rome. Dossena's sheer output is almost beyond comprehension.

In Pope-Hennessy's 1974 *Apollo* article there is a marble relief of the 'Madonna and Child' by Dossena quite similar to one of his terracottas at the Victoria and Albert. It is listed as belonging to the National Museum of Western Art in Tokyo.[25] I wrote to the curator enclosing a copy of the photograph and asking how the Dossena came to Japan. Madoka Ikuta replied: 'I've never even heard that the said marble would be here in Japan. I hope that you will ascertain whether the information is true.'[26] I tried to 'ascertain', but got no response. Curiously the reprint of the article in *The Study and Criticism of Italian Sculpture* (1980) does not carry the photograph.[27]

Another 'missing Dossena' is mentioned in Russell Lynes' article of 1968. In the 'Christmas Eve 1916' story Dossena was carrying under his arm 'the bas-relief of a Madonna which ultimately turned up in St Louis as a Donatello'.[28] After discovering that the 1916 tale was largely an Augusto Jandolo creation, I did not think much about the reference, but it reappeared elsewhere. There was even a suggestion that the 'Donatello Madonna' was once in the hands of the Durlacher firm, and that one of their American proprietors, R. Kirk Askew, had sold it to the Saint Louis Museum.

The only 'Donatello Madonna' known to have been executed by Dossena is the huge piece earlier described and now in a private collection in Venice, and was hardly under Dossena's arm – or anyone else's at any time. I asked the Saint Louis Museum to check their files for a possibility. As before, Saint Louis responded, and the only work now in the museum which could possibly fit is a lovely creamy white marble bust in high relief of a lady who could just as easily have been a 'Madonna'. To my untutored eye, she appears far more likely to be a candidate for something done by Bastianini, and Charles Seymour reported in 1967 that it was a fake – but earlier than Dossena. I guess that by 1967, Saint Louis was very Dossena conscious. The bust was sold to them in 1928 by the New York firm of Arnold Seligmann, Rey and Company.

Another museum which appears unperturbed by suggestions that a Dossena is lurching around in their collection is one of the

world's richest – the Collection Thyssen-Bornemisza at the Villa Favorita in Lugano. When Baron Heinrich Thyssen bought the villa from Prince Leopold of Prussia in 1932, his art collection was already so vast he had to build another twenty galleries. Today it is estimated that the Thyssen collections have a purchasing power of five times greater than the National Gallery, the Tate, and the Arts Council put together. According to an article in *Antique*, the present Baron Thyssen 'is rumoured to spend at least $10 million a year on pictures . . . After the Queen, Baron Thyssen possesses the most valuable private art collection in the world.'[29]

The present Baron, Heini Thyssen, lives much of the year at Daylesford in the Cotswolds, and is an enthusiastic supporter of the British art market. His father, however, was not a particularly discriminating collector on occasion, and purchased in wholesale fashion huge numbers of statues from Italy before the Second World War.

One piece, a marble statue of 'a female saint', is attributed to the style of the little known fourteenth-century Sienese sculptor, Tino di Camaino. A leading expert on Renaissance sculpture suggested to me it might be a Dossena. I wrote to the Thyssen collection in Lugano, and they responded: 'We are aware of the fact that the statue must be a fake, but we do not know by whom it could have been done.'[30]

The catalogue information is very sparse but indicates the baron had acquired the statue before 1938, and that it appeared in a 'Bulletin of Art' in Rome in 1935 which, of course, fits Dossena quite well. All his pieces at this time, however, carried his signature, but who knows, perhaps as before, some enterprising dealer scratched out the evidence. The statue certainly does have a Dossena look about it, and is remarkably similar to several female saints Dossena created after his exposure and which were later pictured in the Lusetti book.

38

A museum that resents even the hint that it might have a Dossena is the J. Paul Getty in Malibu, California, the richest art institution in the world. According to Thomas Hoving the Getty Trust has up to $90 million to spend annually.

Some in the art establishment feel that Hoving, former director of the Metropolitan in New York from 1967 to 1976, in his new position of editor-in-chief of *Connoisseur* magazine has embarked upon relentless Getty-bashing. He has frequently attacked the poor quality of the Getty's acquisitions. His article, 'Money and Masterpieces' (December 1986), which couples the Getty with the Kimbell Art Museum of Fort Worth (Texas) gives the decided edge to the latter, largely because Kimbell has the director 'with the golden eye', Edmund Pillsbury; while the Getty's director, John Walsh, is 'the man with the gold'.[31]

With Geraldine Norman of *The Times*, Hoving exposed a huge tax fraud at the Getty involving its former curator, Jiri Frel, who amassed a collection of antiquities by allowing donors to deduct the full value of charitable donations from taxable income. That was perfectly legal, but the value of the items had been highly distorted by Frel. 'One sculpture, a Roman bust, was sold at Christie's, London, in 1978 for £440, then given anonymously to the Getty a year later with a valuation by Mr Frel of £30,000 . . . Between arriving at the museum in 1973 and his enforced departure in 1984, more than 100 donors contributed items valued, according to the museum's tax return, at £9.6 million.'[32]

Hoving has known controversy throughout his several careers. As a former New Yorker, I remember his flamboyant and innovative time as Parks Commissioner for the city. Thomas Pearsall Field Hoving, now 55, is the son of the former chairman of Tiffany's, and was educated at Princeton University. He rose from being the assistant curator at the Met's medieval department to become director in 1966, when James Rorimer died. Apparently he was chosen over 120 other candidates. As a *Newsweek* cover story put it: 'The Met had known Francis Henry Taylor as "a fire of genius" who was followed by James Rorimer "a sound housekeeper", and now they were looking for another "fire of genius".'[33]

As Parks Commissioner, Hoving turned New York into 'Fun City' with his 'Hoving Happenings' in Central Park – it was a good time to live in the city. The Met also reacted well to his special brand of panache and showmanship, and in his first year as director he exceeded by a million the previous attendance record. Some museum officials, like William Milliken's successor at Cleveland, Sherman Lee, reacted to Hoving's leadership

with less than enthusiasm: 'A museum is not a community center,'[34] he pronounced. Hoving's *King of the Confessors* outraged many in the museum establishment, as he did the unthinkable: revealed in great detail the inner sanctum of the museum world and the iniquities of international art dealing.

In September 1983, a life-size Greek kouros (nude youth) with broken arms and legs was sent to the Getty on approval. In January 1985, it purchased the piece for $7 million. The Getty is one of the world's newest museums. Twelve years ago, the oil magnate, J. Paul Getty, recreated on Pacific Coast Highway the Villa dei Papiri, which once stood on the slopes of Mount Vesuvius overlooking the Bay of Naples. Getty's villa is in an area not prone to volcanic activity – but most certainly to earthquakes.

Though a teenager among museums the Getty already possesses works of Rembrandt, Rubens, Van Dyck and other masters plus an impressive number of Greek and Roman antiquities. It can afford anything which comes on the market. But that is the hitch – the great works it would like are already owned by others. With its huge spending power, the Getty has become prone to buying fakes. After turning over $7 million for the kouros, an early Flemish painting of *The Annunciation*, attributed to Dieric Bouts, arrived in Malibu on approval. The Getty parted with another $7 million soon after. Both painting and kouros were challenged as fakes before the Getty signed the cheques.

In April 1986, the Getty Museum purchased an *Adoration of the Magi* attributed to Mantegna at a Christie's auction for £8.1 million. The Minister for the Arts delayed issuing an export licence in order to give the National Gallery of Scotland a chance to match the price and keep the work in Britain. Some experts were not sorry Scotland was eventually unable to match Getty's buying power. A Royal Scottish Academician, Peter Collins, noted numerous tell-tale items in the painting which indicated it could not be of the time of Mantegna.[35] Five years ago, the Getty spent only $35,000 for a sixteenth-century panel (a 17½-inch square) which they insisted was by Hans Holbein the Younger. It was a bargain, but it too was challenged as a fake.[36]

The public rarely knows about such wheeling and dealing in the art market until sleuths, termed 'sale room correspondents'

in this country, bring them to our attention. Geraldine Norman is recognised and feared as the best, and on 9 August 1986 she released *Connoisseur*'s story (to follow in September) that the authenticity of the Getty kouros was being 'challenged openly for the first time'. Hoving viewed the piece and found it 'strangely stiff, cautious and mechanical in execution. The condition seemed too pristine for an ancient piece. I wondered why the Getty would take the risk of buying an antiquity doubted by even as few as three or four experts.' One of them was Iris Love who was bothered by 'the number of styles dating to different periods'.[37]

Pico Cellini was even stronger in dismissal: 'That figure is simply revolting: *Una schifezza*! Half man, half woman, and clumsily broken to boot!' The grainy quality of the marble also bothered him, and he maintains that photographs he saw of the statue forty years ago when it had been unsuccessfully offered to the Boston Museum did not indicate that surface. 'They probably sandblasted the piece.' Cellini also says he does not reject the piece because of its style – 'but because of its styles – the hair looks like an Egyptian headdress, the mouth like a Louis XVI commode handle. The figure has a lopsided belly button and is even circumcised, a feature rare in, if not totally absent from, early Greek art.'[38]

A clean bill of health had been given, however, by Martin Robertson, former Lincoln Professor of Art and Archaeology at Oxford, and Ernst Berger, director of the Antikenmuseum in Basel. The kouros went on exhibition on 4 November 1986. Marion True, curator of Antiquities, at the Getty came to the defence of the kouros in *The Burlington Magazine* in a highly balanced article. She did not shy away from the obvious problems of the piece and noted its 'eclectic nature . . . The fleshy, asymmetrical face is sensitive and refined, buoyant in its joyful expression and almost feminine in its sweetness.' The face was, however, 'entirely consistent with the slender proportions of the body'.[39] Cellini's objection of circumcision was ridiculous considering True's reminder that the glans of the penis was missing. The concluding remarks contain the heart of the matter: 'Perhaps the unexpected conjunction of features in the statue will ultimately be explained by the discovery of its place of origin, which is still unknown.'[40]

Geraldine Norman and Thomas Hoving are working hard to

track down that origin. The provenance is vague in the extreme: 'The Getty kouros was spotted in 1984 by . . . Jiri Frel at a "Swiss art dealer" who is said to be a Signore Becchina, with headquarters in Basel and Rome. Before that, according to . . . John Walsh, it was in a "Swiss private collection that I cannot reveal".'[41] Cellini suggests that the origins of many similar archaic kouroi

> may be traced back to the Paris atelier of the sculptor Rodin. The story goes that after the excavation of the port of Sounion, two votive figures of *c.*600 BC were shipped to France. The Greek government lodged a protest and the French authorities returned the pieces. Some years later, however, rumour had it that although the figures from Sounion had been returned, other pieces . . . had come into the possession of Rodin and other lovers of Greek art. The fact that most of these pieces were disfigured by chisel blows and had no patina was explained by fanciful reports that they had been stoned by Persian invaders, then reverentially buried in airtight lead containers by the Greeks.

The chief source of this misinformation was one of the dealers with whom Harold Parsons had many dealings, Joseph Brummer, who had been Rodin's studio aide. Brummer went on to become a major New York art dealer, but in the Parsons' notes I read in Rome, Parsons' boss and friend, William Milliken, said he had always mistrusted him. Cellini feels the Getty kouros – and several other works he questions – come from this Brummer-connected batch: 'The formula was one part Italian instigation, one part French execution, one part international marketing.'[42]

Two other links with the Marshall–Warren–Parsons connection have also surfaced in my reading and correspondence. Marion True wrote to me about another kouros that was offered for sale to the Boston Museum by Lacey D. Caskey, curator of the Classical Collection from 1912 to 1944. Caskey catalogued Warren's acquisitions, and was close to both Marshall and him during the later years of their collecting. Marion True says that 'Old photographs in the file, however, prove that this modern forgery is not our statue.'[43] Considering Warren's close contact with Rodin, one cannot help thinking that there is something in Cellini's suggestion of its origin – but he may also have

mistaken the Getty kouros for that offered to Boston by Caskey.

I had returned from the Ashmolean library at Oxford two days before Geraldine Norman's article on the Getty kouros, and the descriptions given rang a few bells. John Marshall frequently arranged his notes according to subject matter, and after discussing a request from the Cleveland Museum, for 'four Greek statues of fairly good quality' which they needed for their central rotunda, was an entry dated 30 April 1925 in which Marshall said he

> saw at the villa of A. Cauesia near Naples a marble statue whose legs and arms had been broken. The style was that of an archaic Greek kouros, and my first impression was that it was a Roman copy. The surface was beautifully smooth, but the patina reminded me more of ancient Greek works. The hair was elaborate and plaited in the manner associated with the archaic style. I found the figure rather feminine in appearance, and the smile unsuccessful.[44]

Unfortunately, that is where the entry breaks off. The description was similar to those given for the Getty kouros, and my first thought was the temptation to leap from A to B to Z. Dossena? We know of Dossena's lack of success with the male form and the Greek smile. The date is perfect. But one isolated description is not much to go on. I sent the description to someone who has dealings with the Getty Museum and they appeared horrified at the hint in the beginning. Subsequently, Marion True has entertained all possibilities of origin – and they certainly will need to do so as Geraldine Norman later shot down the scanty provenance given to the public.[45]

It appears unlikely that Dossena ever created anything like the Getty kouros – or the beautiful 'Cypriot' head, but there is more than a hint of serious possibilities regarding the mysterious Gildo Pedrazzoni. One rumour says that a museum expert remembers seeing 'G.P.' scribbled on the Getty statue. Rumours are also not much to go on, but I suspect much more is going to be heard from Dossena's 'children' – especially the young man who took such a keen interest in his master's expertise with chemical baths.

PART SEVEN

The Blame

39

In December 1928, *Art News* ran two consecutive editorials on the implications of the Dossena affair.

It may perchance be that the present revelations will temporarily lessen the faith of the general public in the omniscience of museum authorities and experts in general. If this means a genuine break in confidence . . . the Dossena episode will be unfortunate. If, on the other hand, it means that the American public ceases to regard certificates by noted authorities as the last word on the value and importance of a work of art, Signor Dossena may have done a good turn after all.[1]

Earlier *Art News* was more specific:

The recent disclosures reveal something more than the fact that scholarship has sometimes stumbled. They show, primarily, that laymen and experts alike suffer too much from the tendency to give weight to attributions and neglect qualitative appraisal. To give a thing a name is apparently more than half the battle toward establishing it as an authentic work. If it is asserted boldly enough that Mino is the author of a marble tomb or Vecchietta of a pair of reliefs, scholar and layman exert themselves to prove the rightness of the ascription.[2]

Next the editorial took on those who were so gleefully 'heaping shame upon' works already proven false: 'a host of men who would otherwise have written in its praise. It is easy, now, to point to the anachronisms in the Mino sarcophagus, since we know that the work was done in the XXth century. But these same anachronisms were accepted by many as proof of the object's genuineness before the debacle.' Lastly, *Art News* asserted:

Emphasis has been placed, too, upon the insatiable desire on the part of museums and collectors for 'supreme masterpieces'. We must have Donatellos, Vecchiettas, Simone Martinis, Desiderios and the Pisani . . . We are eager to persuade ourselves that the name given to a work is evidence of greatness and to find or invent plausible arguments to support our optimism. The search for names

is much more avid than is that for quality and the faker is quick to take advantage of our aberration.[3]

Who's to blame for art forgery? In our preparation for the 'Timewatch' programme it was interesting to see how many dealers and museum officials heaped almost all the censure on the forger himself. Perry Rathbone's 'Dossena was a crook' remark at Christie's is not atypical. A New York dealer who has been royally stung on more than one occasion told us: 'Forgers are the scourge of the art world, and I find it a chief task – acted out with pleasure – to root them out.' Is it as simple as that? More importantly, is it not the truth that the market itself is just as responsible for the proliferation of fake art works as the man with the chisel and the paint-brush? And what about the general attitude towards art today which increasingly concentrates on monetary worth?

James L. Swauger at the Carnegie Museum in Pittsburgh has listened for years to comments about the scourge of forgery. He wrote an article, 'In Praise of Forgers', a few years back in which he said:

> It was with grim amusement the other day at lunch that I heard a comment of David Owsley, curator of Arts at Carnegie . . . He remarked that the number of experienced forgers producing excellent fakes has grown so large that buyers are becoming wary of purchasing antiquities; this to the extent that such buyers may soon demand certification of excavation by a reputable working field archaeologist and processing of the transaction through legal channels. Ha! The sun rises. More power to the forgers. May their tribe increase! They, at least, harm no one and nothing but the buyers.[4]

We may not go that far – but there are forgers and there are forgers. Many have been outright crooks – there is no doubt about that. It is difficult to have much empathy for the likes of Elmyr de Hory or the early career of Clifford Irving, or the recent revelations concerning Mark Hofmann in Salt Lake City. Ioni was indeed a rascal on more than one occasion, and there have been any number of works created as elaborate jokes. As Sepp Schüller says of the latter, 'Their exposure as a rule leads only to amusement. But the laughter is of a kind calculated to teach over-enthusiastic and credulous collectors a

much needed lesson.'[5] Other forgers like the Riccardis and 'Kappa' had their hand in other crimes as well – tomb pilfering and false attributions.

Van Meegeren saw himself as a victim of the dealers, experts and most especially critics. At his trial in 1947 he declared: 'I didn't do it for the money . . . I had been so belittled by the critics that I could no longer exhibit my own work. I was systematically and maliciously damaged by the critics, who don't know the first thing about painting.'[6]

Bastianini and Dossena were a different breed and, with both, it is still unclear as to the full extent of their collaboration with their fraudulent employers. With Dossena the jumbled remains of the Roman court records when he came to trial in 1929 indicate there were no grounds for proceeding against him. In the most lengthy interview he gave the press, Dossena did open the curtain a bit as to his feelings regarding his duplicity:

> Yes, I was the man, I am he who made all those sculptures which caused so much astonishment and admiration, sarcophagi, Madonnas, cherubs, reliefs and all the rest of them. But I'm not a forger. I'm not a swindler. I never copied works. I simply reconstructed them. Even as a boy . . . at Cremona I grew to be perfectly familiar with the various styles of the past, not as represented by any particular treatment of line or mass, but as manifest in the spirit to which they gave material expression. I could not assimilate them in any other way. And that was how I produced all my sculptures, which really deserve to be prized as highly as those of Donatello, Verrocchio, Vecchietta or da Fiesole.[7]

In a sense, Francis Henry Taylor, former director of the Met, probably had the best last word regarding Dossena. In 1953, when Russell Lynes complained to him that so many doors were closed to his investigating the forger, Taylor responded to Lynes's query: 'Were that that many important people involved with the affair?' – 'Everybody had a piece of it . . . and make no mistake about it; Dossena was a very smart fellow.'[8]

40

Arthur Koestler took the role of the devil's advocate regarding art forgery in a piece entitled, 'The Aesthetics of Snobbery'. He

began by describing a case which has a well-worn theme. In 1948, a German art restorer, Dietrich Fey, while working on the restoration of Lübeck's ancient Marienkirche, had to stop excavations as portions of Gothic wall painting began to appear. He employed his assistant, Lothar Malskat, to restore what seemed to be priceless thirteenth-century drawings. In 1951, Chancellor Adenauer came to Marienkirke for a ceremony to celebrate the discovery. Photographs of the occasion show a pleased *Der Älter* next to Fey and Malskat.

Praise was heaped on the discovery and subsequent restoration, and photographs were included in scholarly books on German art. The German Post Office issued special stamps showing details of the paintings. Two years later, Malskat revealed he had created and painted the thirteenth-century masterpieces, and asked to be tried for forgery. German art experts refused to believe him and claimed Malskat was seeking cheap publicity. Only after a Board of Investigation was shown hundreds of works by Malskat – Rembrandts, Toulouse-Lautrecs, Picassos (many of which were in Fey's house) was the forger believed and Fey's master scheme realised.

Koestler says of the case:

My point is not the fallibility of the experts ... The disturbing question that arises is whether the Lübeck saints are less beautiful, and have ceased to be 'a valuable treasure of masterpieces' simply because they had been painted by Herr Malskat and not by somebody else. And furthermore, if van Meegeren can paint Vermeers as good as those of Vermeer himself, why should they be taken off the walls of the Dutch or other national galleries?[9]

Koestler gives a number of other examples (similar to those we have seen throughout the book) and then adopts attitudes which are as responsible for art forgery as the forger himself:

We all tend to believe that our attitude toward an object of art is determined by aesthetic considerations alone, whereas it is decisively influenced by factors of a quite different order. We are unable to see a work of art isolated from the context of its origin or history ... most people get quite indignant when one suggests to them that the origin of a picture has nothing to do with its aesthetic

value as such. For, in our minds, the question of period, authorship, and authenticity, *though in itself extraneous to aesthetic value*, is so intimately mixed up with it that we find it well-nigh impossible to unscramble the two. The phenomenon of snobbery, in all its crude and subtle variants, can always be traced back to some confusion of this type.[10]

How our attitude towards a work changes – to say nothing of the dealer's price – when an earlier admired work turns out not to be a Picasso. It just does not look as good. We are all conditioned to the reaction – 'Oh, it isn't a Picasso!' We begin to see faults never before noticed. And yet, does all its value really come from the lower right-hand corner?

I have a friend in San Francisco who bought what was sold as a 'study for a painting by Rembrandt'. The dealer was highly respected and he paid a good price. It was gloriously framed by the best art shop in the city, and the drawing took a place of pride over his mantelpiece. It was beautifully lighted and all his friends remarked as to 'how fortunate' he was to have discovered it. There was no denying what a pretty scene it was – the Holy Family en route to Egypt in intricate detail. I quite liked it, but on a visit a year later I noticed the Rembrandt was gone, and in its place a large Haitian painting.

My friend told me he had taken the drawing to the De Young Museum, and an expert told him it wasn't by Rembrandt – or even from a school of Rembrandt. Most likely it was the work of a minor Dutch artist who had studied the master, and it was an attempt to emulate Rembrandt's craftsmanship. My friend was aghast at the revelation and felt cheated. The dealer reminded him the label had not really said Rembrandt had done the piece and he had warned him it was only 'judged' by one expert 'to be connected with the master'. I told my friend that as far as I was concerned the work was still beautiful – and he fetched it from the cupboard and gave it to me.

I have it in my sitting room, and am certain I would probably feel different about it if it were a Rembrandt, even though I might protest to the contrary. Names – and big ones at that – are the one essential factor in selling art today. The sum of £800,000 was raised to prevent a Leonardo sketch, to which scant attention had previously been paid, from leaving Britain. And in the United States what about the thousands of us who

queued in 1961 for a second's glance at *Aristotle Contemplating the Bust of Homer*, after the Met purchased the Rembrandt for $2.3 million? Someone remarked that most of us would have as willingly queued to view the $2.3 million.

There is no field of human endeavour more riddled with snobbery than the art world, and it appears to be getting worse. Leaf through the art magazines. The first twenty or so pages consist of classy advertisements linking art to furs and cosmetics and the right place to live or eat or buy. Highly priced art is supposed to 'say something about you'. It is now an essential ingredient in the snob package of the new rich.

Commercial art galleries thrive on snob appeal. First and foremost they must appear unwelcoming – and even intimidating. The façade must project an entrance into a world of status. The staff appear graduates of a reverse Dale Carnegie course, and seem to think that 'grand art' has made them grand. What is unforgivable about many of them is how little they seem to know about art. The setting for galleries has become more important than the wares for sale – the frame more significant than the painting.

Koestler says, 'The art snob's pleasures are derived not from the picture but from the catalogue' as 'the social snob's choice of company is not guided by human value but by rank or celebrity value catalogued in the pages of *Who's Who*.'[11] With this perversion of values one wants to re-echo Swauger's 'More power to the forgers. May their tribe increase!' With there not being a supply of masterpieces to meet the demands of dealers and their clients, forgers are simply giving them what they want.

Snobbery in the art world, unfortunately, is not confined to dealers, clients and glossy art magazines. In the spring of 1974, the Louvre cancelled its plan to exhibit Pablo Picasso's private art collection. The reason given was that the Louvre discovered some of the pictures were fakes. After the cancellation, a number of observers learned that Picasso had known full well this was the case and 'hadn't given a damn'. The Louvre could not bring itself to have fakes on its walls – or come up with labels saying something like 'probably not by Soutine' or 'of doubtful origin'.

The critic Alan Green attacked the cancellation as snobbery, and added, 'Maybe the Louvre was exercising an educational

responsibility when it refused to hang a fake as, say, a Kandinsky. But mightn't it have been at least as educational to hang the exhibit and to say that Picasso believed in his enjoyment of these pictures even more than in some of the signatures?'[12]

There are more Rembrandts in various collections around the world than Rembrandt could possibly have created in his lifetime. Recently, the Rembrandt Research Project, a Dutch group of art historians who study the authenticity of all paintings attributed to the master, presented a list of works in museums in need of new labels. Two were at the Met which had already downgraded fourteen of its thirty-eight Rembrandts. Philippe de Montebello, the director, decided in November 1986 that 'for the moment' it would not relabel the two as 'from the workshop of Rembrandt'. De Montebello probably feels that enough is enough.[13]

'Deattribution' – or the preferred 'reattribution' – is a delicate subject at museums today and has a great deal to say about the general notion of art forgery. I was amused at the variety of labels presented at the Met's brilliant exhibition, 'The Age of Caravaggio' in 1985. We went from 'By Caravaggio' to 'After Caravaggio' to 'Attributed to Caravaggio' and even, 'Attribution Disputed'. Recently Grace Glueck presented the rise and fall of a number of masterpieces in American museums. 'Downgraded' was a Grünewald tablet by Christian Goller at the Cleveland Museum. 'Downgraded then upgraded' was the Met's Greek bronze horse which had been declared a fake by Joseph V. Noble, in 1972, after his involvement with the Etruscan terracotta warriors.[14] Thermoluminescence testing proved that the core of clay and calcium was between 2,000 and 4,000 years old. It is said that the Met's announcement of the test results on the eve of Noble's being considered as Perry Rathbone's successor was a major factor in his not getting the job.

According to John Walsh at the Getty Museum, 'Reattributions are the price of having a good collection, and the fruit of good scholarship. If your staff is active and doing its work and reading that of other people, it's a given that you'll be changing labels. It's a curatorial occupation.' Grace Glueck commented, 'Though to the public "reattribution" may sound pejorative, to art professionals the word has no such connotation.'[15]

Horst W. Janson reminds us:

American museums are more up-to-date than their European
counterparts. In Italy . . . no attribution ever gets changed. You go
to the Bargello in Florence and the labels haven't been changed in
75 years; it's just too much trouble, or no one takes the responsibil-
ity; why get into trouble by changing the label? The ultimate
criterion is always the visual impact. Never look at an artist in
isolation. There is not an artist known whose assumed work is not
subject to modification. Nothing can be taken for granted.[16]

41

Copying old masters was an encouraged practice in medieval
and Renaissance times. Emulating the peculiar brushstrokes
and mixing of colours was seen as an important part of the
novice's education. Few old masters were without eager young
copyists, and many old masterpieces have more of 'the school'
about them than the master. In some cases, the students
surpassed the teachers, as with Leonardo and Verrocchio.
Leonardo's angel in Verrocchio's *The Baptism of Christ* is far
more interesting even to untutored eyes. Vasari says Raphael
imitated his master Perugino so expertly that it was impossible
to tell the one from the other. Andrea del Sarto executed a copy
of Raphael's portrait of Leo X so expertly it was necessary to
have Andrea later tell the Medici family which was which.

The concept of 'original' in art sometimes has to be stretched
very far. Seventy-odd Degas bronzes were all cast after the
master's death, and Picasso never saw the resulting sculpture
constructed from his design in downtown Chicago. Holbein
merely drew on wood blocks, leaving the carving to students.
What is originally Holbein? The most amusing recent variation
of this theme occurred recently in the Met's museum shop.
Someone from the museum discovered that its reproductions of
early American glassware were turning up in smart New York
antique stores for sale as originals. The Met was forced to stamp
MMA on the remaining copies.

Authenticity is at times as relative as forgery. Sally-Anne
Duke, a partner of Antique Discovery, a London shop which
tracks down antiques for clients, asks: 'The problem is basically

what do you call a fake? There is really little left that doesn't have restoration. On the whole, you will not find a totally new piece in the antique shops. It's possible for the restorer to do anything with a piece of furniture.'[17] And, as we have seen with Ioni and others, the same occurs with paintings in restoration.

Augusto Jandolo admitted that 'the step from restoration to forgery is soon taken',[18] and his family's shop on the Via Margutta certainly should know. The German archaeologist Pollak, who was well known to John Marshall, unearthed further components of the ancient *Laocoön* in 1905, which indicated that the original sculpture found in 1506 had been disfigured by Michelangelo's collaborator, Montorsoli. Another Warren–Marshall associate was the archaeologist, Thorwaldsen, whose restoration of the renowned sculptures from the temple at Aegina (now in the Munich Glyptothek) 'amounted to forgery' according to Schüller. 'Missing portions were carved to the originals with iron plugs. It was realised that these restorations were quite incompetent and bore little relation to the grouping of the figures. But no one ventured to revise them. An opportunity was thus missed to state authoritatively which parts were old, which new and which had been remodelled in any way. Thorwaldsen himself, in his old age, could no longer describe the character and extent of his "restorations".'[19] Mercifully, however, the 'restorations' were recently removed.

I have purposely avoided the fine distinctions sometimes made between forgery and fake; forger and faker. This is not because I do not recognise a difference but because the distinction has become so blurred as to be little more than an exercise in semantics to insist upon one as opposed the other. The definitions used by dealers tell the story very well. The handbook used by Christie's makes a great deal of terminology. For forgery it says: 'the making of something in fraudulent imitation of something else. The key concept here is imitation of something else. A Louis XV style commode fraudulently made so that it will be mistaken for an already existing piece is a forgery.'

For fake we have: 'any work of art deliberately made or altered to pretend to be something older or better than it is . . . A commode made so that it has the general characteristics of the Louis XV style, but not in imitation of a known piece, is a fake.' Got it? Obviously the faker is not going to spend that

much time in fine distinctions, and when you go on to some of the examples we have seen with sculpture and painting, the distinction reaches ludicrous proportions. Interestingly, handbooks with these definitions find themselves hard-pressed to come up with very many examples of just what is a fake – and just what is a forgery. But it gets better.

According to the Christie's handbook, a copy is 'an imitation of an original. As long as it remains honest and does not pretend to be the original, it is a copy.' A reproduction 'is a term specifically used for copies of pictures or prints made by photographic or mechanical means'. A replica 'is a term used to denote a copy of a picture made by the artist himself'; a facsimile 'is an exact copy'. Counterfeit 'is a word usually intended for fake or forged money'; and sham and spurious 'are words used to describe a fake or a forgery'.[20]

It appears impossible for the fine distinctions to be maintained without using the various terms to describe the distinctions, and the blurring of fake and forgery passes without note. That's fine and perfectly understandable except that some spend so much time insisting that the classifications are essential in the market place, and both students and clients are supposed to recognise that well-defined distinctions are scrupulously observed. Nomenclature is an obsession with some of the lecturers in the Christie's Fine Arts Courses, and though I found the experience generally stimulating, the excessive habit of prefacing remarks with 'If you like . . .' or 'Shall we say . . .' becomes laughable as if the lecturer is terrified at saying just what he thinks about what is portrayed up there on the screen.

You get the impression at times that art is so almighty grand that experts are fearful of expressing an opinion which might be called out of hand. It is the same syndrome which insists upon reattribution rather than deattribution, and God forbid if you said it might be a fake. All this playing around with words makes a farce of the artist's original intent to have his creations speak for themselves.

42

'The prevalence of fakes is the venereal disorder of the illicit art market – the punishment for bad judgment and excessive

desire,'[21] said Karl Meyer in 1973. Who's to blame? The forger himself cannot be singled out for the crime as easily as say a child molester or a bank robber. He has taken advantage of a situation which has been created by art having been turned into a commodity, a wise investment, and a status symbol. Ironically the forger is less pretentious, less a fake than the market which sells his wares. At least we know who he is and what his true worth is. You cannot say that about much of the ostentatious façade given by art dealers and their galleries.

Art prices are now beyond the wildest dreams of a Dossena or a van Meegeren. It's remarkable there aren't more forgers out there today. John FitzMaurice Mills estimated that of the sales room turnover for 1976 – in access of £300,000,000 – something like £30,000,000 went into the forger's wallet.[22] He could have added it was likely that the lion's share went into the forgers' dealers' wallets. This is one estimation and it may be greatly exaggerated, but gives an indication of how serious art forgery is viewed today.

In the past three decades, the growth of the art market has outpaced that of almost every other field for risk capital, and there appears no end in sight. We have become anaesthetised to the high prices coming forth. In a *Sunday Times* article appropriately entitled 'Smart Art', it was reported in December 1986 that £7.26 million went for a Rembrandt, making the 1961 sale of *Aristotle Contemplating the Bust of Homer* seem not very significant. In November 1986, in New York, where art auctions raised a total of $146 million, no fewer than thirty-four records were set in one sale of forty-five Old Master drawings. The total of $21 million was the most paid for any drawing sale anywhere.[23]

Inflated prices, smart and snobby art all create the environment for a thriving business in art forgery, but there is, however, a final ingredient which many are unwilling to discuss – the closed shop attitude of the powers that be in the art establishment of gallery, museum and auction house. The art market is heavily coated with secrecy and what Karl Meyer aptly describes 'the chiaroscuro language of the trade'.[24] Prices, names of dealers, customers and routes of supply are as jealously concealed today – if not more so – than when Edward Warren and John Marshall operated.

It is no exaggeration to say that it is easier to obtain

information from the Vatican's Secret Archives than those of
American museums. I know because I have tried both. 'Such
secrecy was perhaps justified when the art market was a cozy
club consisting of a few thousand people and when its profits
were minuscule by comparison with other markets,' says Karl
Meyer. 'This is no longer so. Art is big business,' and Meyer
reminds us that in the art market there is no equivalent in the
United States of a Security and Exchange Commission 'to
ensure fair dealing and to protect the public interest'.[25]

Meyer is wrong about one point – the art establishment is still
operating pretty much as 'a cozy club'. When the BBC
approached a number of American museums about the 'Time-
watch' programme, it was only a matter of days before every
potential director and curator knew what had been said to
every other. There is an excessive protectiveness among the old
school of curators, and it does not take much reading between
the lines of the Dossena investigation to see how it was faced at
every turn along the way. Peter Dunn hit upon one of the
unspeakable aspects of this clique in his profile of V & A
director Roy Strong in *The Sunday Times* magazine (1 June
1986).

In discussing the 'virulence behind the anti-Strong cam-
paign' Dunn has 'one distinguished art critic' referring to 'the
museum world's "homosexual mafia", a group whose tall
academic reputations were matched only by Borgia-like cun-
ning, Homeric feuding and casting-couch performances that
would have shamed Hollywood in its heyday. Strong declines to
discuss this aspect of museum-keeping . . . but the conscious
decision he took years ago to keep the group at arm's length has
made him some formidable enemies.'[26]

Curators not only lock horns with directors but more signi-
ficantly with the men in the white coats, the museum scientists.
According to a very perceptive analysis several years back, this
tension has often impeded scientific detections of forgeries. A
reason why science has not found a welcome in the art museum
is that 'a good many curators and connoisseurs do not accept the
view that the art world has very pressing need of scientific and
technological input'. A reaction that Bryan Rostron elicited
gives us a window into the closed world of museum curators.
Alan Shestack, director of the Yale University Art Gallery
said:

While my area of specialization is limited to European paintings, prints and drawings since the Renaissance, I doubt if there are significant numbers of forgeries in any field. The rare instances where they are found get the publicity. Fakes tend to be bought by uninformed collectors. Museums are cautious, and we would always consult a top expert. We know who has the good eye – the museum profession in America is a small enough club, and we help each other out . . . I don't think forgeries are a problem, and I wouldn't have thought there were more than 0.01 per cent of forgeries on view in museums.

Rostron remarked, 'Other curators argue that while forgeries may be common, the first line of defense against them is the curator and not the scientist . . . the most sensitive machine cannot detect what the trained eye can see.' Stuart Fleming, who was at the Oxford Research Laboratory for Archaeology when 'Diana' was tested, went on to head the laboratory at the Philadelphia Museum, and he was Rostron's advocate for increased emphasis in museums on scientific detection. 'Art scholars are still from a generation which finds something alien and even threatening about science,' he told Rostron. 'One could almost say that the forger is more aware at present of what science has to offer.'

Rostron maintains that a final reason for the poor relations between curators and their white-coated colleagues is that while the curators who come from the world of aesthetics may at present be firmly in charge of art museums,

a potential power struggle may be shaping up for the future. For example, many academic accomplishments and museological reputations are based on work that might possibly be called into question and perhaps even demolished by scientific investigation. One scientist puts it this way: 'If you wrote your Ph.D. dissertation on a particular medieval painting of the Crucifixion or earned your stripes in the museum world by acquiring a collection of Chinese pottery, you sure as hell don't want some guy with an X-ray machine coming along and proving you a fool.' In addition, of course, some curators feel uneasy about possible sources of embarrassment to patrons and donors, some of whose gifts may not bear close scientific scrutiny.

Fleming feels that at present the marriage between science

and art scholarship is 'weak and tenuous . . . It is an uphill battle. I think the process is beginning to snowball gently and perhaps we are only a decade away from acceptance. We've got to get together, otherwise the forger will gain the upper hand. If the squabbling continues, only the forger benefits.'[27]

43

Those in the art establishment often assert that fooling the experts and its livelier component – making fools of the experts – is a chief motive behind forgers and those who take an interest in them. Perry Rathbone warmed to this theme when I interviewed him for 'Timewatch'. 'People rather enjoy fooling the experts,' he said in reference to the arguments over 'Diana'. He gave a delightful experience to prove his point. Once he was a panellist for a programme televised from the Philadelphia University Museum called, 'What in the World?' 'We, the experts, were offered all sorts of impossible objects to identify – as to purpose, age, culture, etc.' They came from the deepest recesses of the museum's reserves. The audience was informed in advance of what the panellists were wrestling with, and the result was sheer delight that those 'occupying such high positions' didn't have a clue as to what was in front of them.

At least Rathbone can joke about it which is more than some are capable of, and undoubtedly there is more than a little glee in the public mind when they read that yet again another museum official has been duped by the forger. And one is tempted to add that often the more pompous breed of experts sets itself up royally for a fall by its pontifications and arrogance. One has to go far to equal the pomposity displayed by some experts on the pages of *Apollo* or *The Burlington Magazine*. *Experts aupres du tribunal* (experts whose word is law) should be an endangered species.

There are, thank God, a breed of unpretentious and balanced souls also to be found in the art establishment. One of my favourites is Samuel Sachs II, now director of the Detroit Institute of Arts, who, while still at Minneapolis, responded at a discussion at the World Art Market Conference in New York in 1980, as to the ease with which art experts can spot forgeries,

with the most honest remark I have read: 'Forgeries are obvious only with 20-20 hindsight'.[28] That says it all.

The Metropolitan's seminar on art forgery in 1967 which was open to the public was a step in the right direction. There is a great deal to be said for exposing rather than obscuring the pitfalls into which collectors both public and private may fall. There is nothing to be gained – except for the increase of forgery – from obscuring their techniques, their sales methods and their subterfuges. Even worse is the common ostrich-like stance of some curators that forgery is either something they cannot bring themselves to discuss in public, or pretending it is such a tiny matter as to not be worth their precious time.

In 1961, the British Museum put on a dazzling show of fakes. There was something for every taste: Bronze Age jewels, Persian miniatures, African masks, drawings by Renaissance masters, fake manuscripts. Kenneth Clark contributed a seventeenth-century unicorn horn, and Alister Hardy lent his mummified mermaid. From the museum's basement came the Pinelli sarcophagus.

Thomas Hoving, who was responsible for the 1967 art forgery seminar at the Met, devoted a recent editorial in *Connoisseur* (November 1986) to the subject, and asserted 'I have that old, itchy feeling that suddenly a lot of fakes are appearing on the art market. It seems to happen in cycles, every ten years or so.' Now comfortably away from the day to day museum grind, he admitted: 'In the sixteen years I worked at the Metropolitan Museum of Art, I was responsible for collecting some twenty-five thousand works and must have seen a hundred thousand more. Fully 60 per cent of what I examined was not what it was said to be.'

Noting the 1961 British Museum exhibition, the 1967 seminar and the 1973 Minneapolis show of fakes, Hoving says, 'I think it's time for museums to illuminate us, the public, about fakes ... Surely it's time for another forgery exhibition.' Unfortunately, Hoving ends on a negative note: 'But what art museum in America these days would have the courage to put it on?'[29]

Two months after the 'Timewatch' programme, I returned to Room 46 of the Victoria and Albert to have another look at the fakes. It was a bit like seeing old friends, but I also noted objects to which I had not paid much attention during the madness of

filming. I ambled over to cast court 46B and took a look at the plaster cast of the Hermitage's supposed Rossellino relief which is, of course, a Bastianini. I also noticed the cast of Giovanni Pisano's *Virgin and Child* which was supposedly Dossena's inspiration for the Cleveland 'Madonna'. It has to be more interesting in the original, and I was beginning to like Dossena's sentimentalised version.

I walked by Bastianini's 'Savonarola' and Dossena's terracottas. Rather sad memorials to the latter – especially if you've ever seen the 'Diana' or the Stations of the Cross at San Patrizio in Rome. One piece by Odoardo Fantacchiotti caught my eye. Somehow he never figured prominently in my readings. His sandstone 'Madonna and Child' was acquired by the V & A in 1861 with 'alternative ascriptions to Donatello and Desiderio da Settignano'.[30] The label gave the interesting titbit that 'for many years' it was 'the most well-loved Madonna in the museum, and more plaster casts were sold of it than any other sculpture in the collection'.

I went back to 46B and there was a group of tourists being impressed by their guide. I faced the massive cast of Michelangelo's *David*, and retreated from the group behind the statue. There is a surprise in store for those who do the same. Hung, as it were, at the base of the great nude is an ample fig-leaf in plaster with a delightful explanatory note: '. . . hung on the occasion of visits to the Museum by Royal ladies. Originally used for visits by Queen Victoria, it was last used in the time of the late Queen Mary, a frequent visitor to the Museum when she was Queen Mother.' As I left the court, the group had gone but was replaced by a well-heeled Texas-looking couple. She pointed to the massive cast and exclaimed: 'I thought *David* was in Florence.' So much for authenticity.

Notes and References

Preface

1 Reit, Seymour, *The Day They Stole the Mona Lisa* (London: Robert Hale, 1981) p. 13.

Part One: The Backdrop

1 There are fewer comprehensive books on art forgery than would be supposed. I found the most useful to be Sepp Schüller's *Forgers, Dealers, Experts: Adventures in the Twilight of Art Forgery* (London: Arthur Barker, 1959) which also contains the most up to date record of Alceo Dossena. Lawrence Jeppson's spirited *Fabulous Frauds* (London: Arlington Books, 1971) is the most interesting of all the modern books on art forgery, and his chapter on Dossena is informative but lacking in data on the later years. Otto Kurz's *Fakes* (New York: Dover, 1967) rightly remains the classic on art forgery, but even though it was revised for the Dover publication, it has become rather dated in some areas, and I also question some of his observations regarding Dossena's creations, as the reader will note.

There are other books of general interest – *The Genuine Article* by John FitzMaurice Mills and John M. Mansfield (London: BBC, 1979) based on a television series and notably lacking in *any* references, and Fritz Mendax's amusing *Art Fakes and Forgeries* (London: Werner Laurie, 1975). H. Schmitt under the pseudonym of Frank Arnau produced a comprehensive work, *Three Thousand Years of Deception in Art and Antiques* (London: Jonathan Cape, 1961), which has some notable errors concerning Dossena but generally is better with other forgers. Most recently has been *The Forger's Art*, edited by Denis Dutton (Berkeley: University of California Press, 1983). Here according to the blurb: 'an eminent group of art historians, psychologists, and philosophers of art confront the aesthetic implications of forgery'. Like all efforts trying to put together a diverse bag of opinions the effort becomes tiresome, and was it not possible to talk of any forger other than van Meegeren? There are limits even with this master forger. I found the book often an exercise in American pedantry, but it is worth reading Alfred Lessing's *What Is Wrong with a Forgery?*

2 Lynes, Russell, 'Forgery for Fun and Profit', in *Harper's*, February 1968, p. 22.

3 Ibid.

4 Ibid. p. 24.

5 Schüller, *Forgers, Dealers, Experts*, p. 63.

6 Ibid. p. 167.

7 Ibid. p. 164.

8 Ibid.

9 Ibid. p. 62.

10 Lusetti, Walter, *Alceo Dossena, Scultore* (Rome: De Luca, 1955), p. 15.

11 Much of the foregoing was supplied to me by relatives of Dossena in Cremona, and some of the material was put together in an article in *La Provincia*, 10 March 1987, p. 3.

12 *Art News*, 3 January 1933, p. 12.

13 Lusetti, *Alceo Dossena*, p. 15

14 Pope-Hennessy, John, *The Study and Criticism of Italian Sculpture* (New York: The Metropolitan Museum of Art, 1980), p. 250.

15 Kurz, *Fakes*, p. 132.

16 Pope-Hennessy, *The Study and Criticism*, p. 250.

17 Lusetti, *Alceo Dossena*, p. 14.

18 Harold W. Parsons in private correspondence, 27 August 1947. (Henceforth this material from an anonymous source in Rome will be identified as HWP.)

19 Lusetti, *Alceo Dossena*, p. 15.

20 Ibid. p. 16.

21 Lynes, 'Forgery', p. 24.

22 Ibid.

23 Jeppson, *Fabulous Frauds*, pp. 52–3.

24 Schüller, *Forgers, Dealers, Experts*, p. 63.

25 Ibid.

26 Behrman, S. N., *Duveen* (London: Hamish Hamilton, 1953), p. 1.

27 Ibid. p. 50.

28 Lynes, Russell, *The Tastemakers: The Shaping of American Popular Taste* (New York: Dover, 1980), p. 198.

29 Valentiner, Walter, 'Marble Reliefs by Lorenzo Vecchietta', in *Art in America*, p. 56.

30 Letter to the author, 19 August 1986.

31 *The Illustrated London News*, 5 January 1929, p. 13.

32 *The New York Sun*, 20 February 1924, p. 18.

33 *Art News*, 1 December 1928, pp. 1–2.

34 Headington, Ann, 'The Great Cellini and His Roster of Famous Fakes', in *Connoisseur*, September 1986, p. 99.

35 Lynes, 'Forger', p. 24.

36 Ibid.

37 Jeppson, *Fabulous Frauds*, p. 58.

38 Lynes, 'Forgery', p. 26.

39 Lusetti, *Alceo Dossena*, p. 17.

40 Von Bothmer, Dietrich, 'The History of the Terracotta Warriors', in *Inquiry into the Forgery of the Etruscan Terracotta Warriors* (New York: The Metropolitan Museum of Art, 1961), p. 7.

41 Ashmole, Bernard, 'Forgeries of Ancient Sculpture: Creation and Detection' (The First J. L. Myres Memorial Lecture, New College, Oxford) (Oxford: Blackwell, 1961), pp. 10–11.

42 Ibid. p. 10.

43 Burdett, Osbert and Goddard, E. H. *Edward Perry Warren: The Biography of a Connoisseur* (London: Christophers, 1941), p. 338. Much of what I read in the Warren–Marshall papers is repeated in varying form in Burdett–Goddard, and for the sake of convenience, I usually cite the reference in the biography rather than the papers as the latter are frequently unpaginated and still uncatalogued. Where no similar reference can be ascribed, I use the abbreviation *EPW* for letters by Warren, and *JM* for those by Marshall. Unless otherwise noted, these materials are in the Ashmolean library collection.

44 Burdett–Goddard, *Warren*, p. vii.

45 Ibid. p. 79.

46 Ibid. p. 364.

47 Ibid. p. 58.

48 Ibid. p. 67.

49 Ibid. pp. 367, 373–4.

50 EPW, 22 November 1889.

51 Burdett–Goddard, *Warren*, pp. 257–8.

52 Samuels, Ernest, *Bernard Berenson: The Making of a Connoisseur* (Cambridge, Mass.: The Belknap Press of Harvard University Press, 1979), p. 168.

53 Burdett–Goddard, *Warren*, p. 139.

54 Ibid. pp. 140–1.

55 Tharp, Louise Hall, *Mrs Jack: A Biography of Isabella Stewart Gardner* (Boston: Little, Brown, 1965), p. 256.

56 Letter to the author, 3 February 1987.

57 Rose, Charles, *The Story of Lewes House* (Lewes: Lewes District Council, 1985), p. 3.

58 Samuels, *Berenson*, pp. 60–1; also useful is Whitehill, Walter Muir, *Museum of Fine Arts Boston: A Centennial History*, vol. I (Cambridge, Mass.: The Belknap Press of Harvard University Press, 1970), pp. 142–71.

59 Burdett–Goddard, *Warren*, p. 139.

60 Ibid. pp. 237, 243.

61 Rose, *The Story*, p. 3.

62 Burdett–Goddard, *Warren*, pp. 81–2.

63 Ibid. p. 100.

64 Ibid. p. 413.

65 Ibid. p. 100.

66 Ibid. p. 413.

67 EPW, 13 September, 1889.

68 Burdett–Goddard, *Warren*, p. 127.

69 Ibid. p. 70.

70 Samuels, *Berenson*, p. 328.

71 EPW, 16 February 1893.

72 Burdett–Goddard, *Warren*, p. 348.

73 JM, Undated from Athens and in several drafts at the Ashmolean.
74 Burdett–Goddard, *Warren*, p. 226.
75 Ibid.
76 Letter to the author, 3 February 1987.
77 Jandolo, Augusto, *Le Memorie di un Antiquario* (seconda edizione) (Milano: Casa Editrice Ceschina, 1938), p. 398.
78 Burdett–Goddard, *Warren*, p. 412.
79 Ibid. p. 146.
80 Ibid. p. 339.

Part Two: The Crime

1 Letter to the author, 3 February 1987.
2 Ashmole, 'Forgeries', p. 11.
3 Ibid.
4 Ibid.
5 Lynes, 'Forgery', p. 22.
6 Richter, Gisela M. A., 'Forgeries of Greek Sculpture', in *Bulletin of the Metropolitan Museum of Art*, volume XXIV, number 1, January 1929, p. 3.
7 Ibid. p. 4.
8 Ibid.
9 Ashmole, 'Forgeries', p. 12.
10 Ibid.
11 Ibid.
12 Ibid. p. 14.
13 Ibid.
14 Letter to the author, 3 February 1987.
15 Burdett–Goddard, *Warren*, p. 398.
16 Ibid. p. 399.
17 Ibid.
18 Ibid.
19 Ibid.
20 Ibid.
21 *The Times*, 2 January 1929.
22 Burdett–Goddard, *Warren*, p. 399.
23 *Art News*, 1 December 1928, p. 2
24 *The New York Times*, 28 November 1928, p. 32.
25 *Art News*, 8 December 1928, p. 4.
26 Ibid.
27 *Art News*, 1 December 1928, p. 1.
28 Ashmole, 'Forgeries', p. 15.
29 *The New York Times*, 8 December 1928, p. 22.
30 Ibid.
31 Ibid.
32 Jeppson, *Fabulous Frauds*, p. 56.

33 *Art News*, 1 December 1928, p. 2.
34 *Art News*, 22 December, 1928, p. 12.
35 Pope-Hennessy, *The Study and Criticism*, p. 250.
36 *Corriere della Sera*, 23 December 1928, p. 13.
37 Jeppson, *Fabulous Frauds*, p. 63.
38 *Art News*, 5 January 1929, p. 5.
39 *The New York Times*, 3 August 1980, p. 24.
40 Jeppson, *Fabulous Frauds*, p. 63.
41 *The Illustrated London News*, 5 January 1929, p. 13.
42 *Corriere della Sera*, 3 September 1927, p. 23.
43 Mendax, *Art Fakes*, pp. 215–16.
44 Jeppson, *Fabulous Frauds*, p. 61.
45 Arnau, *Three Thousand Years*, pp. 217–18.
46 Jeppson, *Fabulous Frauds*, p. 53.
47 Jandolo, *Le Memorie*, p. 402.
48 Schüller, *Forgers, Dealers, Experts*, pp. 63–4.
49 Kurz, *Fakes*, p. 122.
50 Whiting, Frederick Allen, 'The Dossena Forgeries', in *The Bulletin of the Cleveland Museum of Art*, volume XVI, no. 4, April 1929, pp. 66–7.
51 Tietze, Hans, *Genuine and False: Copies, Imitations, Forgeries* (London: Max Parrish, 1948), p. 66. (The caption erroneously says the Dossena is marble.)
52 Kurz, *Fakes*, p. 133.
53 HWP, 18 October 1956.
54 Lynes, 'Forgery', pp. 24 and 26.
55 It is difficult to have definite information concerning the set in wood. According to Frank Arnau: 'Without any fraudulent intent, Dossena had obtained the wood for his monumental work by sticking several old blocks of wood together with commercially produced glue of a type which did not come on the market until after 1880. The very fact that its components were glued together in the modern manner proved that the work was not of the early Gothic period, since the contemporary practice was to attach separate components with wedge-shaped pegs, using bone-glue for additional strength.' (*Three Thousand Years*, pp. 241–2.) Arnau gives no source for this information.
 Parsons says the Frick bought two other works by Dossena in the style of Donatello and Vecchietta.
56 Cochrane, Albert Franz, 'The Mystery of the Mino Tomb', in *Harper's Monthly Magazine*, July 1938, p. 140.
57 Ibid.
58 *Lorenzo de' Medici: Bust in Terracotta by Andrea del Verrocchio* (Città di Castello: Grifani-Donati, 1935), p. 3.
59 Lynes, 'Forgery', p. 24.
60 *Art News*, April 1986, p. 45.
61 Alberts, Robert C., *Pitt: The Story of the University of Pittsburgh 1787–1987* (Pittsburgh: University of Pittsburgh Press, 1987), p. 351.
62 Ibid.
63 Schüller, *Forgers, Dealers, Experts*, p. 162.

64 *Art News*, 9 March 1929, p. 1.
65 Siple, Ella S., 'A Critical Attitude Is Developing', in *The Burlington Magazine*, volume 54, 1929, p. 154.
66 Cochrane, 'The Mystery', p. 138.
67 Jeppson, *Fabulous Frauds*, p. 56.
68 Schüller, *Forgers, Dealers, Experts*, p. 64.
69 Jeppson, *Fabulous Frauds*, p. 56.
70 Cochrane, 'The Mystery', p. 139.
71 Ibid. p. 138.
72 Ibid. p. 139.
73 *Art News*, 26 January 1929, p. 7.
74 Cochrane, 'The Mystery', p. 142.
75 Ibid. p. 147.
76 *Art News*, 26 January 1929, p. 8.
77 Cochrane, 'The Mystery', p. 147.
78 Ibid.
79 Ibid.
80 *Art News*, 26 January 1929, p. 7 and 15 February 1929, p. 18.
81 Cochrane, 'The Mystery', p. 144.
82 Letter to the author, 15 August 1986.
83 Cochrane, 'The Mystery', p. 144.
84 'A Modified Tomb Monument of the Italian Renaissance', in *Bulletin of the Museum of Fine Arts* (XXXV, December 1937), p. 90.
85 Cochrane, 'The Mystery', p. 146.
86 After finishing my writing, I received from the Heim Gallery in London a set of photographs of one of the accompanying angels which they had in their files. Heim insists the object was never at the gallery but says, '. . . in the past we have been offered several works we believed to be by Dossena'. Interestingly the coat of arms is identical to that on the left-hand side of the tomb.
87 HWP, 7 May 1954.
88 Cochrane, 'The Mystery', p. 147.
89 Notes to author from Russell Lynes.
90 Burdett–Goddard, *Warren*, p. 173.
91 Ibid. pp. 356–7.
92 Hoving, Thomas, *King of the Confessors* (New York: Simon & Schuster, 1981), p. 172.
93 Headington, 'The Great Cellini', p. 100.
94 Young, William J. and Ashmole, Bernard, 'The Boston Relief and the Ludovisi Throne', in *Museum of Fine Arts, Boston Bulletin* (volume LXIII, number 332, 1965), p. 59.
95 Ibid.
96 Ibid. p. 159.
97 Ibid.

In the recently published *Artful Partners: Bernard Berenson and Joseph Duveen* (New York: Macmillan, 1987), Colin Simpson presents a case of

involvement with Dossena's forgeries which includes not only Elia Volpi and Romano Palesi, but also in varying degrees Wilhelm Bode, W. R. Valentiner, and indirectly even Bernard Berenson. Curiously Fasoli is not mentioned.

Simpson bases much of his research on the Duveen archives held in the Metropolitan Museum of Art, and diaries and notes of Edward Fowles, Duveen's successor in the firm and closest friend. *Artful Partners* details the secret collusion between Berenson and Duveen, and suggests the former rather than the latter was 'probably the most successful and unscrupulous art dealer the world has ever known' (p. 1).

According to Simpson, Carlo Balboni called at the Duveen Paris gallery on 12 October 1928 and 'made a detailed statement setting out his ... relationship with Dossena and a cabal of Italian dealers' (p. 191). He also confirmed that he and another 'had merely used BB as a means of obtaining introductions, and that, though Berenson had been well paid for his efforts, he was unaware that he was dealing with forgeries' (p. 191).

The link between the Dossena forgeries and Berenson began ten years earlier and was initiated by a French sculptor turned dealer, Georges Demotte, who turned to profitable forgery, duping Berenson, Isabella Gardner and the Louvre into purchasing four sculptures of kings (presumably the magi), which he had created using the remains of three sculptures. Two went to the Louvre for $150,000 and the others were sold by Berenson to Isabella Gardner for the same amount (*Connoisseur*, October 1986, pp. 135–6).

With that success Demotte invested his money in showrooms in New York 'offering a direct challenge to Joe Duveen'. As 'a source of ideas' Demotte next turned to Volpi and Palesi who, according to Simpson, paid [Dossena] a regular salary and set him up in a studio in the Via del Vantazzo in Rome' (p. 148). That address for a Dossena studio appears nowhere else – and I cannot even find such a street on my large map of Rome. I also cannot believe Elia Volpi was ever so directly related to Dossena, and all other sources indicate it was Fasoli not Palesi who dealt with Dossena's studios. Simpson also has Demotte and Volpi assisting Palesi in the concoction of a 'cover story to explain the flood of [Dossena] masterpieces they planned to launch on to the market' (p. 148). That was, of course, the earthquake-buried abbey tale of 'Don Mario'.

According to Simpson, certificates of authentication for Dossena's works were supplied by 'the now aging and gullible von Bode, the young and gullible W. R. Valentiner . . . and Volpi' (p. 148). Demotte and Volpi gave Berenson 'photographs of many of their pieces and he, too, believed their story' (p. 148). When Fowles visited Berenson in Florence in 1917 he

was horrified to be shown photographs of what he believed to be forgeries of a Donatello relief of the Madonna with St Anne, a carved Gothic wooden figure of the Madonna attributed to Simone Martini, and a similar version in marble by the same artist. All had been sold to the Frick Museum for a total of $475,000. Bernhard fervently believed in their authenticity. He proudly told Fowles that the gem of the collection was also under consideration by Miss Helen Frick. This was a complete Renaissance sarcophagus, attributed to Mino da Fiesole.

While he was showing Fowles the photographs, Bernhard complained bitterly that

Joe [Duveen] would not listen when he told him about these marvelous sculptures.
Fowles held his tongue, suggesting that Bernhard write to Joe setting out his case.
(p. 149)

Berenson was invited to Paris to discuss the situation, and apparently the
latter told the former the facts of matter at that time.

It is difficult for anyone not privy to the Duveen papers to know just how
much of the foregoing is true, and as Meryle Secrest (*Being Bernard
Berenson: A Biography*, London: Weidenfeld & Nicolson, 1980, p. xix) notes
the Duveen papers 'cannot be made public until the year 2002'. However,
according to other sources, several of Simpson's statements are not borne out
by known facts. The Frick maintains it only purchased the marble *Annuncia-
tion* set now at Pittsburgh. In a footnote to p. 149 Simpson says that 'the
wooden version was purchased by Lord Clark and is at Saltwood Castle in
Kent. It appears on the dust-jacket of Lord Clark's autobiography, *Another
Part of the Wood*. It is reproduced in *Artful Partners* with the caption 'a
modern copy made by Alceo Dossena'. First, the Madonna and Child bear no
resemblance to the marble *Annunciation* set at Pittsburgh or indeed to
Simone Martini's work. Obviously it has been confused with Dossena's
wooden copy of the *Annunciation* which according to the Frick was never in
their possession, and was sold at an auction of Dossena's works, in 1933, in
New York. Also the 'Donatello' relief, if it be that with St Elizabeth (not Anne)
and the infants Jesus and John, was never owned by the Frick, and is now in a
private collection in Venice. However, Parsons maintained that the Frick
Museum once purchased a Dossena Donatello but does not say what the
subject was.

The date 1917 for these events seems impossible. Dossena was still in the
army and not operating out of any studio, and Palesi is said to have offered the
tomb to Miss Frick in 1921. Nevertheless, Simpson's explorations do indicate
there was more of an involvement among various dealers than earlier
supposed. I only wish he had found out more of Balboni's interests as notes
from Harold Parsons kept in the Frick Library, which I checked in March
1987, indicate that Balboni was offering for sale a number of Dossena's works
previously not noted, including statues of St Anne, St Catherine of Siena and
a female saint. Balboni also held the Venetian Donatello relief for a time, but
most of these pieces were in his hands in 1928.

Simpson maintains that if the Frick turned down the 'Mino' tomb, 'Boston
Museum were the next in line to purchase it. Further inquiries showed that
Boston had learned about it from Berenson's old Harvard and Oxford friend
Ned Warren, who in turn had been tipped off by Bernard. In Joe's suspicious
mind that confirmed to him that Bernard was making sure that, as usual, he
had two bites at the cherry. If Demotte did not pay him a commission for the
Frick sale he would get one from Warren if Boston bought' (pp. 149–50).
Obviously this attracted my attention, and again I only wish Simpson had
given more details. As I say in the text, I wonder why the Boston tomb never
appears in any of the Warren–Marshall papers, but with what is learned
elsewhere about Warren it is difficult to believe he was acting in this manner,
and surely there must have been some indication in Fowles' materials of
John Marshall who never appears in *Artful Partners*. According to the

Warren biography (p. 135) it was Marshall rather than Warren who 'renewed acquaintance' with Berenson.

Where there is smoke there is fire, so perhaps Simpson has at least opened up some intriguing possibilities. One for a future sleuth to pursue is the connection between Balboni and the French dealer, René Gimpel. Gimpel married Duveen's youngest sister, Florence, in 1913. In 1909–10, a painting which was designated as a Titian or a Giorgione copy was offered for sale by Balboni to Gimpel, and Berenson castigated Balboni 'for spreading the word that Gimpel was buying the Titian on [his] advice' (Meryle Secrest, *Being Bernard Berenson: A Biography*, p. 256). I hope to be around when the Duveen archives are made public – and those of the Frick for that matter.

Part Three: The Legacy

1 *The Illustrated London News*, 28 December 1929, pp. 1136–7.
2 Lynes, 'Forgery', p. 26.
3 *Art News*, 18 May 1929, p. 12.
4 Ibid.
5 Ibid.
6 *Art News*, 14 December 1929, p. 23.
7 Jeppson, *Fabulous Frauds*, pp. 66–7 and Cürlis, Hans, *Alceo Dossena* (Berlin: Institutes für Kulturforschung, 1930).
8 Ibid. pp. 67–8.
9 Ibid.
10 Rathbone, Perry T., 'Diana the Huntress', in *Archaeology*, Winter 1953, pp. 242–3.
11 Ibid.
12 Entry Number 7059 in Saint Louis Museum.
13 Rathbone, Perry T., 'An Etruscan Diana of the First Rank', in *The Illustrated London News*, 19 September 1953, p. 435.
14 *Art News*, November 1953, p. 2.
15 Hoopes, Thomas T., 'The Terra-Cotta Group of Diana with a fawn: An Abbreviated Digest from the Original Publication by R. Herbig in Abhandlungen der Heidelberger Akademie der Wissenschaften, Philosophisch-historische Klasse, Jahrgang 1956, 3, Abhandlung', in *Bulletin of the City Art Musuem*, Saint Louis, volume XLIII, 1958, pp. 15 and 27.
16 Schüller, *Forgers, Dealers, Experts*, p. 70.
17 Lusetti, *Alceo Dossena*, p. 13.
18 HWP, 31 December 1948.
19 Hoving, *King of the Confessors*, p. 173.
20 Ibid. p. 165.
21 Ibid. p. 169.
22 Ibid. p. 171.
23 Ibid.
24 HWP, 21 November 1932.
25 HWP, 27 August 1947.

26 HWP, 3 September 1947.
27 HWP, 3 May 1954.
28 HWP, 17 May 1954.
29 HWP (1958) no more exact date indicated.
30 Hoving, *King of the Confessors*, p. 172.
31 Headington, 'The Great Cellini', p. 99.
32 HWP, notes from 1948–1949.
33 Headington, 'The Great Cellini', p. 99.
34 Hoving, *King of the Confessors*, p. 173.
35 Ibid. p. 176.
36 Ibid. p. 193.
37 Ibid. p. 176.
38 HWP, 12 June 1956.
39 Cellini, Giuseppe, in *Paragone*, no. 81, 1956 (no title), p. 85.
40 HWP, notes from 1956.
41 Parsons, Harold W., 'The Art of Fake Etruscan Art', in *Art News*, February 1962, p. 36.
42 HWP, 18 October 1956.
43 Ibid.
44 Parsons, 'The Art', p. 35.
45 Nagel, Charles, in letter to the editor, *Art News*, March 1962, p. 10.
46 Parsons, Harold W. in reply to Mr Nagel, *Art News*, March 1962, p. 65.
47 Ashmole, 'Forgeries', p. 4.
48 'The Forger', *Timewatch*, BBC TV, 4 December 1986. I was the interviewer and the presenter of the programme.

Part Four: The Italian Connection

1 Parsons, 'The Art', p. 37.
2 Ibid. p. 34.
3 Ibid.
4 Hoving, *King of the Confessors*, p. 173.
5 Von Bothmer, 'The History of the Terracotta Warriors', p. 12. Von Bothmer's article credits materials kept in the Warren–Marshall collection of the Ashmolean, but curiously I did not find that some of the papers quoted are still there.
6 *Time*, 24 February 1961, p. 60.
7 Pope-Hennessy, *The Study and Criticism*, p. 265.
8 Meyer, Karl E., 'The Plundered Past', in *The New Yorker*, 7 April 1973 (Part III), p. 96.
9 Jeppson, *Fabulous Frauds*, p. 158.
10 Parsons, 'The Art', p. 37.
11 Kurz, *Fakes*, p. 147.
12 Von Bothmer, 'The History of the Terracotta Warriors', p. 15.
13 JM (from Rome), 1 November 1892.
14 Von Bothmer, 'The History of the Terracotta Warriors', p. 14.
15 Ibid.

16 HWP, 31 August 1948.
17 Von Bothmer, 'The History of the Terracotta Warriors', p. 12.
18 Ibid. p. 7.
19 Ibid.
20 Ibid.
21 Ibid. p. 8.
22 Ibid.
23 Frankfurter, Alfred, 'Unhappy Warriors', *Art News*, March 1961, p. 65.
24 Von Bothmer, 'The History of the Terracotta Warriors', p. 19.
25 Ibid.
26 Ibid. p. 9.
27 Ibid.
28 Ibid. p. 10.
29 Ibid.
30 Burdett–Goddard, *Warren*, p. 337.
31 Von Bothmer, 'The History of the Terracotta Warriors', p. 10.
32 Ibid.
33 Ibid. p. 11.
34 Ibid.
35 Ibid.
36 Ibid.
37 Pallotino, Massimo, in *Roma*, December 1937, p. 437.
38 Von Bothmer, 'The History of the Terracotta Warriors', p. 12.
39 Noble, Joseph V., 'Proof of the Forgery: Technical Considerations', in
 Inquiry into the Forgery of the Etruscan Terracotta Warriors (New York:
 Metropolitan Museum of Art), p. 20.
40 *Newsweek*, 27 February 1961, p. 57.
41 Frankfurter, 'Unhappy Warriors', p. 25.
42 Parsons, 'The Art', p. 36.
43 Ibid.
44 Ibid.

Colin Simpson in *Artful Partners* adds another dimension to the Etruscan warrior story. He insists that at the same time that Duveen's inquiries had discovered the 'Mino' tomb was to go to the Frick or to the Boston Museum and that Berenson was involved through Ned Warren, other inquiries revealed that the Met

> had just spent almost $600,000 on a series of major Etruscan terra-cotta figures and were contemplating the purchase of several more. The negotiator was the Metropolitan's assistant keeper of Classical art, a Miss Gisela Richter, the daughter of J. P. Richter, Bernhard's silent partner in many an old master deal.
>
> Joe's information came from sources within the Metropolitan who were jealous that Miss Richter had been allocated purchasing funds denied to their departments . . . In fact, the Metropolitan's Etruscan purchases were a separate hoax. Demotte [see chapter note in Part Two] was peripherally connected, but the main beneficiaries of the swindle were Pietro Stenniner [sic], then a senior official in the Rome post office, a Rome-based dealer called Domenico Fuschini, and a family of forgers from Assisi called Fioravanti . . .

Joe, unaware that the only connection between the two operations was Demotte, leapt to the conclusion that Bernhard was up to his ears in both plots. The misconception was based on Miss Richter's and Warren's involvement, Bernhard's connection with Demotte, and his possession of the photographs that Fowles had seen. Joe's letter cordially invited Bernhard to Paris and was the first stage of a defensive plan to isolate himself, Duveen Brothers and, because he had to, Bernhard from the inevitable denouement. The second stage was secretly to advise the Frick, and Miss Richter's rival curators, that their recent purchases were doubtful to say the least.

The Frick took him at his word, and courteously allowed the Boston Museum to acquire the Renaissance sarcophagus, where it is today. The Metropolitan took no action for years. (pp. 150–1)

Again Simpson's intriguing plots are marred by obvious errors: the timing for both occurring at the same time is difficult if not impossible, the absence of Marshall's role, the amount of $600,000 is more than excessive, the misspelling of Stettiner, and the confusion of the Riccardi family with Fioravanti do not instil confidence in the rest of the story. However, there is clear indication from Simpson's research into the Duveen files that there was more than a casual awareness by powers like Duveen and Berenson of the Etruscan warriors and Dossena forgeries. It is hard to believe that Miss Richter could have remained in the dark so long. And how was it possible that Simpson could not have come across John Marshall's name in all this?

Part Five: The Precursor

1 Joni (Ioni), Icilio Federico, *Affairs of a Painter* (London: Faber and Faber, 1936), p. 342.
2 Ibid. p. 7.
3 Ibid. pp. 331–2.
4 Clark, Kenneth, 'Forgeries' in *History Today*, November 1979, p. 732.
5 Headington, 'The Great Cellini', p. 102.
6 Ibid.
7 Strachey, Barbara and Samuels, Jayne (eds), *Mary Berenson: A Self-Portrait from Her Letters and Diaries* (London: Gollancz, 1983), p. 103.
8 Ibid.
9 Clark, 'Forgeries', p. 732.
10 *The Times*, 3 January 1987, p. 21.
11 Joni, *Affairs of a Painter*, p. 184.
12 Kurz, *Fakes*, pp. 42–3.
13 Clark, 'Forgeries', p. 732.
14 Ibid.
15 Joni, *Affairs of a Painter*, pp. 338–9.
16 Clark, 'Forgeries', p. 730.
17 Ibid. and Clark, Kenneth, *Another Part of the Wood: A Self-Portrait* (London: John Murray, 1974), pp. 56–7.
18 Barstow, Nina, 'The Forgeries of Bastianini', in *The Magazine of Art*, 1885–6, p. 503.
19 Pope-Hennessy John, *Catalogue of Italian Sculpture in the Victoria and*

Albert Museum, volume III (London: Victoria and Albert Museum, 1964), p. 683.

20 Pope-Hennessy, *The Study and Criticism*, pp. 239–40.
21 Ibid. p. 257
22 Ibid.
23 Ibid. p. 260.
24 Barstow, 'The Forgeries', p. 505.
25 Ibid.
26 Ibid. p. 506.
27 Ibid.
28 Kurz, *Fakes*, p. 150.
29 Schüller, *Forgers, Dealers, Experts*, p. 31.
30 Pope-Hennessy, *The Study and Criticism*, p. 256.
31 Schüller, *Forgers, Dealers, Experts*, p. 26.
32 Jeppson, *Fabulous Frauds*, pp. 13–14.
33 Schüller, *Forgers, Dealers, Experts*, p. 28.
34 Ibid. pp. 28–9.
35 Ibid. and Jeppson, *Fabulous Frauds*, p. 21.
36 Ibid. pp. 28–30.
37 *The Times*, 23 October 1909, p. 18.
38 Schüller, *Forgers, Dealers, Experts*, p. 56.
39 Pope-Hennessy, John, 'The Forging of Italian Renaissance Sculpture', in *Apollo*, April 1974, p. 250.
40 Ibid. p. 260.
41 The Eleganza Collection catalogue, 1987.
42 Pope-Hennessy, *The Study and Criticism*, p. 240.
43 Ibid. p. 241.
44 Ibid. p. 231
45 Ibid. pp. 231–3.
46 Sachs II, Samuel, *Fakes and Forgeries* (Minneapolis: Minneapolis Institute of Arts, 1973).
47 Meyer, 'The Plundered Past', p. 120.

Part Six: The Survivors

1 *The Sunday Times*, 30 March 1986, p. 17.
2 *US News and World Report*, 25 August 1986, p. 38.
3 *The Sunday Times*, p. 17.
4 Meyer, 'The Plundered Past', p. 122.
5 *The Times*, 30 December 1986, p. 10.
6 Meyer, 'The Plundered Past', p. 123.
7 Ibid. p. 124.
8 Dornberg, John, 'Artists Who Fake Fine Art Have Met Their Match – in the Laboratory', in *The Smithsonian*, October 1985, p. 68.
9 Ibid.
10 Ibid.
11 Ibid.

12 Ibid.
13 Secrest, Meryle, 'Memo to a Forger', in *Saturday Review*, September–October 1983, p. 24.
14 A revised version given by Meryle Secrest with insights from other observers.
15 Secrest, 'Memo', p. 25.
16 Dutton, *The Forger's Art*, pp. 30–1.
17 *The New York Times*, 11 February 1987, p. 27.
18 *The Observer*, 20 October 1985, p. 17.
19 *Time*, 20 May 1985, p. 40.
20 *The New York Times*, p. 27.
21 Ibid.
22 Ibid.
23 Kurz, *Fakes*, p. 123.
24 HWP, 12 June 1956.
25 Pope-Hennessy, 'The Forging', p. 259.
26 Letter to the author, 29 September 1986.
27 Pope-Hennessy, *The Study and Criticism*.
28 Lynes, 'Forgery', p. 24.
29 *Antique*, Winter 1986 (no author given), p. 24.
30 Letter to the author, 2 February 1987.
31 Hoving, Thomas, 'Money and Masterpieces', in *Connoisseur*, December 1986, p. 93.
32 *The Times*, 13 February 1987, pp. 1 and 14.
33 *Newsweek*, 1 April 1966, p. 12.
34 Ibid.
35 *The Times*, 4 December 1985, p. 12.
36 Norman, Geraldine, 'The Bargain Holbein – Or Is It a Holbein?', in *Art News*, pp. 134–5.
37 *The Times*, 9 August 1986, p. 1 and 8.
38 Headington, 'The Great Cellini', p. 103.
39 True, Marion, 'A Kouros at the Getty Museum', in *The Burlington Magazine*, January 1987, pp. 7, 9 and 11.
40 Ibid. p. 11.
41 Headington, 'The Great Cellini', p. 100. (These comments were given by Thomas Hoving.)
42 Ibid. p. 103.
43 Letter to the author, 27 January 1987.
44 JM, 30 April 1925.
45 *The Times*, 30 March 1987, p. 2.

Part Seven: The Blame

1 *Art News*, 8 December 1928, p. 12.
2 *Art News*, 1 December 1928, p. 14.
3 Ibid.
4 Meyer, 'The Plundered Past', p. 125.

5 Schüller, *Forgers, Dealers, Experts*, pp. 142–53.
6 Dutton, *The Forger's Art*, p. 48.
7 Schüller, *Forgers, Dealers, Experts*, p. 68.
8 Notes from Russell Lynes.
9 Koestler, Arthur, 'The Aesthetics of Snobbery', in *Horizon*, Winter 1965, p. 50.
10 Ibid. p. 52.
11 Ibid. p. 53.
12 Green, Alan, 'Hugger-mugger at the Louvre', in *Saturday Review*, 17 May 1975, p. 45.
13 *The New York Times*, 15 November 1986, p. 46.
14 *The New York Times*, 7 December 1986, pp. 31 and 35.
15 Ibid. p. 35.
16 Horsley, Carter B., 'Who Really Painted It?', in *Art News*, March 1973, p. 49.
17 *International Herald Tribune*, 10 March 1986, p. 9.
18 Schüller, *Forgers, Dealers, Experts*, p. 153.
19 Ibid. pp. 153–4.
20 Cumming, Robert, *Christie's Guide to Collecting* (Oxford: Phaidon, 1984), p. 58.
21 Meyer, 'The Plundered Past', p. 120.
22 Mills, John FitzMaurice, *The Guinness Book of Art Facts and Feats* (Enfield, Middlesex: Guinness Superlatives, 1978), p. 140.
23 *The Sunday Times*, 14 December 1986, p. 27.
24 Meyer, 'The Plundered Past' (Part I), in *The New Yorker*, 24 March 1973, p. 96.
25 Ibid.
26 Dunn, Peter, 'Portrait of the Director under Fire', *The Sunday Times Magazine*, 1 June 1986, p. 50.
27 Rostron, Bryan, 'The Curator Versus the Scientist in Today's Art Museum', in *The New York Times* (Section II), pp. 1 and 24.
28 *Art News*, May 1980, p. 105.
29 Hoving, Thomas, 'The Forgery Boom', in *Connoisseur*, November 1986, p. 41.
30 Pope-Hennessy, *Catalogue*, p. 691.

Index